EVOCATIONS OF PLACE

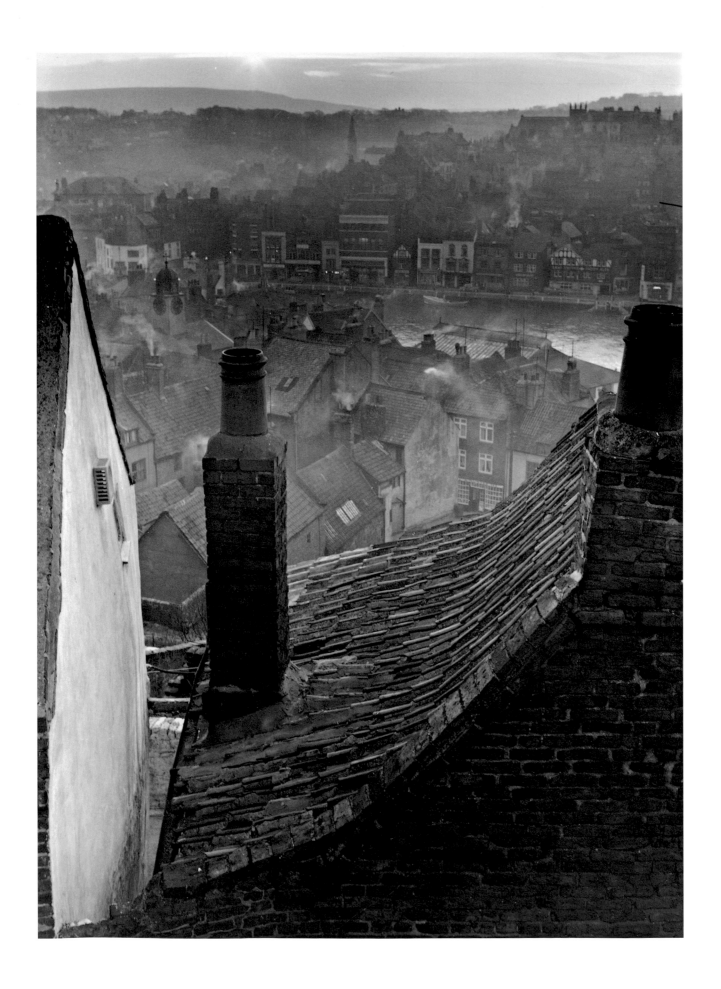

ROBERT ELWALL

EVOCATIONS OF PLACE
THE PHOTOGRAPHY OF
EDWIN SMITH

MERRELL
LONDON · NEW YORK

RIBA Trust

First published 2007
by Merrell Publishers Limited

Head office
81 Southwark Street
London SE1 0HX

New York office
49 West 24th Street, 8th Floor
New York, NY 10010

merrellpublishers.com

in association with the
RIBA Trust
Royal Institute of British Architects
66 Portland Place
London W1B 1AD

British Library Cataloguing-in-Publication Data:
Elwall, Robert
Evocations of place : the photography of Edwin Smith
1. Smith, Edwin, 1912–1971 2. Architectural photography
I. Title II. RIBA Trust
779′.092

ISBN-13: 978-1-8589-4373-2
ISBN-10: 1-8589-4373-6

Produced by Merrell Publishers
Designed by Maggi Smith
Copy-edited by Michael Bird
Proof-read by Barbara Roby
Indexed by Hilary Bird

Printed and bound in Italy

Front jacket: *Villa Garzoni, Collodi, Italy* (1962; see p. 145)
Back jacket: *Brighton beach* (1952; see p. 87)
Page 2: *Roofscape, Whitby* (1959)

County names used in the captions in this book
are those used when the photographs were taken,
as in Edwin Smith's original captions.

CONTENTS

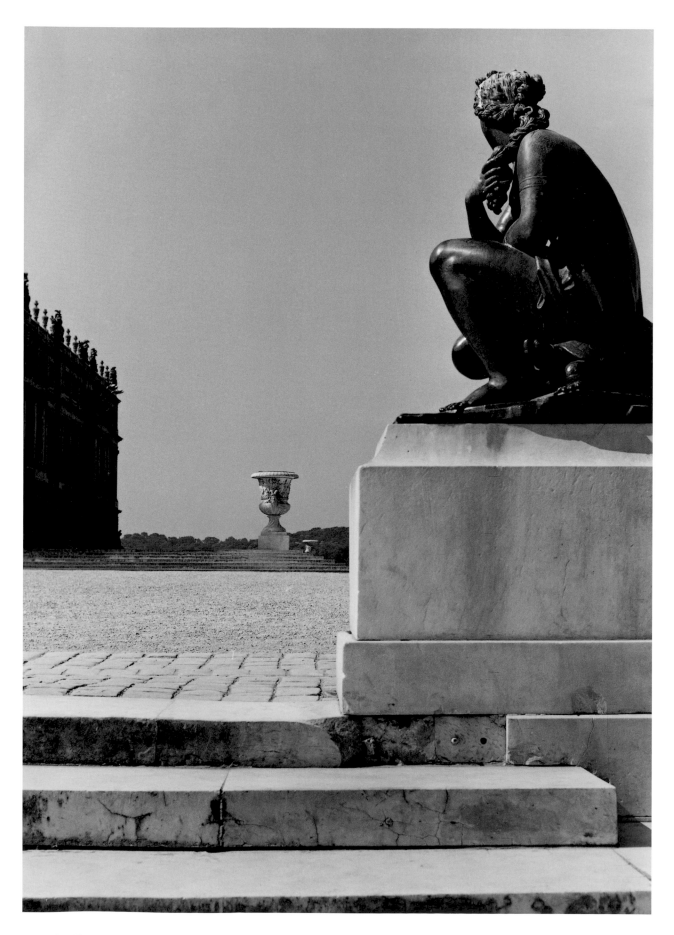

Versailles, France (1962)

Fig. 1 Edwin Smith (1951)

Hailed by Sir John Betjeman as "a genius at photography"[1] and by Cecil Beaton as "an understanding and loving connoisseur of his subject",[2] Edwin Smith (1912–1971) was one of Britain's foremost photographers (fig. 1). At the time of his tragic death from cancer at the relatively early age of fifty-nine his reputation was at its peak. Eagerly courted by publishers, he had provided the core illustrative material for more than thirty books, many of them handsome volumes that had proved both popular and influential. In addition, he was widely regarded as without peer in his sensitive renditions of historical architecture and his empathetic evocations of place, which displayed an unerring ability to conjure up the *genius loci* and earned him the prestigious soubriquet 'the English Atget'. Yet today, despite the unstinting efforts of his widow, Olive Cook, to keep his memory alive through a series of exhibitions and a major publication, *Edwin Smith: Photographs 1935–1971* (1984), his work remains virtually unknown beyond an ageing group of cognoscenti. One of the chief aims of this book, therefore, is to introduce Smith's imagery to a new generation of photographic enthusiasts.

The decline in Smith's standing can be attributed to a number of factors. Certainly Smith's own modesty, indeed equivocation, about his work and the photographic medium in general, has played a part. With typical self-effacement, Smith described his photography as "co-operating with the inevitable",[3] while it was only at the very end of his life that he finally acknowledged the appellation 'photographer' at all, having labelled himself 'artist' on successive passports, and consistently insisted that he was "an architect by training, a painter by inclination and a photographer by necessity".[4] In this self-portrayal Smith presented photography merely as a means of financing the artistic endeavours by which he set greater store. Indeed, he maintained a prodigious output of artworks – oils, watercolours, woodcuts and sketches – throughout his life. These, especially the woodcuts, displayed a not inconsiderable talent, but they failed to find an audience, and, much to Smith's bitter disappointment, his artistic aspirations remained unfulfilled. His apparently dismissive attitude towards photography, a sentiment interestingly shared by Henri Cartier-Bresson (1908–2004), cannot be taken at face value, however, for the numerous books Smith wrote about the medium and the infinite care he took over the production of his prints betray a deep love and understanding of his craft. Ultimately, it is for his photography that he will be remembered.

The years since Smith's death have witnessed not only a burgeoning public interest in photography but also a major expansion of photographic studies. It could be contended, however, that this fecundity is illusory, masking a narrowness of vision in which a deeper understanding of our photographic patrimony is increasingly being sacrificed on the altar of marketability. Thus, many museums and galleries feel obliged to mount exhibitions that can guarantee a 'high footfall' and lucrative merchandising, while for publishers all too often the first consideration in deciding whether to publish is how well the proposed book will sell in the high-volume American market. This has led to a circumscribed concentration on a core elite of marketable photographers whose work, beloved of agents, dealers and corporate sponsors, increasingly dominates the standard photographic histories to the extent that photographers such as Smith are seldom accorded their due. This situation is compounded by a similarly blinkered attitude in relation to monographs on particular photographers, too many of which appear hermetically sealed in their refusal to open out and consider their subject's work in a wider cultural context or even to compare it to that of other photographers. Aping the methodology of such nineteenth-century art critics as Walter Pater, many of these studies remain over-reliant on the author's sensibility, which treats photographs purely from an aesthetic standpoint to the exclusion of their role as functional artefacts made for a

Fig. 2 Farm near Deptford, Wiltshire (1956)

particular purpose and with a particular audience in mind. Even more crucially neglected is the way in which photographs most often reached their audience – not through the original print revered by collectors and curators but through reproduction. Few of Smith's prints, for example, were displayed during his lifetime, and his reputation and influence were founded almost entirely on a rich corpus of book illustrations. The result is that much photographic analysis exists in a ghetto of its own making, and consequently photography is excluded from mainstream critical debate. General cultural commentaries may draw their examples from literature, art, music and cinema, but rarely from photography.

Against this backdrop it is easier to comprehend the judgement of Magnum photographer Martin Parr, otherwise an astute commentator on the medium, that post-war British photography is riven with a mawkish sentimentality that renders it unworthy of critical regard, especially when compared to contemporaneous American output.[5] If, however, we take a wider view and explore the imagery of such photographers as Smith from a broader perspective, then Parr's dismissal appears increasingly unsustainable. Smith's photographs have much to tell us about the state of post-war Britain and notions of Britishness – arguably more than those photographs of the City of London or Welsh mining communities made by one of Parr's heroes, the American Robert Frank. Above all, Parr's verdict owes less to considered historical appraisal than to the fact that such photography as Smith's is currently unfashionable. While it is true that the genres – architecture and landscape (fig. 2) – in which he predominantly worked have been photography's perennial pariahs, Smith's gentle, probing imagery has recently fallen victim to a changed photographic taste that now values visceral shock over subtle resonance. This is all the more regrettable as the recurrent themes of Smith's work – a concern for the fragility of the environment, both natural and man-made; an acute appreciation of the need to combat cultural homogenization by safeguarding regional diversity; and, above all, a conviction that architecture should be rooted in time and place – are as pressing today as when Smith first framed them in his elegantly precise compositions. In a world of unrelenting pace, instant gratification and the fleeting glimpse of 'zoomscape',[6] Smith's photographs invaluably teach us to pause, look, reflect and understand.

1 *Daily Telegraph & Morning Post*, 23 August 1954.
2 Cecil Beaton, 'Preface', in *Great Interiors*, ed. Ian Grant, London (Weidenfeld & Nicolson) 1967, p. 9.
3 Olive Cook, *Edwin Smith: Photographs 1935–1971*, London (Thames & Hudson) 1984, p. 11.

4 *Ibid.*, p. 5.
5 See, for example, *The Guardian Weekend*, 20 August 2005, p. 70.
6 Cf. Mitchell Schwarzer, *Zoomscape: Architecture in Motion and Media*, New York (Princeton Architectural Press) 2004.

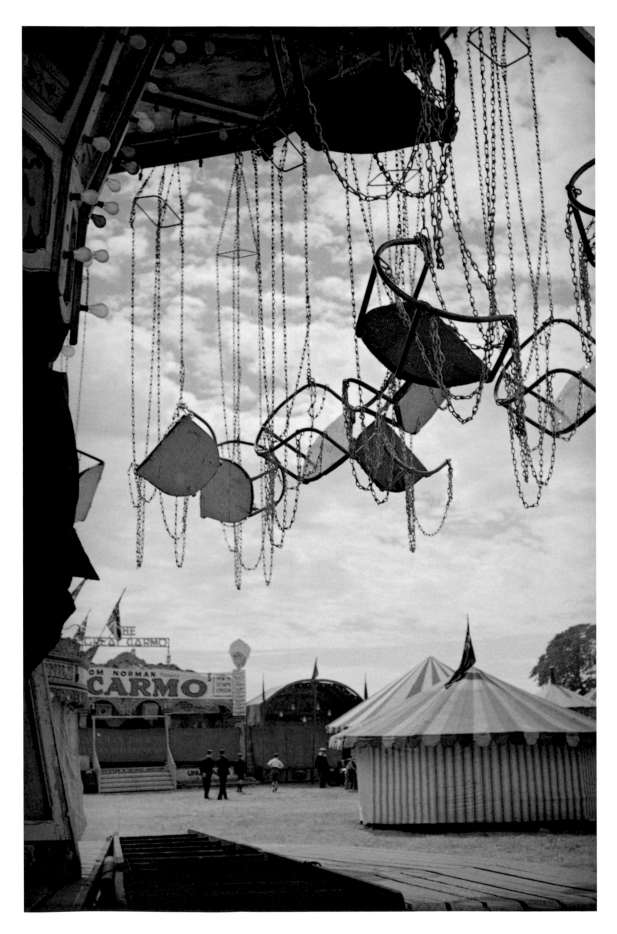

Mitcham fair, London (1935)

CHAPTER 1
DISCOVERING PHOTOGRAPHY

In 1936, on the recommendation of the American photographer Francis Bruguière (1879–1945), Edwin Smith was invited to contribute an example of his work to the annual magazine *Modern Photography*. Smith chose one of his favourite fairground studies, an image of a helter-skelter. The accompanying text he wrote revealed not only the heady excitement he felt at his inclusion in such an august journal alongside some of the medium's most esteemed practitioners, such as László Moholy-Nagy and Edward Weston, but also his photographic philosophy:

> Photographically one year old. Having an incurable tendency very early in life of preferring the two-dimensional image to its three-dimensional counterpart, it was inevitable that I should discover the camera. Camera-eye has revealed a new visual sphere for my habitation; much that was before visually incomprehensible has become, in the presence of the camera, significant. A divining rod finding its own peculiar water, with myself a passive diviner. There is, of course, much still to be divined.[1]

This conception of photography as an exhilarating voyage of discovery into the teeming richness of the visual world, which could be divined in the ordinary as well as the extraordinary, and of the photographer as the unassuming recorder and celebrant of this world, was to remain one of the guiding principles of Smith's camera work for nearly forty years.

Smith's interest in photography had initially been kindled several years before with the acquisition of his first camera, a Kodak Box Brownie, which he obtained by redeeming cornflake-packet coupons, probably in 1927. His early experiments with this popular but limited piece of equipment explored the familiar terrain of a young camera enthusiast: relatives and friends; family holidays at home and abroad; still lifes; and street scenes and buildings in and around Camden Town, London. He had been born there in humble circumstances Edwin George Herbert Smith on 15 May 1912, to Edwin Stanley Smith, a stonemason, and Lily Beatrice Smith, née Gray. The young Smith showed little aptitude for academic work, hindered perhaps by his short-sightedness. This went undiagnosed for several years and then, to the youngster's delight, was 'magically' remedied by spectacles, a revelatory experience that led Smith throughout his life to prize so highly intense looking and visual acuity. In 1924 he left his elementary school to attend the Northern Polytechnic, Holloway, London, where he excelled at a range of practical building crafts, including bricklaying and plumbing. Four years later he won a scholarship to study architecture at the same institution; then in 1930 he repeated the feat, winning a place at London's Architectural Association, one of the most prestigious and progressive schools of architecture. At this time he met two people who were to help shape his future career and remain lifelong friends, Oswell Blakeston and James Burford.

Five years Smith's senior, Blakeston was a polymath whose diverse talents included film direction and the writing of poetry, novels, and non-fiction works on subjects ranging from cookery through travelogues to photography and film. These last were the topics he covered under the pseudonym 'Mercurius' for the leading architectural magazine of the period, the *Architectural Review*, in which he railed against "diehard pictorialists" and their "visual platitudes", and insisted that "modern buildings call for modern-artistic photographs to do them justice".[2] It may well have been Blakeston who drew Bruguière's attention to Smith's photography, as the two collaborated on one of Britain's earliest abstract films, *Light Rhythms*, in 1929, and in the following year Blakeston fulsomely praised Bruguière's experimental light photography in his *Architectural Review* column.[3] With Smith, Blakeston shared a fascination for cats that led to their joint publication *Phototips on Cats and Dogs* (1938) and a taste for the eccentric and fantastical, especially follies. Blakeston's *Cruising with a Camera: Phototips for Sea and Shore* (1939), written with F.W. Frerk, also contained eleven of Smith's characteristically witty drawings.

Burford's career, by contrast, was more narrowly focused on architecture, which he both practised and taught, principally at the Bartlett School of Architecture at London University but also occasionally at the Architectural Association. In 1932, when Smith was forced to give up his course without qualifying, owing to his mother's straitened circumstances in the wake of her husband's abandonment of the family some years before, it was Burford who found Smith a position in the office of one of his former students and occasional partner in practice, Marshall Sisson. At that time Sisson's work lay primarily in the design of Modern Movement houses – among them a brick example in Madingley Road, Cambridge (1932), a group of three speculative houses at Carlyon Bay in Cornwall (1933–34), and a further Cambridge residence in Millington Road (1934) – the severe asceticism of which Smith found appalling. For Smith this was a formative experience, convincing him not only that modern architecture was on the wrong track and that consequently he should look elsewhere for career fulfilment, but also more generally that Modernism in the arts was to be abhorred. He later wrote decrying

> the removal of all but abstract formal content in painting and sculpture. The functionalism of architecture, where the value of all that does not structurally contribute – and is therefore intellectually justifiable – is denied … . In all one can see the Puritanism that the predominance of intellect in art produces, the fear of betraying warm humanity, the fear of obvious beauty.[4]

For Smith "warm humanity" and beauty, which he often found in the not altogether obvious, were to be touchstones of his photography.

Despite his misgivings, Smith subsequently worked in the office of another Modernist architect who had also studied at the AA, Raymond Myerscough-Walker, where he found the bohemian office life and part-time hours more congenial. He may also have been attracted by Myerscough-Walker's deserved reputation as one of the foremost exponents of the perspective drawing, an art Myerscough-Walker had enlivened by his use of dramatic chiaroscuro effects. Recollected by his employer "as a beautiful and extremely capable draughtsman",[5] Smith set up the drawings in ink on linen for Myerscough-Walker to colour in. One of the most striking examples is *London University – Nocturne* (1936), which was heavily influenced by the contemporary vogue for night

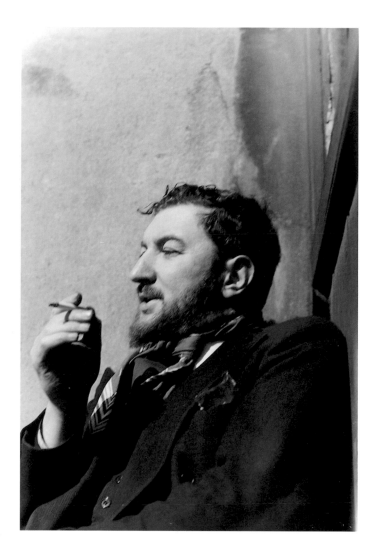

Fig. 3 Raymond Myerscough-Walker (1940)

photography. While in Myerscough-Walker's office Smith produced one of his finest portraits, which perfectly imparted the architect's raffish, larger-than-life personality (fig. 3), and photographed one of Myerscough-Walker's few executed buildings, a white Modernist house near Nottingham (1937; see p. 29). For this he used the distorted perspectival views being popularized at the time by such architectural photographers as Dell and Wainwright, official photographers to the *Architectural Review*.

By this time Smith had increasingly turned to photography as the principal means of support for himself and his wife, Rosemary Monica Louise Ansell, a confectioner's daughter, whom he had married in 1935. Shortly afterwards he was given a better camera[6] by his friend the artist Enid Marx, and his photographs fortuitously came to the attention of another artist, Paul Nash (1889–1946). Marx's former teacher at the Royal College of Art, Nash had himself taken up photography in 1930. A group of his images revelling in the abstract forms of ship architecture would have been known to Smith through their publication in the *Architectural Review*,[7] a magazine, generously catholic in its subject-matter, to which he was a lifelong subscriber and by which he was heavily influenced. Perhaps recognizing a similar feel for texture and light, Nash was impressed by Smith's photographs and arranged for him to use the darkroom of the publisher Lund Humphries outside normal office hours, thus freeing Smith from reliance on local chemists to process his film. This facility enabled Smith to learn the craft of his medium and to hone the developing and printing skills for which his photography became notable. Nash also introduced Smith to the editor of the British edition of *Vogue*, for which magazine Smith continued to photograph on and off until the Second World War, even though he found fashion photography unappealing.

As well as his work for *Vogue*, Smith was regularly commissioned by Marcus Brumwell's Stuart Advertising Agency, where he joined a stable of artists that included Edward Bawden, John Piper, Edward McKnight Kauffer and Edward Ardizzone. There he produced brochure designs and photographs for a clutch of the agency's clients, among them Imperial Airways (see p. 33). This work serves to emphasize that Smith's photography during this period, whether commissioned or done for his own satisfaction, was heterogeneous in nature, reflecting his desire to exploit the full range of the medium's possibilities. To this end he had at his disposal a number of cameras, including a quarter-plate, which he used less often, and several that employed a variety of smaller film formats. Chief among these was a Contax, utilizing 35 mm film negatives, which had originally been introduced by Zeiss Ikon in 1932 and subsequently refined in an effort to exploit the success of the first lightweight camera, the Leica, launched in 1924. The Leica had revolutionized photography, making it possible for the photographer to ape the darting glimpse of the human eye, and Smith's photography took full advantage of this new-found freedom and flexibility. He also experimented with some of the early colour films then appearing on the market, while his desire to learn through experience is demonstrated by the way in which he carefully annotated his prints with critical self-appraisals, such as "Much too dull – Repeat before noon" and "Good, but House No. 6

could be made a brighter study", and occasionally noted details of film and exposure times – a practice he was to adopt more systematically in the 1950s and 1960s. Thus, a winter view of Hampstead with the sun setting (1939) was recorded as having been taken with the Contax using a 5 cm Sonnar lens with a light yellow filter. The exposure time was half a second at f4; the film used, Agfa Isochrom; and the printing paper employed, Kodak Nikko, Grade 4.

Landscape, architecture, found objects, plant and flower studies, the ballet and theatre, nudes and portraits all came before Smith's lens in pictures that were early revelations of his feel for pattern and texture and his relish for the incongruous. One of the most remarkable photographs of this period was an interior of a Camden Town bedroom (1935), a study in light effects reminiscent of seventeenth-century Dutch painting (see p. 28). Smith's ballet photographs include coverage of Léonide Massine's *La Boutique Fantasque* (1935), starring Alexandra Danilova, and the Jubilee production of Massine's *Le Tricorne*, featuring Tamara Toumanova, with costumes and sets designed by Pablo Picasso. John Gielgud's Prospero in Shakespeare's *The Tempest* at the Old Vic in 1940 was one of several theatre performances he photographed. Among those who posed for their portraits was the novelist Rayner Heppenstall, himself a keen amateur photographer, who used a thinly disguised Smith as the model for his fictional photographer, Aloysius Smith, in two autobiographically based novels. In the first of these, *Saturnine* (1943), Heppenstall penned a vivid, if probably exaggerated, picture of Smith at work photographing a young woman, Pat Mallard:

> He lay on his back and photographed half vertically up mighty columns of leg. He leaped on top of the desk and photographed an upward-looking face with a perspective of body receding down to absurdly diminished feet. He was in every corner of the room at once, so that if he demanded Pat Mallard's face she did not know in which direction to look. He tossed her bits of drapery and photographed her as she caught them. He handed her a guitar or Japanese sword or such other properties as I had been able to find, or snatched them away and recorded the turn of a bewildered arm and shoulder. Even visually, woman is inexhaustible in her variety, but that evening every detail of a superb body was, if not made captive, yet momentarily, lyrically acknowledged. The discordant personality of this inhibited girl was caught and resolved.[8]

Smith's photographs of bathers on Brighton and South Shields beaches recall the candid photography of the 1890s of Paul Martin; a coiled deck rope, Nash's nautical imagery (see p. 30); a street scene in a blizzard, Alfred Stieglitz's famed *Winter on Fifth Avenue* (1912); and a row of chimneys punctuating the smoggy London sky (fig. 4), the rich velvety tones of C.R.W. Nevinson's mezzotint *From an Office Window* (1918). The one influence Smith acknowledged, however, was the great French photographer Eugène Atget (1857–1927), fittingly described as "a Balzac of the camera".[9] Atget's self-imposed mission from 1898 onwards was to record *Vieux Paris*, those largely seventeenth- and eighteenth-century survivals that had escaped Baron Haussmann's 'improvements' but that were then threatened anew by the construction of the Métro. Although ostensibly documentary in nature, Atget's revelatory images – delighting in the city's visual intricacies and incongruities, revelling in the discovery of such neglected architectural details as decorative ironwork and door knockers, and achieving an intense lyricism – were far

Fig. 4 Chimneys, London (1938)

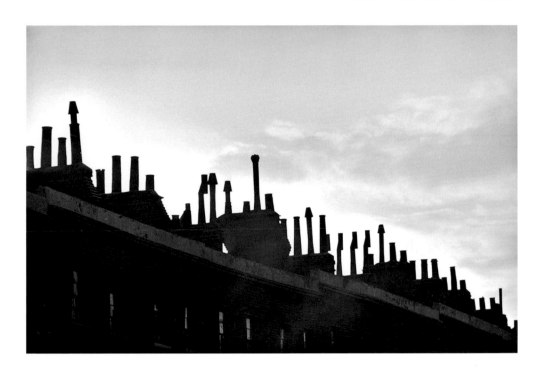

removed from the conventional offerings of the many firms that catered to the tourist market. It was only towards the end of his life and significantly at a formative period for Smith, however, that Atget's work became more widely known. This came about largely through its promotion by Man Ray and the Surrealists in the mid-1920s and Atget's subsequent championing by Man Ray's former assistant, Berenice Abbott, who arranged for a collection of his photographs to be posthumously published in 1930 under the title *Atget: Photographe de Paris*.[10]

For Smith, who soon counted a copy of the book among his most cherished possessions, the influence of Atget remained undimmed, helping to inform his choice of subject-matter and compositional strategy as well as stimulating his taste for the strangely discordant. During the 1930s this can be seen, for example, in the numerous studies he made of trees (see p. 34), which possess an earthy reality similar to that of Atget's arboreal musings, but especially in his photographs of shop window displays, many of them taken in London's Oxford Street in 1935 (see p. 35). In their adroit exploitation of reflection and repetition, their underscoring of the grotesque forms of mannequins, and in their ability to energize inanimate objects, these images, using techniques derived directly from Atget's photographs of Parisian shopfronts, realized that same unsettling, hallucinatory quality that so endeared Atget's ground-breaking work to the Surrealists. A fondness for the quirky and fantastical was to be one of Atget's enduring legacies to Smith, in this respect marking Smith's photography as a harbinger of the work of those shrewd observers of British eccentricity, Tony Ray-Jones in the 1960s and today Martin Parr. Above all, however, Smith was impressed by the forensic nature of Atget's photography, by its ability to uncover and render significant previously disregarded traces of everyday existence.

This quality, together with the need for systematic recording and cataloguing to satisfy the demands of such institutions as the Bibliothèque Nationale and the Musée Carnavalet that were his principal clients, rendered Atget's photography a form of collecting, a trait that evoked a ready response from Smith both photographically and philosophically. The 'unconsidered trifles' Smith collected – matchbox tops, printed

ephemera and lantern slides – were the domestic equivalents of the mass of hitherto overlooked street details that Atget lovingly captured. Atget's unassuming description of his photographs as "documents, nothing but documents"[11] was echoed by Smith's similarly humble declaration:

> The man who lives in his eyes is continually confronted with scenes and spectacles that compel his attention, or admiration, and demand an adequate reaction. To pass on without pause is impossible, and to continue after purely mental applause is unsatisfying, some real tribute must be paid. Photography, to many of its addicts, is a convenient and simple means of discharging these ever-recurring debts to the visual world.[12]

Atget's influence is again apparent on by far the largest single body of Smith's pre-war imagery, which recorded the varied manifestations of popular culture – the pub, music hall, night club and, above all, the circus and fairground – to which he was ineluctably attracted. Thus, Smith photographed the fairs at Mitcham, Epsom and Hampstead, near to his home, and, between 1935 and 1938, performances of Bertram Mills's, Hagenbeck's and Althoff's circuses at Olympia and the Royal Agricultural Hall. As these photographs strikingly demonstrate, Smith was drawn to this demi-monde by his unfettered enthusiasm for its illusion and artifice, its effervescent theatricality, its surreal conjunctions, the vitality of its performers and, in the case of the fairground, by the baroque exuberance of its artefacts. Advertisements for the rifle range dangle from two bizarrely outsized hands; the 'Chinese Lucky Girls' awe the crowds with their gymnastic contortions; a top-hatted man on stilts etched against the background of the big top appears king of all the circus paraphernalia he haughtily surveys (fig. 5); and the manically grinning faces of the carousel gallopers induce that frisson of disquietude essential to the fairground experience (see p. 37).

Taken with small-format cameras and far removed from the set-piece formality of Smith's mature work, these are thrillingly animated images that capture not only the excitement of performance but also the lives of the artists away from the public gaze. Clowns such as the Pleiss Brothers and Toni Gerboli, with whom Smith established a warm rapport, are seen making up for performance, reading their fan mail or apprehensively waiting their turn in the ring. These photographs are different in manner from Smith's later imagery and more focused on people. Yet, in their fond dwelling on the richly baroque trappings of the fairground booths, carousels and caravans that Smith saw as combining craftsmanship and an almost hysterical vigour, they adumbrate his later appreciative documentation of the flamboyant excesses of such architects as William Burges, Antoni Gaudí and Ferdinand Cheval. At the same time, at least in their subject-matter, these images also recall Atget's affectionate

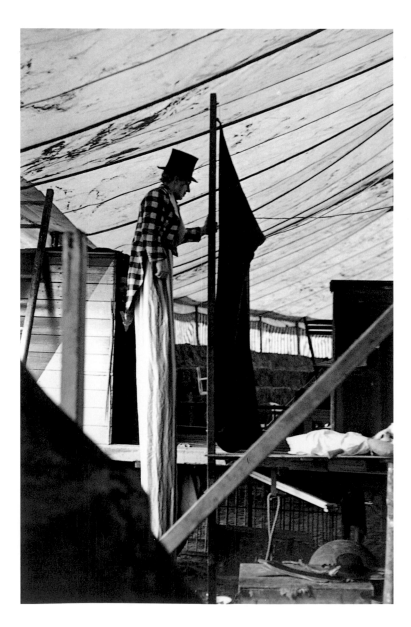

Fig. 5 Man on stilts, Sanger's Circus, Hayes, London (1937)

documentation – inspired in part by a youthful spell as a provincial actor – of popular entertainments, including the Théâtres de Guignol and Paris's street and travelling fairs, especially the Fête de Vaugirard. Smith's pictures, however, are markedly different in mood to those of Atget, who usually worked early in the morning with a bulky 18 × 24 cm glass-plate camera and was therefore unable to capture the bustle of crowds or the fleetingly observed, fragmentary views of decorative details that Smith was able to do with his smaller, more spontaneous Contax. Consequently, Atget's fair photographs, most often deserted, exude the melancholic air of a disappearing world entirely absent from Smith's more celebratory imagery. Far from being a threnody for a doomed culture, Smith's photographs were a panegyric to a dynamic tradition.

In addition to being indebted to Atget, Smith's preoccupation with popular culture reflected a wider revival of interest in the subject, a development to which Smith and his collaborator, and later wife, Olive Cook were to prove major contributors in the coming years. Smith's connection to this more general trend is symbolized by a photograph of 1937 showing the famous clown Coco locked in earnest conversation with Laura Knight, president of the Circus Fans' Association and a painter noted for her vibrantly colourful depictions of circus life, such as *Charivari* (1929), which were instrumental in drawing attention to what she feared to be a threatened folk art form. More significantly, one of the prime movers in highlighting the importance of popular art and lending it academic respectability was none other than Smith's close friend Enid Marx. Her illustrated scrapbook *When Victoria Began to Reign* (1937), produced in collaboration with the historian Margaret Lambert and foreshadowing the post-war Victorian revival, was paralleled by Smith's photographic documentation of that year's popular festivities marking the coronation of King George VI. Marx, who, like Smith, was an enthralled habitué of Benjamin Pollock's Toy Theatre shop in Hoxton Street, London, a favourite haunt of popular art's acolytes, continued to extol the merits of "the art which ordinary people have, from time immemorial, introduced into their everyday lives"[13] in two further books written with Lambert, *English Popular and Traditional Art* (1946) and *English Popular Art* (1951). In the former, using arguments later amplified by Smith and Cook, she maintained that "we have a long and living tradition of popular art, which not only survived the industrial revolution, but in some cases, such as fair-ground decoration … even drew new inspiration from the potentialities of the machine"[14] and asserted that its distinctive qualities were "forthrightness, gaiety, delight in bright colours and sense of well-balanced design".[15]

These sentiments were echoed by another passionate proponent of popular art, the prolific writer and illustrator Barbara Jones. Her series of articles in the *Architectural Review* from 1945 onwards were republished in expanded book form in 1951 as *The Unsophisticated Arts* to accompany Jones's pioneering exhibition on the subject, *Black Eyes and Lemonade*. Held at London's Whitechapel Art Gallery, this was one of a host of events that took place under the umbrella of the Festival of Britain, which itself enshrined many of the values and aspirations of popular art's devotees. Jones's book, including several photographs by Smith, dealt with an impressively wide-ranging array of artefacts and activities, including roundabouts, canal boats, piers, bandstands, kiosks, seaside bungalows, garden furniture, confectionery, old advertisements, shop signs, greetings cards, funerals and fireworks. Many of these things, Jones contended, evinced "a nice rich debased baroque",[16] which was regrettably being superseded by "jazz and streamline"[17] as the newly dominant architecture of pleasure.

These were precisely the kinds of subjects that held a perennial fascination for Smith and Cook and that they were contemporaneously exploring in their contributions to *The Saturday Book*, in which they declared popular art to be enjoying a revival: "once despised as crude and uncultivated, its vivid and eloquent spontaneity now appeals".[18] In *The Saturday Book 6* (1946) Smith wrote approvingly of matchbox-top design:

> Discouraged by the machine's prim perfections and by the self-conscious standards of the professional, popular art is as rare today as the unsophistication that once abundantly created it. Yet in some common things it inexplicably lingers. The match-box top is one of those unacknowledged rarities: simple in heart and design, lovably crude in colour, irrational in emblem and anonymous ... it is authentic popular art.[19]

Figureheads, "the robust work of ship's carpenters", were similarly proclaimed "true folk art"[20] in *The Saturday Book 10* (1950). In *The Saturday Book 13* (1953) Smith and Cook tackled traditional Christmas fancies, such as cribs and crackers, while as late as 1971 Cook was still enthusing about fairground baroque and illustrating her piece with Smith's photographs of the 1930s, many of which were being published for the first time. Prompted by their observation that the seaside resort was its spiritual home, 'Beside the Seaside', published in *The Saturday Book 12* (1952), was perhaps the couple's most engaging study of popular art. In a passage reminiscent of their artist friend John Piper's encomium on 'The Nautical Style', which had first appeared in the *Architectural Review* in 1938 and subsequently been reprinted in his *Buildings and Prospects* (1948), Smith and Cook declared "almost all the perquisites of the promenade, bandstands and bathing machines, pink rock, pebble sweets and postcards, piers and paddleboats, lighthouses and lobster pots have that air of salty simplicity, that mixture of artlessness and artfulness, which we call the 'folk'".[21]

It would be wrong to regard this reawakened interest in popular art simply as a product of whimsical nostalgia. While an acute sense of impending loss undoubtedly acted as a spur, many of the movement's adherents regarded popular art as a living tradition that held important lessons for contemporary design, not least as a humane antidote to the austere formalism of Modernism, which even some of Modernism's most zealous advocates had come to acknowledge was urgently required. Thus, the *Architectural Review*, which had been in the vanguard of promoting Modernism in the 1930s, was in the post-war period searching for mellowing panaceas, with popular art taking its place in a prescription list that included Swedish architecture's inventive use of traditional materials, more sensitive landscaping, interior planting and a reassertion of picturesque principles. As the Festival of Britain, with its townscape of changing textures and scale, irregularities and contrasts, vividly demonstrated, visual delight and gaiety were now firmly back on the agenda. The popular-art movement had played an important role in bringing this about, but at the same time it represented something more profound: the search for cultural roots that gathered momentum in the post-war period. The fundamental 'back to basics' nature of this quest is underlined by the language employed at the time, with much talk of 'simplicity', 'artlessness', 'timeless tradition' and 'forthrightness'. It was with this quest that Smith was to become intimately involved during the 1950s.

For different reasons, two further groups of pre-war photographs merit closer scrutiny. The first of these records the mining, fishing and shipbuilding communities

of north-east England and was assembled in 1936 at the behest of the maverick National Conservative Member of Parliament for the leafy Hertfordshire constituency of Hitchin, Sir Arnold Talbot Wilson. A former colonial administrator in Mesopotamia and regional director of the Anglo-Persian Oil Company, Wilson unusually combined a libertarian zeal for social reform at home with enthusiastic support for Fascist regimes abroad. Shortly after becoming an MP in 1933, he embarked on a series of fact-finding visits to the North-East in support of his campaign to alleviate unemployment and introduce improved schemes of training and industrial assurance. How Smith came to be commissioned by Wilson and what his brief was remain unclear.[22] Certainly his photographs, almost all taken in and around Newcastle, South Shields, Gateshead and the colliery at Ashington, possess little of the reformist ardour that Wilson might have expected or that characterized *Picture Post*'s images later in the decade. Still less do they echo the lacerating condemnations of the working man's lot to be found in J.B. Priestley's *English Journey* (1934), in which Gateshead was dismissed as appearing "to have been carefully planned by an enemy of the human race",[23] or in George Orwell's *The Road to Wigan Pier* (1937). Nor did Smith photograph the pitmen at work as Humphrey Spender, the *Daily Mirror*'s 'Lensman', had done two years before.

On the contrary, Smith's images stand not in a tradition of campaigning social photography concerned to expose the ills of "how the other half lives"[24], but in a long photographic lineage, stretching back to nineteenth-century construction-gang photographs and forward to Joel Meyerowitz's paean to the rescue workers at New York's Ground Zero, that lauds the fortitude and nobility of labour. A mixture of the formal, rather in the style of the *Daily Herald*'s photographer James Jarché, and the informal, Smith's documentation shows us well-accoutred miners posing proudly for the camera (see p. 38). Their homes, too, appear clean and well appointed, with the range refulgent and the aspidistra flying (see p. 41). Graphically silhouetted against the dawn sky as they ascend to the cage to begin their shift, Ashington's pitmen are portrayed as heroically as the workers in a Soviet propaganda film (see p. 39). Only occasionally does a starker reality intrude: filthy children play in a cramped, fetid backyard, while more acerbically four men while away the hours seated beneath a graffito sardonically proclaiming "Jesus Died for You" (see p. 39). These are exceptions, however, and perhaps Smith's photographs were intended to provide vindication for Wilson's view on a visit in 1936 that conditions were better than they had been two years previously.

The origins of the second body of photographs, which documents a group tour of Germany, Belgium and Czechoslovakia, are also unclear (fig. 6). The majority of the photographs were taken on the German leg of the visit and picture the group being officially welcomed by high-ranking officials, and wined and dined and treated to a demonstration of his archery skills by General Hermann Goering. They show the usual achievements that the Nazi regime liked to put on parade to impress foreign visitors, among them the Zeiss and AG Farben factories, UFA's film studios, autobahns under construction and displays of physical prowess by the Hitler Youth. Further photographs intriguingly chronicle the arrival and tour of a high-level Japanese delegation. Although the date of these pictures cannot be confirmed, the venues correspond to those visited by Wilson on his frequent trips to Germany in the 1930s, and it seems likely that Smith accompanied him on one of these.[25] Wilson was a fervent supporter of Hitler and Nazi ideology; he particularly admired Nazism's single-minded sense of purpose, youthful energy and commitment to racial purity along the lines controversially proposed by

Fig. 6 Einstein Tower, Potsdam,
Germany (1930s)

Houston Chamberlain, whose writings, including the observation that "it is as necessary
and possible to breed good people as good cattle",[26] had made a profound impression on
him. There is circumstantial evidence, supported by the testimony of contemporaries,
that Smith may also have espoused pronounced right-wing views. His close friend Burford
moved in right-wing circles and encouraged Sisson to join the British Union of Fascists,
while Smith spoke disparagingly of democracy and eluded conscription, unlike Wilson,
who, although above the official age limit, joined the Royal Air Force and was killed in
action in 1940. Whatever the truth of the matter, Smith, like Wilson, was not anti-
Semitic, counting many Jews among his friends and offering to stand surety for Andor
Kraszna-Krausz, the founder of Focal Press, when he was threatened with internment.

Smith's acquaintance with Kraszna-Krausz stemmed from the latter's commission-
ing him to produce five books for the Focal Press between 1938 and 1940, itself a testimony
to Smith's growing stature as a photographer and his mastery of the complexities of the
medium. The first of these, the joint work with Blakeston on cats and dogs, was followed
in quick succession by three slim paperbacks in the publisher's Photo Guide series: *Better
Snapshots with Any Camera* (1939), *All about Winter Photography and Your Camera*
(1940) and *All about Light and Shade and Your Camera* (1940). The final volume com-
pleting the quintet was the most substantial: *All the Photo-Tricks*, which also appeared in
1940 (fig. 7). Practical instruction manuals aimed primarily at the amateur, these books
were well written, informative and wittily entertaining. Not surprisingly, therefore, they
proved highly popular, all of them running to several editions. While at first it may seem
strange, given Smith's later reputation as a 'straight' photographer who had little recourse
to manipulation beyond the accepted standard procedures, it is *All the Photo-Tricks* that
sheds most light on his working methods and attitude to photography at this time.

Dedicated to Blakeston "for all the best tricks" and illustrated with examples by
a number of photographers, including Angus McBean, Bruguière and Hugo van
Wadenoyen in addition to Smith himself, the book explains both common practices,
such as the employment of filters and dodging and shading, and more outré tricks

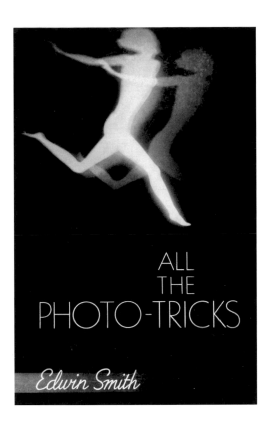

Fig. 7 Cover of *All the Photo-Tricks* (1940)

involving the use, for example, of a lazy shutter, mirrors and screens. With further sections on ghosts and doubles, photomontage, photograms ("It has long been the author's pet obsession that the biggest obstacle to a good photograph is the camera"[27]) and even printing on unusual surfaces, such as eggs, the book fully justifies its subtitle "ways and ideas off the beaten track". Immediately warming to his subject, Smith begins with a chapter on the ease with which the camera can deceive those too inclined to trust in its veracity. He contends that such deception goes beyond the mere amusement that "must appeal to the anarchist in us all":

> for the imaginative photographer, and others who resent the camera's too slavish dependence on commonplace reality, who envy the painter his freedom of creation and covet his powers to mould the world closer to his heart's desire, the formulas that follow will more than amuse. Their imaginative use will remove the camera one step further from the tyranny of everyday appearance, and one nearer the world of ideas, granting power to suppress prosaic fact in favour of creative imagination.[28]

This passage is highly revealing of the tension between Smith the youthful photographer, eager to venture beyond the camera's usually prescribed boundaries and excited by its experimental possibilities, and Smith the aspirant artist, who spent much of his time painting and sketching but was increasingly frustrated by his failure to gain recognition for these artistic endeavours.

While Smith later largely forsook the more outlandish 'tricks' of his youth, there remained something of the 'anarchist' in his photographs, expressed both in his unveiling of life's everyday curiosities and in his darkroom creativity, which meant that on occasion he was prepared to embellish rather than simply "co-operate with the inevitable". A dramatic instance of this is one of Smith's best-known photographs, namely the view of the early-warning station on Fylingdales Moor in North Yorkshire (1969; see p. 163), its now demolished golf-ball shapes perfectly complemented by a wan sun. The sun, however, is a fabrication, the knowing professional's trick of printing a coin with the negative, and a stratagem for both sun and moon to which Smith resorted on a number of occasions. Similarly, he sometimes utilized the technique of combination printing, which had been popular in the Victorian period, most notoriously in the highly contrived compositions of Henry Peach Robinson, by which two or more negatives were printed together to form a single image. Although such examples are uncommon, and Cook's assertion that for Smith "the successful 'straight photograph' was … a triumph"[29] is generally accurate, they serve to emphasize that Smith saw what happened in the darkroom as of equal importance to what happened in the field. Indeed, one of the reasons he later rebelled against colour photography was precisely because its laboratory processing diminished the photographer's creative control. It is also true that his negatives often required a considerable amount of work to achieve what he regarded as a satisfactory print. In *All the Photo-Tricks* Smith even went so far as to opine, "however expert its creator, the negative that yields its best print without manipulation, and whose tones are not improved by judicious dodging, shading or spot-printing, is as rare as a camera in a fortified area".[30] In this sense, therefore, although he entirely rejected the Pictorialist ethos that photographs should be hand-worked to resemble paintings or other artistic media, the darkroom could be seen as his photographic equivalent of the fully stocked artist's studio that he maintained throughout most of his life.

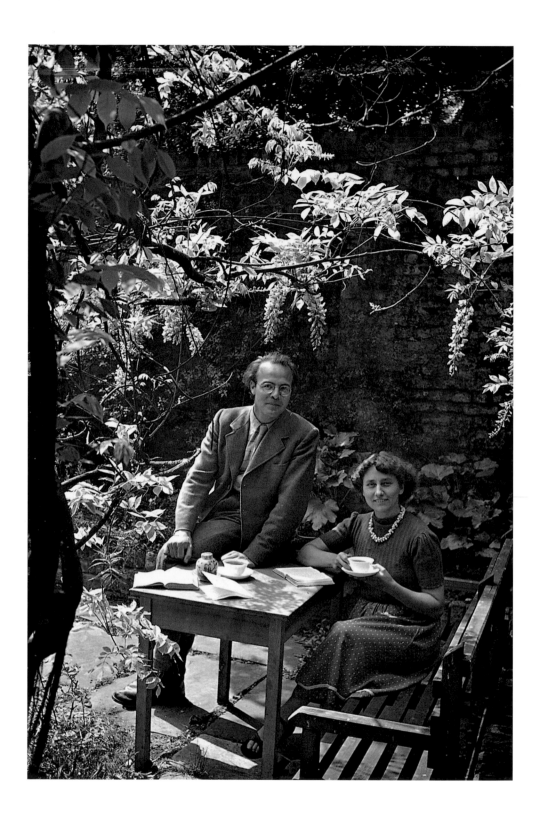

Fig. 8 Edwin Smith and Olive Cook (1949)

The publication of *All the Photo-Tricks* coincided with a particularly troubled period in Smith's life about which it is difficult to obtain hard facts. There is little reason to doubt, however, that Heppenstall's characterization of Aloysius Smith in the second of his autobiographical novels, *The Lesser Infortune* (1953), as "brazenly avoiding con-scription"[31] could be applied to the real Smith, who seems to have led a nomadic exis-tence, evading the recruiting authorities. As later revealed by Cook, Smith's anti-war

stance was based not on conscientious objection but on the philosophically dubious reasoning that, if the state prevented him from killing someone he knew who was threatening his personal identity, it had no moral authority to require him to destroy an enemy "who was abstract only. … not a personal menace, but merely another servant obeying the commands of another distorted power".[32] One of Smith's main refuges at this time was the nearby Hampstead home of the Czech émigré artist Oskar Kokoschka (1886–1980), several of whose works had been condemned by the Nazis as degenerate art and who had finally fled Prague for London in 1938. It was Kokoschka who wrote the foreword to the modest catalogue of Smith's first one-man show of his artworks, somewhat prosaically entitled *Cats and Women*, held at William Ohly's Berkeley Galleries in Davies Street, London, in 1944. That only one of the eighty exhibited oils, watercolours, drawings and prints was sold dealt a severe blow to Smith's hope of establishing himself as an artist. By this time, too, his marriage had foundered. In 1940 he and his wife had moved to the top-floor flat at 38 Rosslyn Hill, Hampstead, and in the following year a son, Martin, was born; but in 1943 Smith abandoned them, leaving with a neighbour from one of the flats below. That neighbour was Olive Cook, and thus was born a remarkable partnership that endured for the rest of Smith's life (fig. 8). In 1954 the couple were married, Smith's first marriage having been dissolved in 1946.

Born in 1912, the same year as Smith, Cook hailed from Cambridge, where her father was a long-serving librarian at the University Library and her mother a dressmaker at the local department store of Robert Sayle. In 1931 Cook won a scholarship to Newnham College, Cambridge, where she read modern languages. Then, after a short spell as a typographer with the publishing firm of Chatto & Windus, she joined the publications department of the National Gallery in London in 1937. There she worked closely with its director, Sir Kenneth Clark, and helped to supervise the evacuation of the gallery's paintings to the relative safety of the abandoned slate mines at Blaenau Ffestiniog. A woman of formidable intellect, boundless energy and a deep knowledge of painting, Cook was herself a painter of some standing, being invited to participate in the Recording Britain scheme established by Clark and the Pilgrim Trust in 1941 to commission artists to record buildings and landscapes threatened with destruction. Through these activities she became friends with a wide range of artists, among them Stanley Spencer, Thomas Hennell, Michael Rothenstein and John Aldridge.

In 1945 Cook gave up her job at the National Gallery to pursue, in tandem with Smith, a freelance career in painting and writing. The couple were well matched. Both were self-confessed political and cultural elitists who had no time for the levelling tendencies of Welfare State Britain and were quick to condemn any perceived falling off from the very highest standards. Both shared a wide range of aesthetic interests and were fine writers of prose, with Smith's flair for naturalistic description being counterpointed by Cook's more imaginative flights, as seen in a number of short stories for children she published. Both relished what their artist friend Z. Ruszkowski called "objects, often purposeless, where human caprice and phantasy found expression".[33] Their active social life, full of humour and playfulness, was similarly pervaded by an air of thespian excess, with Cook's extravagant greeting of "Darling" matched by Smith's frequent declarations of "adorable". Warm and loyal friends, capable of great acts of generosity, even though their finances were often stretched, neither suffered fools gladly; Smith, in particular, was prone to intemperate outbursts. In Cook, Smith found the ideal companion who not only introduced him to a wider cultural circle but also remained fiercely supportive, both

spiritually and practically, of all that he did. Freed from much of the drudgery of every-day life, Smith was able to pursue his photography as well as his art and leisure interests, such as listening to Schubert – the concert pianist Clifford Curzon was a close friend – and reading the works of Stendhal and Sir Thomas Browne.

One of the first fruits of the couple's collaboration was their work for that idiosyncratic 'cabinet of curiosities', *The Saturday Book*. Its name deliberately redolent of "leisure and week-ends",[34] *The Saturday Book* was the brainchild of the literary editor Leonard Russell, who conceived of it as a latter-day equivalent to the *Strand Magazine*. Published by Hutchinson and appearing annually in time for Christmas, it ran for thirty-four issues between 1941 and 1975, consistent only in the rich eclecticism of its contents, its visual sensuousness and its insistence on enjoyment and utter unconcern "with work, problems, issues, movements, and trends".[35] Its boast, recurrent to the point of disingenuousness, was that it had "no more literary, aesthetic or social pretensions than a casual gathering of congenial friends in a room which happens to contain an assortment of pleasant bric-à-brac, *objets d'art* and comfortable curiosities".[36] One example must suffice to give some indication of the imaginatively wide-ranging nature of *The Saturday Book*'s concerns, of the stellar nature of its cast of contributors, and the aptness of a critic's remark that "one always knows what to expect of *The Saturday Book* but one never knows what one will find in it."[37] Thus, readers of *The Saturday Book* 9 (1949) were regaled *inter alia* by Julian Huxley on Petra; C.P. Snow on Niels Bohr; John Arlott on cricket gadgets; Raymond Mortimer on the death of charm in London; Harold Hobson on his job as a drama critic; Walter and Leonora Ison on the High Street; and Cook and Smith on shop window displays. There were articles on drabness, Apulia, bird artists, Florence Nightingale's pet owl and Mountbatten of Burma; verse by Ogden Nash and Virginia Graham; and colour reproductions of paintings owned by such luminaries as Dame Edith Evans, Sir Kenneth Clark, Rebecca West, the Archbishop of Canterbury and J. Arthur Rank.

This intoxicatingly abundant "mish-mash", as *The Saturday Book* was proud to term it, was both a popular and a critical success. After its initial issues, *The Saturday Book* regularly sold out and was fêted by John Betjeman as "the best magazine in the world".[38] It was more soberly appraised by Sir Francis Meynell and Desmond Flower in their catalogue of 1951 to the *Modern Books and Writers Exhibition* held at the National Book League:

> If one book [*The Saturday Book 10* (1950)], and one book only, had to represent the full versatility and fanciful possibilities of printing today, this would be it. It is not made in the traditional manner of a book or even of a keepsake or album. It is a 'mixty-maxty', to use a pleasant old term for a medley, not merely in its contents, as are other albums, but also in its typography and illustration. Every section is designed anew to fit its theme: but so closely interwoven are theme and presentation that it is hard to determine which partner predominates. The editor and the designer must to some extent have shared functions, even perhaps on occasion exchanged them. The result is a brilliant *tour de force* … the whole is a magazine light-hearted, intelligent, civilized and 'amusing', like a clever intimate review.[39]

The personnel instrumental in shaping *The Saturday Book* were Russell, who edited the first eleven issues; his successor from 1952 onwards, John Hadfield, who had been the

first director of the National Book League and organizer of the Festival of Britain's book exhibition at the Victoria and Albert Museum; its brilliantly inventive designer, Laurence Scarfe; its long-standing contributor, the Cockney diarist Fred Bason; and Smith and Cook, who were more than anyone else, as Russell acknowledged, "responsible for the odd, individual and imaginative visual quality of the book".[40] The distinction of its writing notwithstanding, the popular appeal of *The Saturday Book* was due in large measure to its provision of high-quality illustrations and its appreciation that "they need not all be subservient to the text, mere illustrations to it: some could be articles, as it were, in their own right, telling a story visually",[41] a precept that Smith and Cook brilliantly exploited. The crucial role of illustrations in *The Saturday Book*'s success is underlined by the lukewarm reception given to the text-heavy inaugural issue, which was illustrated almost entirely by wood engravings and unappealingly exuded "a certain air of *belles lettres*".[42] As Hadfield later conceded, it was only with the adoption of the scrapbook type of layout in issue three (1943) and more importantly with the greatly expanded pictorial section in issue four (1944), which included fourteen colour pages – "a resplendent gesture of lavish extravagance in a year dominated by scarcity, drabness and austerity"[43] – that the magazine established the formula that saw sales soar. This consisted pre-eminently of a visually seductive amalgam of colour reproductions, photographs supplied by such leading practitioners as Brassaï, Bill Brandt and Clarence John Laughlin as well as taken from Russell's own collection of the Victorian photographer Paul Martin, and engravings contributed by artists including Robert Gibbings and George Mackley. Introduced to Russell by Scarfe, it was Smith, however, who was by far the largest single provider of illustrative material. His photographs adorned every issue after his debut contribution, 'The Domestic Shell', to the revamped issue four had proved a key factor in broadening the magazine's appeal.[44]

Although Hadfield believed this debut piece revealed Smith "as a most accomplished and original photographer of buildings",[45] 'The Domestic Shell' today appears unexceptional. The photographs, by the standards of the architectural photography of the period, are modest and the page layout staidly conventional. More striking is the integration of illustrations and text, and the mutually reinforcing way in which they are deployed to advance Smith's argument about the appropriateness of simplicity in domestic façades. By *The Saturday Book 9*, Smith and Cook had developed this stratagem further, and the pictures were laid out in a freer manner that rendered 'The One in the Window', which reproduced several of Smith's shopfront images of the previous decade, one of their early classic pieces. Granted free rein by the editors "to indulge their personal pleasure in buildings, artifacts and 'curiosities'",[46] the couple produced many more such classics, with Cook usually supplying the commentaries to Smith's photographs but also writing her own pieces. Besides their examination of popular art, the subjects the pair tackled were typically disparate, ranging from 'The Art of Adornment' to 'Moving Pictures before the Cinematograph', from bicycling to embroidery, as well as the pictorial retelling of such traditional tales as Bluebeard in "a neo-Elizabethan narrative strip".[47] Architecture, however, remained a recurrent theme, although Smith and Cook characteristically tended to focus on the offbeat and unconventional, with articles on 'Exits and Entrances'; Ferdinand Cheval's bizarre, self-built home, the Palais Idéal at Hauterives, so admired by the Surrealists; and an engrossing study of ceilings and floors entitled 'Ups and Downs' in *The Saturday Book 14* (1954), which seemed conceived to complement the *Architectural Review*'s contemporaneous obsession with 'floorscape'.

Normally laid out by Smith and Cook themselves, these articles were not exclusively photographic essays. In keeping with the general look of *The Saturday Book*, Smith and Cook mixed their illustrations, blending photographs of actual places and buildings with photographs of *objets d'art* and reproductions of paintings, prints and engravings, a generous number in colour. This stimulating visual cocktail emphasizes not only what a discerning eye they had but also their ability to research and gather together pictures from widely varying sources and, by making telling connections between them, meld these illustrations into a coherent whole. Their pictorial essays could thus be considered a form of collage, an inventive assemblage of 'found objects' that included material from their own collections as well as the photographs themselves, which had often been taken several years before for entirely different purposes.

At its peak in the 1940s and 1950s, *The Saturday Book* caught the nation's mood, offering a yearned-for, 'off-rations', rejuvenating tonic, artfully mixed to alleviate the constricting symptoms of post-war austerity. Despite its frequent protestations to the contrary, the magazine was not, however, solely dedicated to escapism. Like the post-war Ealing comedies, it laced fun with serious comment. Thus, it championed such unfashionable artists as John Tunnard, anticipated the rediscovery of Aubrey Beardsley and the poetry of Edmund Blunden, and even delved into Eastern mysticism before the Beatles sought enlightenment from the Maharishi Mahesh Yogi. In addition, it consistently espoused popular art and, above all, played a key role in fostering appreciation of Victorian culture, which held a special fascination for Russell but which was otherwise then held in near universal contempt. For Smith, who along with Cook was deemed by Hadfield to be not simply a contributor to but also a collaborator on *The Saturday Book*, and to have launched "many a collecting fashion",[48] the magazine provided the first real outlet for his creative instincts. It gave him access to a much larger audience and with it an enhanced reputation; a stream of useful new contacts and friends; and a familiarity with the rubric of page layout that was to stand him in good stead in his dealings with publishers in the years to come.

In 1951 Cook wrote excitedly to Smith of her visit to the Festival of Britain, describing how enchanted she had been by the Land of Britain section and the Lion and Unicorn Pavilion: "The exhibits themselves are nothing, but all the rest is humour and fantasy of a kind I have always thought peculiar to you. It is rather as if your scrap books and your workroom had suddenly expanded to the size of a village."[49] When Smith himself visited the Festival shortly afterwards, he pointedly ignored the Modernist environment its organizers had created on the South Bank, choosing instead to photograph the funfair attractions at the Festival's pleasure gardens in Battersea, conceived by a team headed by the exhibition designer James Gardner and including Piper and Osbert Lancaster. For Smith the fantastical aspect of the British character symbolized by the Festival's unicorn remained a constant of his photography. Styled "the autobiography of a nation",[50] the Festival examined notions of Britishness while reflecting the ever more fervent debate about whether the urge to build a better tomorrow could or should be reconciled with the desire to preserve those traditions, places and buildings that were increasingly held to be embodiments of national consciousness. It was to this debate that Smith was to contribute so articulately in the ensuing years, and in so doing he forged his own distinctive mode of photographic expression.

1 *Modern Photography: The Studio Annual of Camera Art*, 1935–36, p. 19. Further examples of Smith's photography appeared in the volumes for 1940–41 and 1941–42.

2 *Architectural Review*, vol. 71, April 1932, p. 154.

3 'Light: The Photography of Francis Bruguière', *Architectural Review*, vol. 67, January 1930, p. 39.

4 Letter from Edwin Smith to Marcus Brumwell, 19 March 1943 (Olive Cook Papers, Newnham College Archives, Cambridge, Box 37 7/3/oddments).

5 Letter from Raymond Myerscough-Walker to Olive Cook, Chilgrove, 18 December 1976 (Olive Cook Papers, Newnham College Archives, Cambridge, Box 14 2/1/6).

6 Cook gives differing accounts of the camera Marx gave to Smith, citing it as a Contax II, which did not appear on the market until 1936, and elsewhere as a broken quarter-plate that he repaired. The latter is more likely, and both it and a Contax were the cameras Smith used most regularly until the 1950s.

7 Raymond Mortimer, 'Nature Imitates Art', *Architectural Review*, vol. 77, January 1935, pp. 27–29, plates ii–iii.

8 Rayner Heppenstall, *Saturnine*, London (Secker & Warburg) 1943, p. 98. Heppenstall also featured Smith in the novel *The Lesser Infortune* (1953). A third book, *The Greater Infortune* (1960), was a revision of much of the material to be found in the earlier novels and adds nothing new about Smith.

9 Berenice Abbott, quoted in *Atget's Paris*, ed. Hans Christian Adam, Cologne (Taschen) 2001, p. 6.

10 How Smith first encountered Atget's photography is unclear. Certainly there is no evidence to support Cook's assertion that he saw Atget's work reproduced in the late 1920s in the *Architectural Review*. Elsewhere Cook contends that he saw examples in the library of the Northern Polytechnic and at an exhibition. Smith's copy of Abbott's book is now in the National Art Library at the Victoria and Albert Museum, London.

11 Quoted in *Atget's Paris*, p. 28.

12 Edwin Smith, *All the Photo-Tricks*, London and New York (Focal Press) 1940, p. 271.

13 Enid Marx and Margaret Lambert, *English Popular and Traditional Art*, London (Collins) 1946, p. 7.

14 *Ibid.*, p. 7.

15 *Ibid.*, p. 8.

16 Barbara Jones, *The Unsophisticated Arts*, London (Architectural Press) 1951, p. 10.

17 *Ibid.*

18 Olive Cook and Edwin Smith, 'The Art of Acquisition', *The Saturday Book 8*, London (Hutchinson) 1948, p. 27.

19 Edwin Smith, 'Rare and Common', *The Saturday Book 6*, London (Hutchinson) 1946, p. 111.

20 Olive Cook and Edwin Smith, 'Ship Shape', *The Saturday Book 10*, London (Hutchinson) 1950, p. 60.

21 Olive Cook and Edwin Smith, 'Beside the Seaside', *The Saturday Book 12*, London (Hutchinson) 1952, p. 38.

22 Cook gives contradictory accounts of the commission, saying on the one hand that it resulted from Smith's attendance at a lecture given by Wilson on the plight of the North-East's coalminers and on the other that it was due to Wilson's admiration for Smith's photographs of street scenes in Camden Town. An annotation in one of Smith's negative books also indicates that Smith's photographs of slums in London's East End were taken at Wilson's behest. Wilson's observations on the mining community can be found particularly in his *Thoughts and Talks 1935–7: The Diary of a Member of Parliament*, London (Longmans, Green & Co.) 1938.

23 J.B. Priestley, *English Journey*, Harmondsworth (Penguin Books) 1934, p. 284.

24 Cf. Jacob Riis, *How the Other Half Lives: Studies Among the Tenements of New York*, New York (Charles Scribner's Sons) 1890.

25 Wilson's accounts of his trips to Germany can be found principally in *Walks and Talks Abroad: The Diary of a Member of Parliament in 1934–6*, London (Oxford University Press, Humphrey Milford) 1936; *Thoughts and Talks 1935–7* (1938); and *More Thoughts and Talks: The Diary and Scrap-Book of a Member of Parliament from September 1937 to August 1939*, London (Longmans, Green & Co.) 1939.

26 Sir Arnold Wilson, 'Germany in May', *English Review*, June 1934, p. 698.

27 Smith, *All the Photo-Tricks* 1940, p. 257.

28 *Ibid.*, p. 8.

29 Olive Cook, 'Introduction', in *As We Were: Photographs by Edwin Smith*, exhib. cat., Saffron Walden, Fry Art Gallery, 1997, p. [1].

30 Smith, *All the Photo-Tricks* 1940, p. 159.

31 Rayner Heppenstall, *The Lesser Infortune*, London (Jonathan Cape) 1953, p. 196.

32 Olive Cook, unpublished typescript entitled 'Co-operating with the Inevitable' (Olive Cook Papers, Newnham College Archives, Cambridge, Box 20 3/1/9).

33 'Recollections by His Friends: Z. Ruszkowski', in *Aspects of the Art of Edwin Smith*, exhib. cat., Colchester, The Minories, 1974, p. [11].

34 *The Saturday Book 8*, p. 5.

35 *The Saturday Book 19*, London (Hutchinson) 1959, p. 6.

36 *The Saturday Book 17*, London (Hutchinson) 1957, p. 5.

37 *The Saturday Book 25*, London (Hutchinson) 1965, dust jacket.

38 Quoted in *The Saturday Book 21*, London (Hutchinson) 1961, p. 6.

39 Quoted in *The Saturday Book 11*, London (Hutchinson) 1951, pp. 7–8.

40 *The Saturday Book 32*, London (Hutchinson) 1972, p. 6.

41 *The Saturday Book 10*, p.11.

42 *The Saturday Book 31*, London (Hutchinson) 1971, p. 5.

43 *The Saturday Book 31*, p. 5.

44 Cook ensured Smith's photographs continued to appear posthumously in each issue of *The Saturday Book*.

45 *The Saturday Book 32*, p. 6.

46 John Hadfield, obituary of Edwin Smith, *The Times*, 4 January 1972, p. 12.

47 Olive Cook and Edwin Smith, 'Bluebeard in Bits and Pieces', *The Saturday Book 16*, London (Hutchinson) 1956, p. 6.

48 Hadfield 1972, p. 12.

49 Letter from Olive Cook to Edwin Smith, Melbourn, 16 July [1951] (Edwin Smith Collection, RIBA British Architectural Library Photographs Collection).

50 See, for example, Becky E. Conekin, '*The Autobiography of a Nation': The 1951 Festival of Britain*, Manchester (Manchester University Press) 2003.

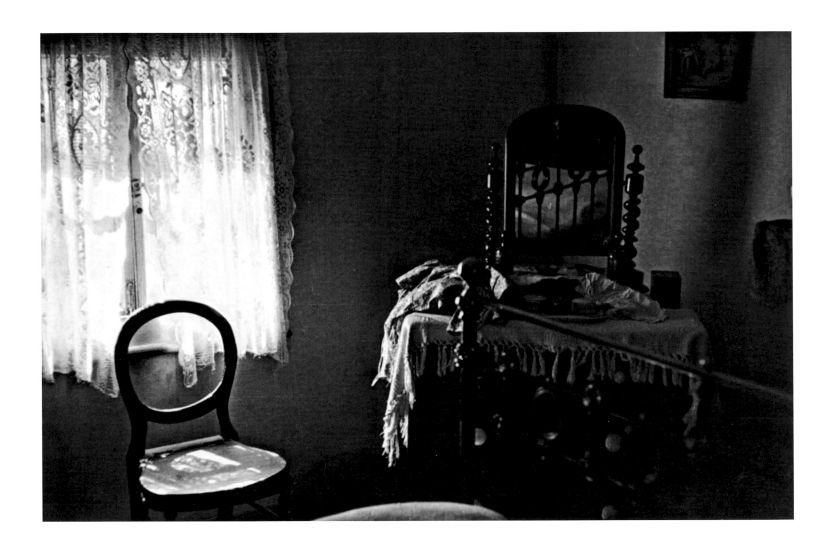

Camden Town bedroom, London (1935)

House at Chilwell, near Nottingham (1937)

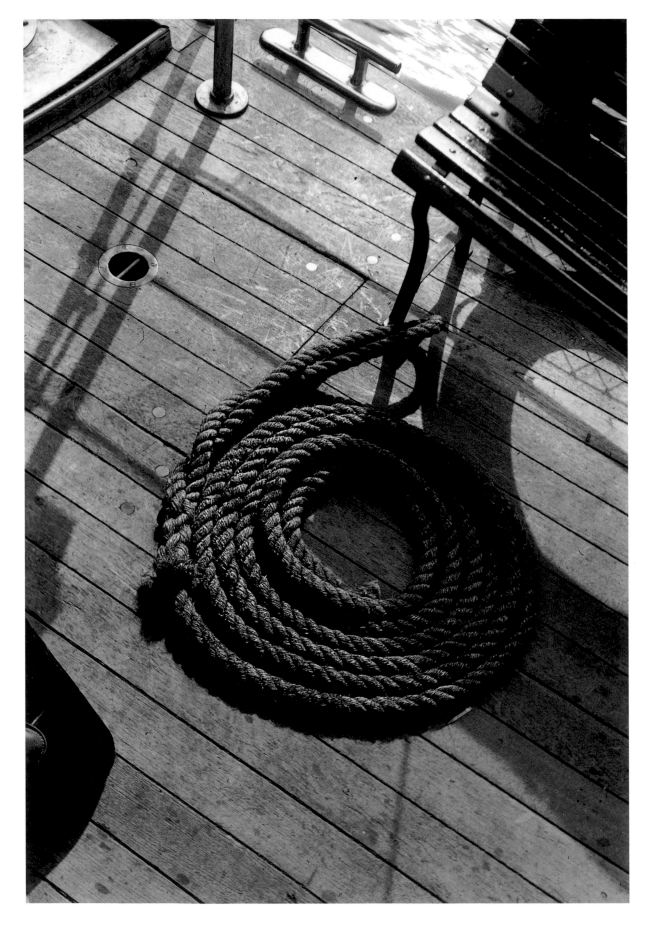

Coiled rope on deck (1935)

Photogram (*c.* 1940)

Kentish Town Station, London (1936)

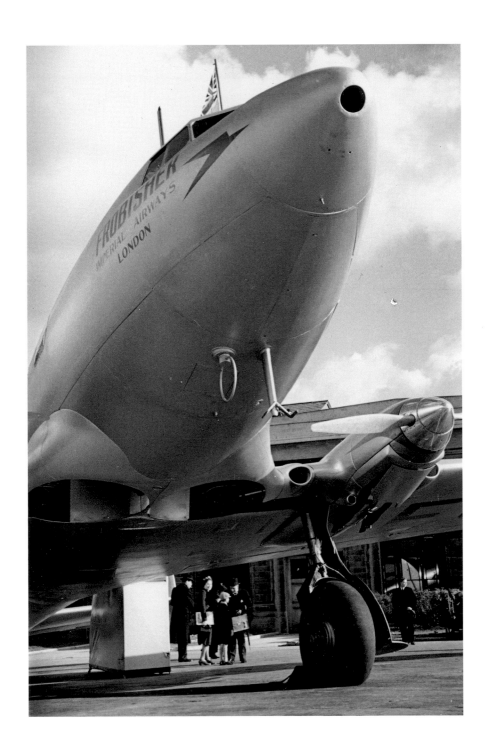

Advertising photograph for Imperial Airways (1938)

Tree, Kenwood, London (1935)

The sands, Equihen-Plage, France (1937)

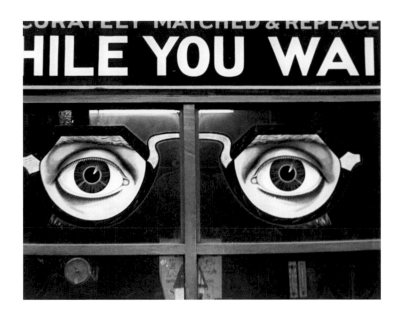

Optician's, London (1935)

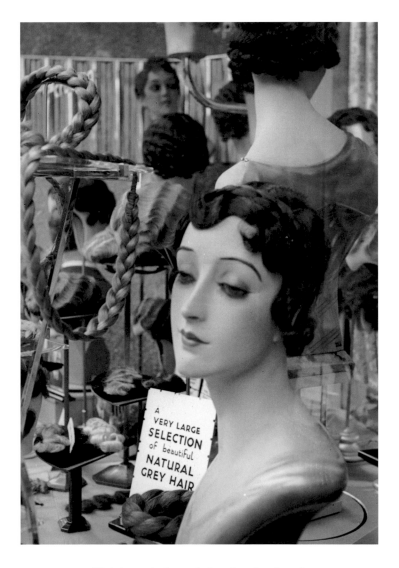

Hairdresser's shop window, London (1935)

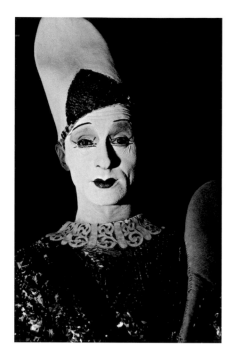

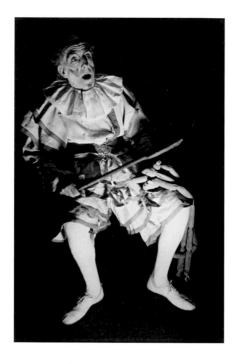

Coco, one of the Pleiss Brothers,
at Olympia, London (1935)

Clown, Althoff's Circus,
London (1938)

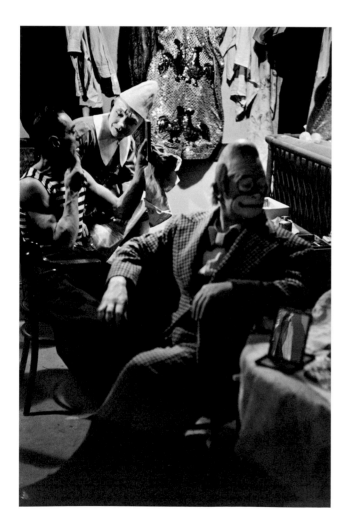

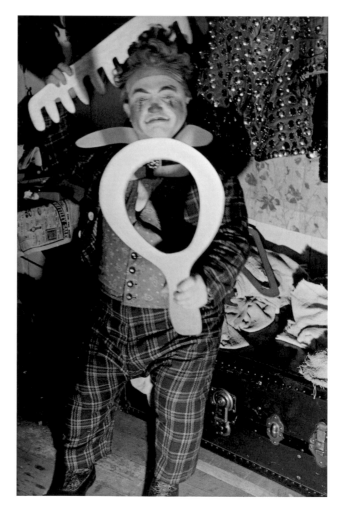

Clowns, Olympia, London (1938)

Clown, Olympia, London (1936)

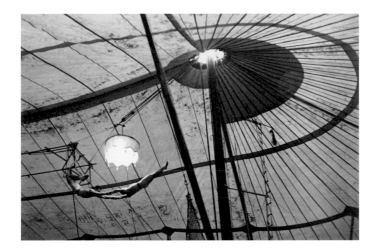

Trapeze artists, Sanger's Circus, Hayes, London (1937)

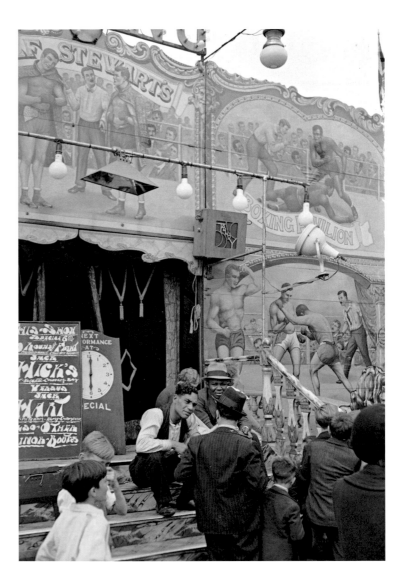

Mitcham fair, London (1935)

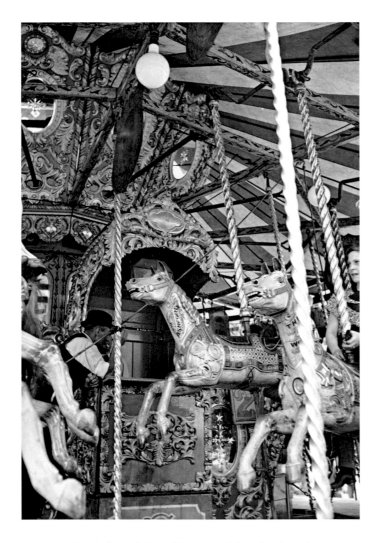

Gray's Roundabout, Hampstead, London (1935)

Fairground figure (1937)

Gray's Organ (1937)

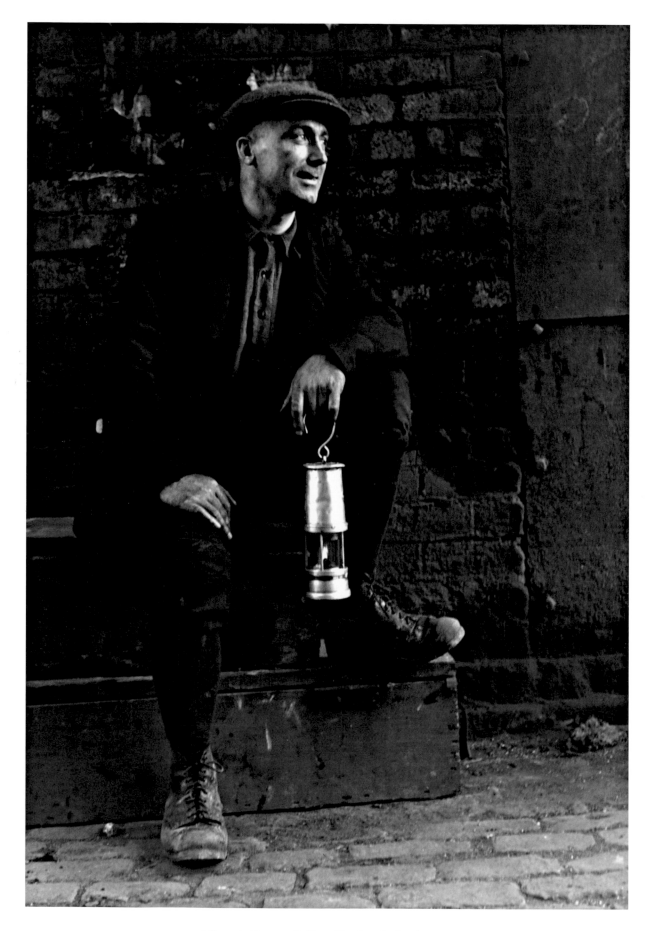

Miner, Ashington Colliery, Northumberland (1936)

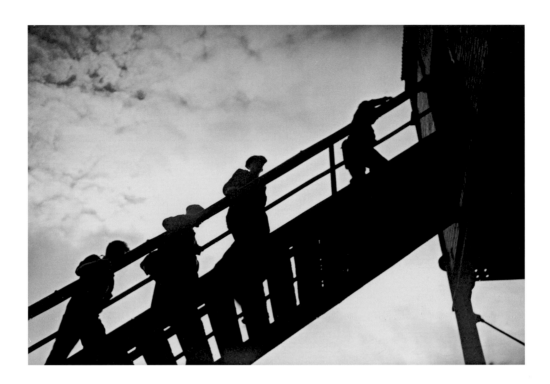

Ashington Colliery, Northumberland (1936)

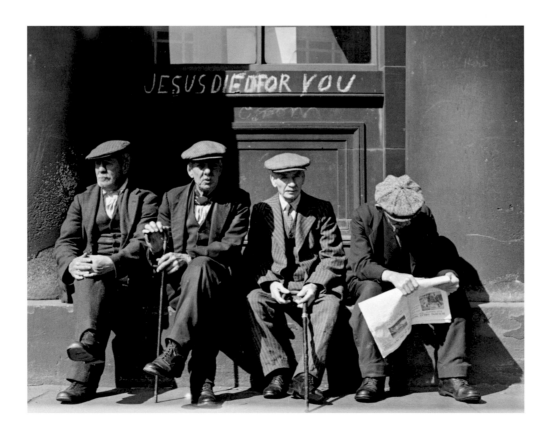

Outside the Guildhall, Newcastle (1936)

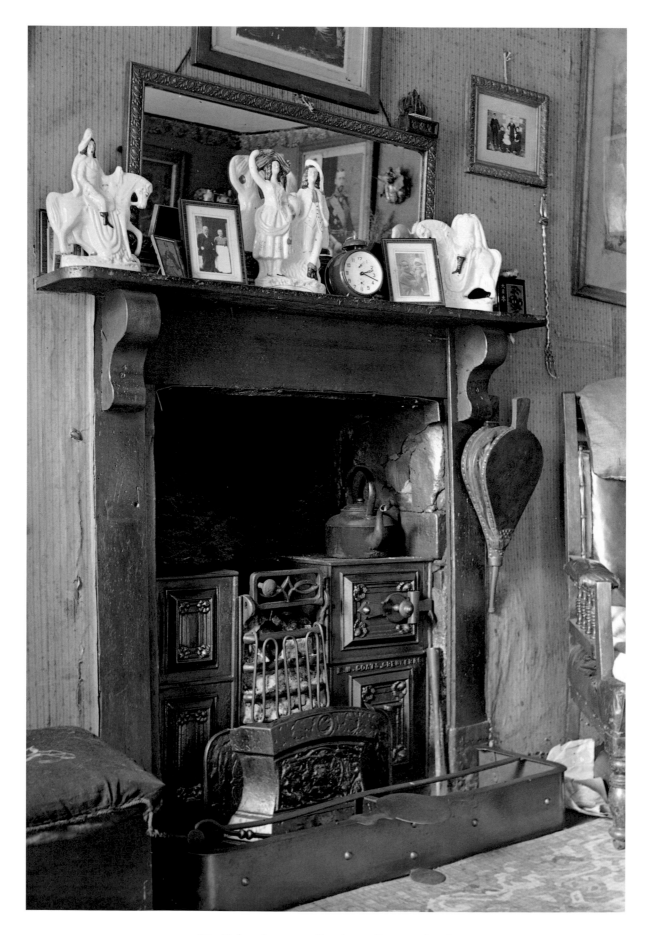

Mrs Holman's cottage, Crewkerne, Somerset (1936)

Outside a collier's house, Ashington, Northumberland (1936)

Miner's house, Ashington, Northumberland (1936)

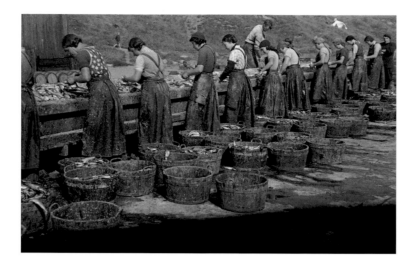

Gutting fish, Newcastle (1936)

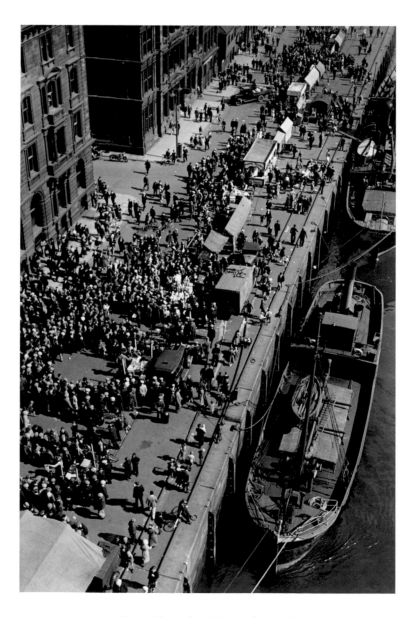

Quayside market, Newcastle (1936)

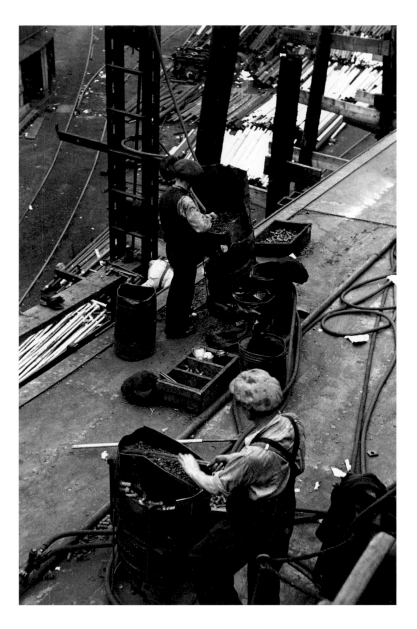

Shipyard, Newcastle (1936)

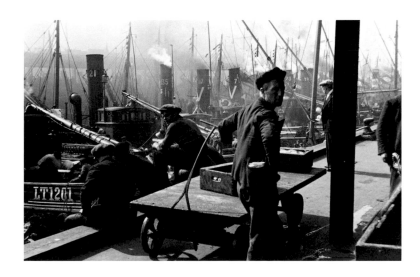

Quayside, Newcastle (1936)

Cleopatra's Needle, Victoria Embankment, London (1935)

Ruins from Leptis Magna, Virginia Water, Surrey (1935)

Garden, White House, Highgate, London (1949)

Somers Town, London (*c.* 1936)

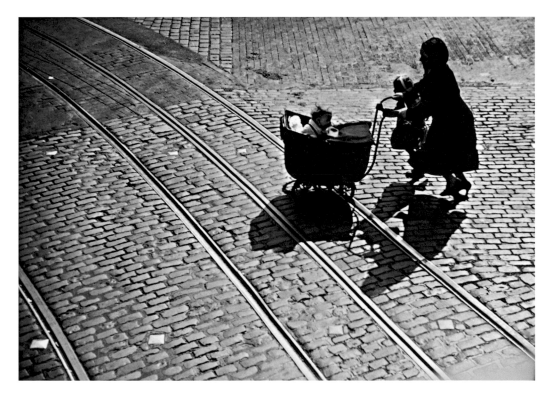

Camden Town, London (1938)

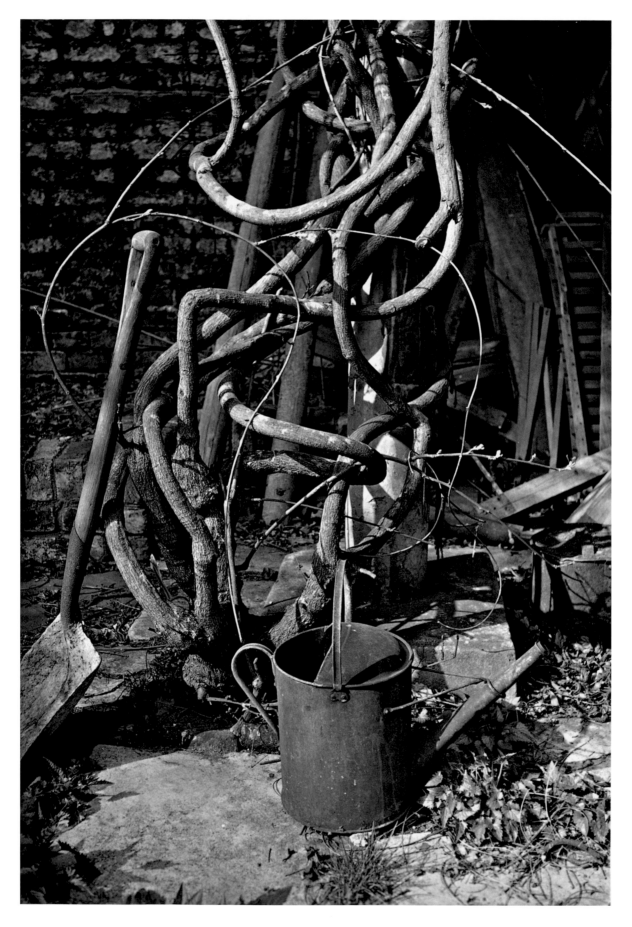

Garden, Church Row, London (1945)

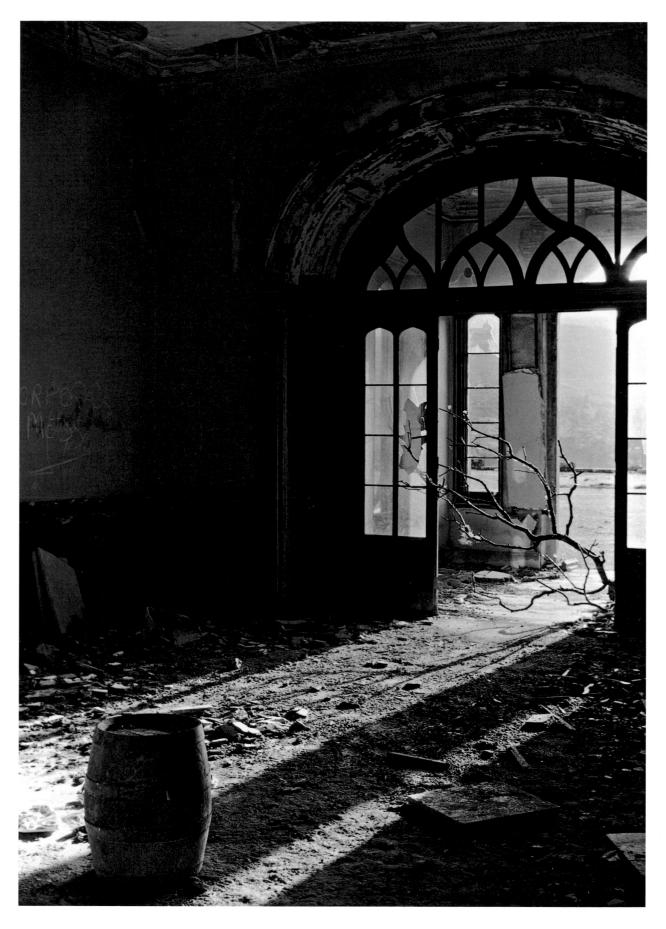

Entrance hall, Hafod, Cardiganshire (1950)

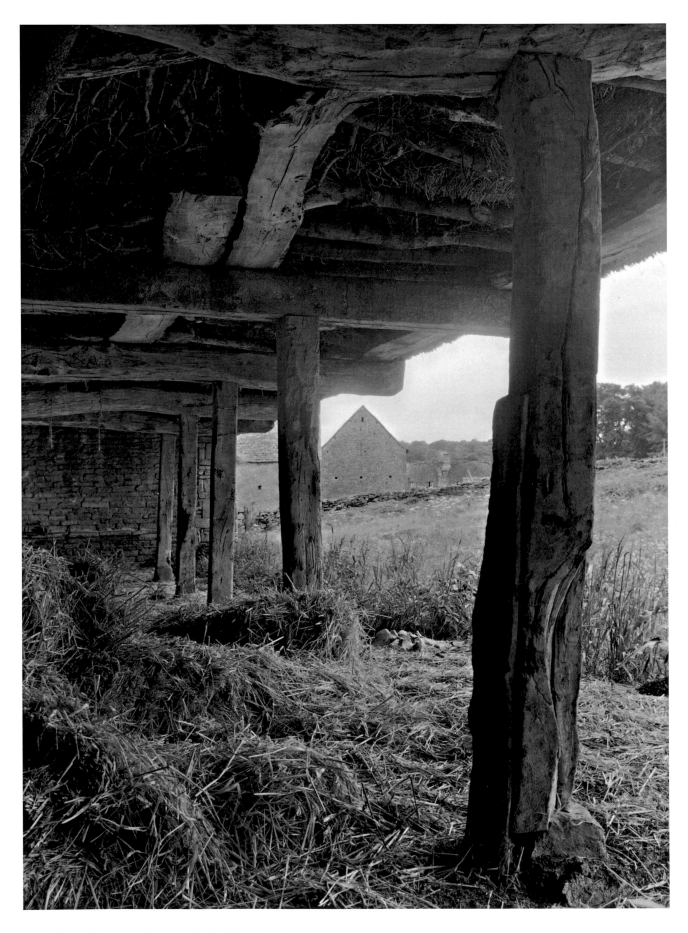

Barn, Upton Farm, near Burford, Oxfordshire (1953)

CHAPTER 2
DISCOVERING BRITAIN

Inspired largely by a series of commissions for book illustrations from the newly established publishing firm of Thames & Hudson, Smith found the 1950s a formative decade in the development of his photography. This extended patronage saw the heretofore heterogeneous nature of his subject-matter distil into a concentrated and affecting examination of British architecture and topography that not only posited a lyrically evocative alternative to the graphic economy of mainstream architectural photography, but also presented a visually compelling case for preservation of the country's increasingly threatened built heritage, and gave potent visual expression to the re-evaluation of British national identity. As Smith found a focus for his photography and demand for his images proliferated, so his long-cherished ambition of becoming an artist receded ever further into the background. A decade that began with Smith editing a textbook on artists' materials and techniques[1] ended with the eminent architectural historian John Summerson admiringly declaring, "Edwin Smith's photographs are unbeatable ... He has such a good eye."[2] Smith's photography had found its mature expression.

Published in 1952 with a text by his fellow 'zealous ecclesiologist', the economist Graham Hutton, *English Parish Churches* was Smith's first book for Thames & Hudson. The company had been founded three years earlier, with backing from the printer John Jarrold and the process engraver William Gilchrist, by the Viennese émigré Walter Neurath and his wife-to-be, the Berlin-born Eva Feuchtwang, who was also a refugee from Nazism. Both had worked previously for Adprint, the firm established in 1937 by another Viennese exile, Wolfgang Foges. Adprint was notable for pioneering the concept of book packaging, whereby books are produced for other companies to publish and distribute. In his role as Adprint's production manager, it was Neurath who was primarily responsible for the firm's most striking success, the extensive and stylishly designed *Britain in Pictures* series. Published by Collins (1941–50), this was conceived by the Ministry of Information as a succession of morale-boosting but concisely informative surveys of many different aspects of British life, the continued existence of which was imperilled. The stress on serial publication and high-quality illustrations, together with the exploration of Britishness, that marked *Britain in Pictures* were to become major components of Thames & Hudson's publishing strategy. Above all, Neurath was concerned to redress the balance in a culture he considered verbally rich but visually impoverished.[3]

This sentiment was reinforced by the perceived visual drabness of post-war Britain and shared by, among others, the *Architectural Review*, which in 1947 had grandiosely proclaimed its determination to "re-educate the eye",[4] and by John Piper who, through his painting and photography, sought to stimulate a new visual appreciation of British landscape and buildings. Neurath accordingly placed a premium on outstanding photography reproduced to the very best standards. The choice of Smith, therefore, represented something of a gamble, as he had little experience with the large-format camera he would now be obliged to use and almost no track record in photographing ecclesiastical

buildings, although a contract from Art and Technics in 1947 for a book on the Gothic Revival had steered Smith's photography increasingly towards architecture. One of his finest photographs intended for this aborted book was of the derelict interior of the Welsh Gothic mansion of Hafod, which evoked Walker Evans's studies from the mid-1930s of the similarly ruinous antebellum plantation houses of America's Deep South (see p. 47).[5] It may be that the Thames & Hudson commission came to Smith through Oskar Kokoschka, who was a close friend of Neurath, or perhaps through Cook's acquaintance with Feuchtwang. Even so, Neurath discovered in Smith a photographer who proved more than able to match his exacting requirements.

English Parish Churches was designed as a companion volume to Thames & Hudson's inaugural publication *English Cathedrals* (1950), and followed its format closely. Significantly the latter was a translation of a German original produced by Martin Hürlimann, the photographer/owner of the Zurich publishing house Atlantis Verlag, who was to co-operate on a string of publications with Thames & Hudson in the coming years. As the name Thames & Hudson (the rivers of London and New York) underlined, such co-editions formed an essential part of the company's output and dictated the layout of the books by Smith that it published during the 1950s, which had a general introduction followed by notes on the plates, and finally the plates themselves in a self-contained section. This arrangement enabled foreign editions to be readily produced without the need for expensive reprinting of the illustrations that formed the core of the books.

The formulaic nature of these quarto publications did not, however, detract from the handsomeness of their appearance. This was due in no small measure to the superb photogravure reproduction of the plates, many of them full page, executed in Smith's case mainly by Clarke and Sherwell of Northampton. Invented in 1879 by Karl Klíč, photogravure was an intaglio process in which the image was etched on to a copper plate or cylinder, the durability of which allowed long print runs. Its sensitivity to a full range of tones from rich, deep blacks to pallid greys rendered the process an especially good means of reproducing monochrome photographs, particularly when, like Smith's, they were softly lit and subtly nuanced. Lying partly in the fibres of the usually uncoated paper on which it was printed, the photogravure displayed broad, soft-toned effects similar to those achieved by William Henry Fox Talbot's salt print. It was also the chosen reproductive method of Pictorialist photographers at the turn of the twentieth century, such as Frederick Henry Evans (1853–1943). Both facts suggest the line of descent in which Smith's photography should be placed. While it may be hard to comprehend today, in the post-war period these books set new standards of visual richness, as the architectural historian Nikolaus Pevsner recognized:

> Some people, with intent to wound, call them coffee-table books. The term in my opinion does not justify any pejorative undertones. It simply means large books with plenty of illustrations. Now I can think back of the time when Basil Clarke's *Church Builders of the Nineteenth Century* came out (in 1938) with a total of thirty-two plates, and Geoffrey Grigson's *Samuel Palmer, the Visionary Years* (in 1947) with eighteen illustrations, and my illustrious colleague's at Birkbeck College, Sir John Summerson's book on Christopher Wren without any.[6]

For all their reworkings by Victorian architects and the unbridled enthusiasm of John Betjeman, who reckoned "church crawling" to be "the richest of pleasures",[7] parish

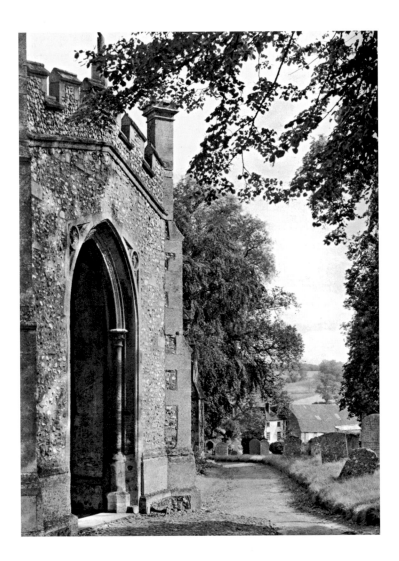

Fig. 9 Holy Trinity, Littlebury, Essex (1950)

churches had been relatively little studied and certainly not exposed to the kind of intense photographic scrutiny Smith brought to bear, which stressed not only their architectural but also their social importance. There is thus something of an air of mystery about Smith's photographs, a tone intensified by the frequency with which his camera peers through doorways or peeps between columns and set by the very first plate in the book, a beautifully composed interior, gently washed by a waning evening sun, of St Lawrence, Bradford-on-Avon, looking across the nave from the north to the south porch (see p. 67). Similarly, Smith's close affinity with his subject is apparent throughout, which led him later to reveal, "For me, photography in a good village church is unalloyed bliss. ... The visual pleasures and surprises of visiting country churches have been among the most vivid and poignant of my life."[8] An oblique view of the porch of Holy Trinity, Littlebury (fig. 9), for instance, allows Smith to include the village beyond, thus reinforcing Hutton's point that parish churches were "the first communal buildings in English history".[9] In addition, a number of traits characteristic of Smith's mature style are already clearly discernible. First, there is the typically English love of the small-scale and picturesque, which led him to prefer the intimacy of the parish church to the majestic sublimity of the cathedral. Secondly, there is his unmatched capacity for conveying the textures of materials in a way that recalls John Ruskin's elation when he began experimenting with photography in the 1840s and wrote excitedly of his daguerreotype plates, "every chip of stone and stain is there".[10] What Fox Talbot memorably referred to as "the abraded state of the stone"[11] is well captured by Smith in his image of the vaulted porch of St Margaret's, Cley-next-the-Sea (see p. 67). Finally, there are those 'incidentals' that other photographers might have banished from the frame but which were prized by Smith and helped to humanize his pictures, even when no people were present. Witness the casually abandoned dustpan and brush on a bench at St Mary's, Iffley; the processional cross propped up on an arch at St Michael, Blewbury; or the tail of a cart that has not quite vanished from view in his image of St Mary, West Walton. As John Betjeman later observed, Smith could "find a significant detail in a church – an oil lamp, a bell rope, or a harmonium which would conjure up a whole parish of people".[12]

In its reverence for these incidentals, which Smith dubbed "bonuses" and which similarly fascinated Fox Talbot, who considered them part of the medium's intrinsic promiscuity, Smith's photography resembles that of the American Walker Evans (1903–1975), significantly a fellow admirer of Atget, who, like Smith, also had a partiality for patina, folk culture and the eccentric. As a result of these attributes, Smith's pictures evince a romantic sensibility that contrasts markedly with Hürlimann's more analytical cathedral studies, which are very much in the Neue Sachlichkeit (New Objectivity) tradition of German Modernist photography as pioneered by Albert Renger-Patzsch (1897–1966) in the 1920s, with its emphasis on clarity, detachment and sober appraisal. The differing mood of Smith's imagery becomes even more pronounced when compared to that of A.F. Kersting in Batsford's *A Portrait of English Churches*, published four

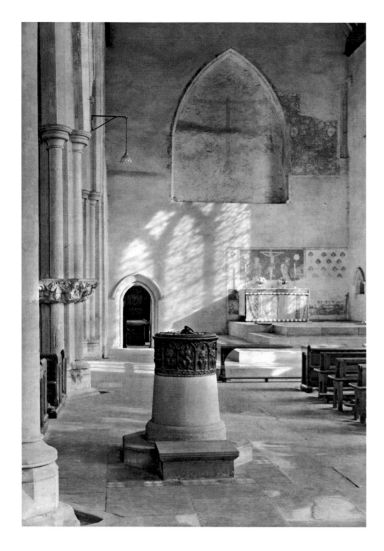

Fig. 10 St Peter and St Paul, Dorchester,
Oxfordshire (1950)

years later, which, although technically competent and factually informative, lacks the intensity of engagement and creative understanding of Smith's best work.

Information on Smith's working methods at this time can be gleaned from the logbooks, recording details of his larger-format work, that he began systematically to keep during this period, from the photographs themselves and from his later account 'On Photographing Cathedrals and Parish Churches'.[13] The demands of architectural recording, particularly the need to avoid the perspective distortion of converging verticals resulting from the camera being tilted upwards, rendered inappropriate the small-format cameras that Smith had used almost exclusively before the war. He thus purchased a second-hand, half-plate field camera – a 1904 Ruby manufactured by Thornton Pickard of Leeds – which was equipped with all the necessary movements. Mostly using this, together with a smaller quarter-plate Sanderson camera that was more easily portable to subjects difficult of access, he made almost 600 exposures on both glass and film for *English Parish Churches*, of which 226 were published. Not all were successful, and occasional logbook entries to the effect that the plates had been fogged or over- or under-exposed remind us that Smith was mastering new techniques as he went. The logbooks also reveal that few churches were covered in depth, with Smith and Hutton preferring to concentrate on a minimal number of characteristic features. These were carefully selected after an initial survey, in which Smith would seek

the vantage points that not only compose in terms of form but where the range of light and shade falls within the scope of the film. Every photographer favours a particular direction of light: I am drawn to situations where the source of light lies diagonally in front of me and not behind. To this direction I react instinctively and I gravitate without conscious design to those parts of the structure where this light obtains.[14]

One of the best examples in *English Parish Churches* is the interior of St Peter and St Paul, Dorchester, its rather bare aisle wall enlivened by the cast shadow of its window tracery (fig. 10). As most such views were taken in the light available, Smith's exposures could be long, with one interior of St Lawrence, Bradford-on-Avon, occupying a daunting 27½ minutes. Smith was also accustomed to dividing such exposures to ensure the exclusion of distracting figures, with "the lens being covered while anyone saunters across its path", even splitting "a minute's exposure into as many as thirty separate units as absorbed visitors pass in and out of sight behind piers and monuments".[15] The length of such exposures Smith usually judged not by use of a meter but by experience, his logbooks providing an invaluable record of the type of conditions encountered, the materials used, and the time consequently needed to obtain a successful picture. As he later wrote, "A great part of the magic of church monuments … is the total ambience of setting and given lighting. To intrude more than the minimum apparatus is not only to unsettle a mood and to dispel a magic but often to create more problems than can be solved."

He added, "providing the conditions of light do not exceed a modest range of contrast, however dimly a subject is lit, it can by well judged exposure and the relationship of that exposure to processing technique, be made to yield a bright image on the final print".[16]

The most daunting challenge Smith faced was the photography of misericords, which he described thus: "Bog-blackened by time but with highlights brilliantly polished by an infinity of church wardens' and choir-boys' seats, these enchanting subjects represent the ultimate, in the technical sense, of the non-photogenic."[17] By spreading the source of the light through reflection or diffusion and pre-focusing the camera at a carefully calculated distance, Smith managed triumphantly to overcome these difficulties. In addition to grappling with such technical problems, Smith now put his previous involvement with Cook in the design of *The Saturday Book* to good use. As Russell enthused, "Both prodigies, they were an editor's dream. They did everything themselves, layout included: you just sent the words to the printers and the pictures to the blockmakers".[18] This experience rendered Smith acutely conscious of the need to harness his working methods to book production. Accordingly, he considered that "the photographer should not fill the frame, but should allow a considerable latitude for trim, both for 'bleeds' and for any difficulties of fitting a halftone reproduction to a layout".[19] While we tend to think of photographs as essentially static, literally 'stills', they are often much more dynamic in the sense that, as in Smith's work, there is frequently no definitive print, and the same images often recur in differing versions in different contexts. Although intolerant of publishing houses that dared to retouch his pictures, Smith accepted this flexibility as an inevitable part of the publishing process, and there is thus often a significant variance between original negative and published picture.

The success of *English Parish Churches*, which saw it reprinted in 1952 and reissued in a new edition in 1957,[20] encouraged Thames & Hudson to commission a similar volume from Smith, *English Cottages and Farmhouses* (1954), a subject for which he had already shown a predilection during visits to relatives and friends in Somerset during the 1930s. In this book the preservationist concerns that had been relatively muted in *English Parish Churches*, but which had nevertheless seen Smith's photographs used in a series of travelling exhibitions organized by the newly founded Historic Churches Preservation Trust as part of its campaign to promote awareness of the dangers these churches faced, came more to the fore. This was partly due to the fact that Smith's collaborator this time was Cook, whose passion for conservation of historic buildings resulted in a text far more *engagé* than Hutton's sober account, expressed in lush, billowing sentences that, like Smith's photographs, brilliantly combined authoritative information with emotional intensity. While Cook gave verbal affirmation to the celebratory spirit animating the photographs, there was nevertheless a creative tension between Smith's photography and Cook's prose.

Occasionally hovering perilously close to the sentimentality of such artists as Myles Birkett Foster, as in the opening image of Limetree Cottage at East Hagbourne (fig. 11), or, in another of a fourteenth-century cottage at Didbrook (see p. 70), to an idealized Mrs Miniver-style Hollywood version of the mother country, Smith's photographs again demonstrate his fondness for the humble by

Fig. 11 Limetree Cottage, East Hagbourne, Berkshire (1953)

extolling the sheer ingenuity and variety of vernacular building. Rarely are we permitted a glimpse into the harsher reality of working rural life, although in particular the interior of a scullery at Harthill Hall Farm, Alport (see p. 72), recalls the claustrophobic intensity and the emotional investment in the simple artefacts of diurnal existence that characterized Walker Evans's moving documentation of Depression-ravaged Alabama in the 1930s. Rather, Smith proffers a humbler version of Charles Latham's romantic views of country houses, taken in the early 1900s for *Country Life*, in which the cottages and farmhouses are carefully framed to eliminate all the unwelcome appurtenances of modern life, and so summons up, like Latham, a vision of an idyllically tranquil, unchanging England. Lovingly crafted using local materials and techniques, and sympathetic to their site and climate, these buildings were for Smith, as Cook wrote, "the most moving and vivid expressions of the variety which is still the most outstanding quality of the English landscape".[21] They were therefore the perfect embodiment of the *genius loci* Smith was most concerned to evoke in his photography.

It was left to Cook to sound the warning note of the dangers looming beyond the camera's frame – "yet five miles distant heavy traffic thunders continuously through the villages of Harston and Melbourn, giving the lie to the peaceful aspect of the row of cottages shown"[22] – and to emphasize the precariousness of these buildings' survival. In Cook's view, rapid technological change and the concomitant unprecedented "ruthless rupture with local tradition" made "the existence of farmers and cottagers as described by writers as near to us in time as George Eliot and Hardy seem as distant from us as the farmhouse life depicted in the Paston letters".[23] While inevitable in terms of convenience and economic necessity, these changes were ushering in an era of numbing standardization that would soon make Smith's photographs "which now portray a living present … merely record a vanished past".[24] Concrete, tainted by its association with Modernism, in particular provoked Cook's full ire for being used "more or less conspicuously in farmbuildings all over the country", yet being "the most inexpressive of all materials, the most destructive of regional character".[25] At the same time as reluctantly admitting the necessity of change, Smith and Cook maintained that these often overlooked examples of minor domestic architecture possessed an inestimable worth in "their power of inspiration, their power to move men to a creative effort which will transcend the bonds of technique and the rules that can be learnt from books".[26]

Cook and Smith were not alone in expressing such sentiments. Indeed *English Cottages and Farmhouses* reflected the burgeoning interest in local history and vernacular architecture that was itself prompted in part by wider concerns about the rapid changes that were dramatically reshaping the British landscape. Thus, the book was warmly welcomed by one of the most influential writers on these subjects, W.G. Hoskins, whose seminal work, *The Making of the English Landscape*, appeared a year after *English Cottages and Farmhouses*. Reader in economic history at Oxford University and, like Smith and Cook, a strident anti-Modernist who fulminated against "councillor's concrete" and "the lunacy of the twentieth century",[27] Hoskins maintained, "Edwin Smith's photographs are superb and are brilliantly reproduced in photogravure, showing among other things the texture of the building materials in a way that makes them as valuable as the text."[28] Complementing this academic imprimatur, and of more importance in boosting Smith's reputation as a gifted and sensitive photographer, was the fulsome praise heaped upon his photographs by Betjeman in his review in the *Daily Telegraph & Morning Post*:

They have a sharpness and clarity about them which bring out all the varying textures of the buildings they portray, whether flint or stone or wood or sun-shadowed plaster. They show the rounded trees and background hills and the foreground with its well-worked garden. … Mr Smith is a genius at photography. The shades of limestone from silver to gold, the reds and browns of old tiles, the cobbles of entries; the feathery grey-blue of Cornish slate are all conveyed in his photographs, so that though in monochrome they are as full of the suggestion of colour as are those marvellous etchings of Norfolk which Cotman made at the beginning of the last century.[29]

Another collaboration with Cook, *English Abbeys and Priories* (1960) represented the last of the triptych of books on building types that Smith produced for Thames & Hudson. The illustrations in these and Smith's other commissions during the period vividly demonstrate how far his style of picture-making diverged from contemporary mainstream British architectural photography, which concentrated almost exclusively on new buildings portrayed in the Modernist idiom introduced by Dell and Wainwright in the 1930s. Although shot on stand cameras not dissimilar to Smith's, this was an altogether more dynamic, assertive photography of tipped views with diagonals thrusting to the edges of the frame, sharp contrasts of black and white with bold cast shadow employed to animate often bland, undecorated surfaces, and frequently disorientating changes of scale. Buildings were typically portrayed as isolated, single structures severed from their urban or landscape setting, and bright sunshine was de rigueur before the lens cap was removed. "It never rains in the *Architectural Review*",[30] caustically quipped the photographer John Donat. Thus was created a phantasmagorically immaculate, perennially sunlit International Style architecture, deracinated and oblivious to climate, that glowed far more seductively on the magazine page than it could ever hope to do in reality.

Significantly, one of the most perceptive criticisms of this style of photography came from the artist Michael Rothenstein, a friend of Smith and Cook and a member of the Great Bardfield coterie of artists that included Edward Bawden and John Aldridge, with whom Smith and Cook were also on intimate terms. Rothenstein argued that architects' slavish dependence on ubiquitous and beguiling black-and-white photographs for inspiration had bred an "architecture deficient in chromatic values". Such photographs, moreover, were

> misleading in another way; for they so often show us walls and window-openings bathed in clear sunlight. The relationship between different volumes is thus shown to great advantage; while in the cloudy light typical of our own weather, cast shadows rarely lend such vigorous character to the contrasting planes. The modern architect imitates the photographer; he builds with lights and shadows, with black and white. The infinitely varied polychromatic possibilities of his medium are neglected.[31]

Smith's photography by contrast was, as Betjeman had rightly recognized, "full of the suggestion of colour",[32] employing a full palette of monochrome hues. In addition it was concerned not with buildings fixed on other photographers' plates in the vigour of eternal youth but with architecture that had endured the injuries of time and bore the marks of human experience. Smith's was a photography of stillness, of quiet accommodation to his subject, and of wonder at, and reflection on, the multifariousness of Britain's landscape and architecture. Indeed his imagery was often at its most hauntingly revelatory

precisely where architecture and landscape met – in the ruin or garden, for instance, or where buildings sought to harmonize with nature rather than impose themselves upon it. Furthermore Smith, like Rothenstein, was contemptuous of "fair weather"[33] photographers, preferring to work under a neutral sky, where strong shadows could be avoided, as he revealed in one of his letters: "The day is really too brilliant for photography. The shadows are harsh & black, and at the moment the sun is dizzily overhead, higher than I recognise, and it will be an hour or so before it becomes congenial and pictorial again."[34]

This aspect of Smith's photography was commended by the poet, critic and naturalist Geoffrey Grigson, an ardent Anglophile and a prime mover in the Neo-Romantic movement, who was Smith's author/collaborator on *England* (1957). Here he asserted:

> I have known landscape photographers who complain that in England there are only a few dozen photographic days in the year – a few of them in spring, a few in autumn. But what a falsity that exhibits, and what a desire to give everything the sparkle of an always optimistic sentimentality! All they want is art-editor's England grinning through a horse-collar. *Per contra*, Edwin Smith once remarked to me that he does not bother so much about light; he adapts his photograph to the day and the time, as well as the situation. Landscape pure or landscape with buildings – either way, landscape has a face: she … is for ever altering her face. She smiles, laughs, sets into a brown study, frowns, is sad; laughs and smiles again, changes from repose to excitement; and scowls, threatens, and gets angry; puts on a look of sociability, and a look of being aloof. The face of a building, external, internal, is just as moody. I hope everyone familiar or unfamiliar with England will see and feel in these plates the proper changeability of these faces, and from south to north, east to west the variety of their features.[35]

Changeability and variety were key words in the Smith lexicon to be pitted against the standardizing tendencies of the age, whether manifested in the form of a Modernist architecture that paid scant regard to place or its photography, which sought to pretend that Britain continually basked beneath a warm, Mediterranean sun. No new post-war British building would have been photographed in the manner Smith viewed Hardwick Hall, its outline forms softened by an early morning mist (see p. 88).

Smith belonged to an alternative tradition of architectural photography, which, though boasting few adherents, was long and distinguished. The origins of both his subject-matter and its treatment can be traced back to the very beginnings of the medium and to the work of those early amateur photographers and fledgling professionals such as Francis Bedford (1816–1894) and Benjamin Brecknell Turner (1815–1894), whose vision dominated the way British architecture was photographically depicted in the 1840s and 1850s. In turn this vision was shaped by pre-photographic modes of architectural representation, especially the etchings of John Sell Cotman and the topographical watercolours of such artists as Thomas Girtin, Paul and Thomas Sandby, and a young J.M.W. Turner – artists whose work Smith knew and admired, even if he was almost certainly ignorant of the imagery of those photographers who drew inspiration from them.[36] Nowhere is Smith's debt to these artists better shown than in his photograph of St Mary's Church, Swinbrook, viewed across the River Windrush (fig. 12). These early photographers were also heavily influenced by Picturesque theory – significantly undergoing a major revival in the post-war years – which determined their choice of subject-matter and

Fig. 12 St Mary's, Swinbrook, Oxfordshire,
seen across the River Windrush (1955)

the painterly way in which it was presented. "The picturesque eye", wrote the Revd William Gilpin in one of the doctrine's key texts, *Three Essays* (1792), "is perhaps most inquisitive after the elegant relics of ancient architecture; the ruined tower, the Gothic arch, the remains of castles and abbeys."[37] Bedford in particular excelled in these subjects, earning the praise of the architect T.L. Donaldson for being "particularly successful in his combinations of building and landscape scenery",[38] an accolade that could be bestowed with equal justification on Smith. To pick one from many possible examples, Smith's photographs of Bolton Priory are Bedfordian in conception, while B.B. Turner's views of the farm buildings at Bredicot can be seen as harbingers of the similar scenes to be found in *English Cottages and Farmhouses*.

The dominance of this picturesque photographic vision of architecture was ended in the 1860s by the rise of professional firms dedicated to recording the rash of new building that was such a feature of the late Victorian era. These companies, chief among them Bedford Lemere & Co., sacrificed a more creative use of light for a straightforward documentary approach, which emphasized pin-sharp clarity over the entire image area. Henceforth there was to be a clear divide between the photography of modern buildings and the photography of historical architecture that few photographers managed to cross. This split was thrown into sharp relief with the advent of Pictorialism at the turn of the twentieth century, which sought to revive many of the ideals of the early amateurs, not least their insistence that photography should be an art. Pictorialism's concern with emotions rather than ideas, the universal rather than the specific, and impressionistic soft-focus effects rather than razor-sharp detail, together with its predilection for printing processes that allowed considerable scope for hand manipulation, represented a fundamental challenge to the basic tenets of professional architectural photography. This was a point forcefully made by the noted Pictorialist landscape photographer and regular commentator on the photographic salons for *Country Life*, Alfred Horsley Hinton (1863–1908). In a passage with which, fifty years later, Smith would surely have concurred, he maintained,

The very qualities of the photograph which have too often alienated the sympathies of the artistic and earned the contempt of the draughtsman, have in architectural reproductions been ever more than ordinarily present, such as the absence of atmosphere, the indiscriminate distribution of high lights, the equally sharp definition of detail in all planes, and the exaggeration of perspective due to the wrong use of the lens, all of them errors of judgement and taste on the part of the photographer, and by no means the inevitable and inherent shortcomings of the process. Those who have to any considerable extent photographed architectural subjects appear to have lacked sympathy with the originals, regarding them as set models with which to demonstrate the *res consummatum* of the triumphant optician, and so have been led to achieve a mere *tour de force* of mechanical reproduction, counting the beauty of light and shade contrasts a disadvantage, because all

parts are not equally illuminated, and striving to eliminate the effect of veiling atmosphere to the end that every detail may be set forth with uniform clearness.[39]

Not surprisingly, therefore, few Pictorialists deigned to tackle architectural subjects, and those that did, most notably Frederick Evans, confined their image-making almost entirely to medieval ecclesiastical architecture.

Acclaimed by the American Pictorialist Alfred Stieglitz as "the greatest exponent of architectural photography"[40] and inspired by J.M.W. Turner, Evans, in his unmanipulated, emotionally charged, numinous platinum prints of cathedral interiors, can be seen as the spiritual forebear of Smith. As fellow photographer J. Dudley Johnston aptly remarked, Evans "showed us how the photography of our beautiful cathedrals and ancient buildings could be raised from a matter of mere record into the domain of poetry and pictorial achievement".[41] This was a mission continued and extended by Smith but with significant differences. Smith's pictures are less spiritually intense than those of Evans, less ethereal and more focused on the palpable, material world before his lens. Although some of Smith's images, such as that of Brighton beach (see p. 87), could be described as Pictorialist in vein, he repudiated entirely the Pictorialist photographers' tendency to dissolve the specifics of a locale into a haze of light, mood and atmosphere and to give their pictures poetic titles that left the viewer frustratingly ignorant of their actual locations. Unlike those of Evans, often made for his own satisfaction, Smith's photographs, taken to commission, combined Pictorialism's imaginative use of light and conviction that photography should be interpretative, not merely an act of record, with the clarity and specificity of mainstream architectural photography. Smith's choice of printing paper reflected this strategy. His glossy, unglazed, warm-toned paper represented a *media via* between the hard, high-gloss prints of the professional architectural photographer on the one hand and the soft, painterly print processes of the Pictorialist on the other. As Cook succinctly put it in the title she gave to a retrospective exhibition of Smith's work, his photographs were poised between "record and revelation".[42]

With four further books for Thames & Hudson sandwiched between *English Cottages and Farmhouses* and *English Abbeys and Priories*, these were productive years for Smith. *Art Treasures of the British Museum* (1957) revealed Smith to be an exceptional photographer of museum artefacts, with a keen appreciation of the subtle lighting required to disclose the pieces' modelling and texture (see p. 82). Further such work followed in the 1960s, culminating in his book on the subject with John Lewis, *The Graphic Reproduction and Photography of Works of Art* (1969). On the other hand, despite its unalloyed success as a promotional vehicle, *The Living City: A New View of the City of London* (1957), published by Thames & Hudson for the Corporation of London, shows Smith ill at ease with much of his subject-matter, his attempts to depict the bustle of London's Square Mile seeming stiff and formal, especially when set alongside the photojournalism of the period. Far better, and of more significance, were *Scotland* (1955), with a text by George Fraser, and his collaboration with Grigson, *England* (1957), which introduced his imagery to a wider, more general audience. These books were notable in helping to revive the tradition of creative topographical photography. Since its rise in the second half of the nineteenth century, with such large firms as Francis Frith of Reigate, George Washington Wilson of Aberdeen and James Valentine of Dundee issuing matter-of-fact views in their millions to satisfy the fast-developing tourist market, this tradition had ossified into the picture postcard blandness scornfully dismissed by Betjeman, after one of its leading proponents, as

the 'Dixon Scott' school of photography.[43] It was Betjeman himself who played a key role in this revival, through his editorship of the *Shell Guides*, launched in 1934 with his own *Cornwall*. As Piper, who wrote several of the guides, beginning with that on *Oxfordshire* (1938), and became joint editor of the series with Betjeman in 1962, maintained,

> The pictures in these guides are not chosen for their popular holiday appeal, nor as advertisements for the places and buildings they show. The special character of a village or house or a stretch of country is what, in the end, is exciting and memorable about it and this character may be brought out not only by camera angles and quality of negative and print but by cloud or lack of it, in fact by many different aspects of mood, weather and season. These considerations have influenced the choice of pictures more than the demand for conventional compositions in sharp focus and perpetual sunshine.[44]

Scotland and *England* followed suit, with Grigson insisting that England be "freshly observed"[45] and that nothing should be included purely for associative, sentimental or antiquarian reasons. In a shift away from the souvenir view, quality and significance were to be the watchwords, paralleled by photographs that sought not simply, as G.W. Wilson had expressed it, "the genuine presentment of the object under consideration"[46] but also its spirit. Above all it was to illustrate what Grigson, like Smith, saw as the essence of the English landscape – its infinite variety. Despite Smith complaining to Eva Neurath, "I will do my best, short of self-destruction, to complete ENGLAND in three months but I rather think it impossible. I confess to feeling a little jaded and apprehensive about the project, it seems so vast and diffuse",[47] he rose magnificently to the challenge. Grigson's refrain *varietas delectat* is admirably expressed in Smith's photographs, from the fading Piranesian grandeur of Lulworth Castle, through the radiantly illumined, marble-smooth rocks of Kimmeridge Bay (see p. 85) and the eerily beautiful desolation of Wastwater (see p. 97), to the melancholic view of Hadrian's Wall (see p. 100), the setting sun metaphorically suggesting the end of empire. In *Scotland* the accent was on the sturdiness of its buildings shown, for example, in images of the chunky neo-Grec of Alexander 'Greek' Thomson's houses in Oakfield Avenue, Glasgow, or in the thick, plain walls of Coxton Tower, Moray, and the rugged beauty of its landscape, be it the ominous *terribilità* of Glencoe or the basalt pillars of Staffa. Indeed, in both *England* and *Scotland*, Smith was afforded the opportunity of exploring for the first time the natural landscape, unsullied by man, a subject with which he became increasingly preoccupied in the ensuing decade.

Taken together, Smith's publications during the 1950s made a powerful contribution to the contemporary quest to rediscover Britain, then, as now, often simply equated with England. While there was nothing new about such a quest, during the 1930s as war loomed and in the post-war period as the pace of reconstruction accelerated, Britain was investigated with an unprecedented intensity. This exploration, which was both actual and imaginative, a fecund amalgam of Gradgrindian audit and creative myth-making, was motivated by a number of factors. First there was a growing belief among such artists as Nash and Piper that British art and architecture were the equals of their Continental counterparts and accordingly to be cherished and studied. Secondly there was the need to discover exactly what the war and the large-scale redevelopment that followed were putting at risk, and what should be preserved and recorded. In this respect these years could be seen as a rerun of the late Victorian era, when ruthless rebuilding bred such preservationist

and recording bodies as the Society for Photographing Relics of Old London (established 1875), Sir Benjamin Stone's National Photographic Record Association (1897) and the Society for the Protection of Ancient Buildings (1877), which were paralleled in the middle years of the twentieth century by the foundation of the National Buildings Record (1941), Mass Observation (1937) and the Victorian Society (1958). Added to this was the sense of isolation experienced during the war and after, when foreign travel remained problematic. The artist Michael Ayrton's observation that artists had "been forced by circumstances to fall back not only upon British art but upon British landscape"[48] was echoed by Piper's recollection that "Roots became something to be nurtured and clung to instead of destroyed. Objects we had not been able to look at, let alone see, because of their positive personality or the proliferation of other artists' visions of them, now became of great visual and emotional importance."[49] Smith's photography can thus be seen as part of the prevailing mood of geographical introspection, as artists bowed to W.H. Auden's injunction to "Look, stranger, on this island now."[50]

Finally, as Piper implied, the rediscovery of Britain was inexorably bound up with notions of Britishness and the need for a myth and shared vision that would sustain the country during its darkest hour. The favourite wartime song had been Gracie Fields's stirring rendition of 'There'll Always Be an England', but its line "If England means as much to you/ As England means to me"[51] begged the question of what did England connote to its populace? With the undermining of old certainties and the loss of the Empire, the question became more pressing. Increasingly the answer seemed to lie in the country's physical fabric, which was suddenly rendered more precious by its possible obliteration by bombing or the bulldozer – a feeling intensified by the number of people encountering its diversity at first hand for the first time. To many of its inhabitants, before the transformative experience of evacuation to a rural haven, posting to a barracks far away from home or service in the Land Army, Britain was the "undiscovered country" that caused the London soldier in Michael Powell and Emeric Pressburger's *A Canterbury Tale* (1944), one of the great myth-making films, to exclaim, "I never realized there was a countryside before the war."[52] The composers of 'There'll Always Be an England', Ross Parker and Hughie Charles, presented a notion of their homeland as something that would exist "While there's a country lane,/ Wherever there's a cottage small/ Beside a field of grain". This was an expression of what has been termed "the myth of Deep England",[53] a myth of a prelapsarian pastoral arcadia that was widely shared, not least by Smith and Cook, who were among its nurturers. The response to Mass Observation's wartime survey questioning what people considered they were fighting for – "landscape, village life, country churches and thatched cottages" – was the very stuff of Smith's photography.[54] His image-making thus not only contributed to the factual inventory of Britain but also helped to shape and sustain one of its most compelling myths.

The re-examination of the matter of Britain affected all the arts and was an important element in the Neo-Romantic movement, first described as such by the writer Raymond Mortimer in 1942. In music Benjamin Britten returned from America to pursue British themes in such operas as *Peter Grimes* (1945), *Albert Herring* (1947) and his celebration of the coronation of Queen Elizabeth II, *Gloriana* (1953). Cinema was also pervaded by nationalist sentiment, with Michael Balcon, the head of Ealing Studios, striving to realize his contention that "a film, to be international, must be thoroughly national in the first instance".[55] Beyond Ealing, in addition to Powell and Pressburger, such directors as David Lean in *Great Expectations* (1946), one of a series of films

derived from British literary sources, were similarly concentrating on indigenous subjects. The visual kinship between some of Smith's Tyneside views of the 1930s and John Grierson's powerful documentary of fishing life, *Drifters* (1929), and the resemblance, for example, of Smith's image of Whitby (1959; see p. 2) to a film establishing-shot of the period lead one to ponder how far Smith was influenced by contemporary cinema. Certainly he and Cook were fascinated by the illusionistic tricks of cinema's early pioneers, such as Georges Méliès, stills of whose work they possessed, and by the optical toys from which cinema evolved, a subject treated by Cook in her book *Movement in Two Dimensions* (1963).[56] Film-making, together with written reports, painting and photography, was also an important ingredient in the work of Mass Observation, founded by the anthropologist Tom Harrisson and the poet Charles Madge in an attempt to investigate what lay beyond 'Deep England' by gathering comprehensive facts about all aspects of British life. In literature the cause was promoted with fervent evangelism by John Betjeman, while J.B. Priestley and George Orwell supplemented their respective quests, *English Journey* (1934) and *The Road to Wigan Pier* (1937), with radio broadcasts and further writings that discussed the nature of Englishness. In *The Beauty of Britain* (1935) Priestley described a scene that he could later have encountered in *English Cottages and Farmhouses*:

> We see a cornfield and a cottage, both solid evidences of Man's presence. But notice how these things, in the middle of the scene, are surrounded by witnesses to that ancient England that was nearly all forest and heath. The fence and the gate are man-made, but are not severely regular and trim – as they would be in some other countries. The trees and hedges, the grass and wild flowers in the foreground, all suggest that Nature has not been dragooned into obedience. Even the cottage … looks nearly as much a piece of natural history as the trees: you feel it might have grown there. In some countries, that cottage would have been an uncompromising cube of brick which would have declared "No nonsense now. Man, the drainer, the tiller, the builder, has settled here." In this English scene there is no such direct opposition.[57]

The need to work with rather than in opposition to nature was indeed one of the leitmotifs of Smith's photography.

In art the shift away from Continental to home-bred sources of inspiration, noted by Ayrton and Piper, was particularly marked, having been given official sanction by the Recording Britain scheme. One of the scheme's chief contributors was Piper himself, to whose topographical painting and photography Smith's work bears a close affinity, particularly in its respect for place and its alertness to the discernment of the extraordinary in the ordinary. Thus, Smith's image of the gates of Hardwick House Park, Bury St Edmunds (see p. 89), has all the romantic melancholy of a Piper painting, such as *Entrance to the Wilderness, Renishaw* (1942–43), while his photography consistently betrays what Summerson aptly hailed as one of Piper's main achievements, namely exciting "a new curiosity about unnoticed, unlisted things".[58] Piper's self-assessment, "The basic and unexplainable thing about my paintings is a feeling for places. Not for 'travel', but just for going somewhere – anywhere, really – and trying to see what hasn't been seen before",[59] would have been equally apt as an evaluation of Smith's photography.

Smith enjoyed close links with other artists as well, in particular two colonies whose establishment in the rural retreats of 'Deep England' symbolized not only their

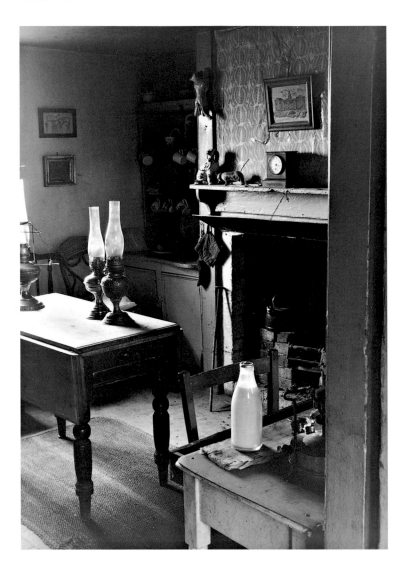

Fig. 13 Kitchen at Furlongs, near Firle, Sussex (1953)

members' concern to explore the English landscape but also their sensitivity to regional differences. Eric Ravilious's love of the chalk downs of Sussex drew him to Furlongs, an isolated farmstead near Firle, which the wallpaper designer Peggy Angus had discovered and rented as a holiday home. Despite the rudimentary nature of its accommodation, Furlongs became notable for its artistic gatherings, presided over by Angus, who until 1948 was married to Jim Richards, the editor of the *Architectural Review*. Cook and Smith were frequent visitors from 1947 onwards, with Smith taking photographs of the rather dilapidated cottages and the various revels in which the group indulged (fig. 13). Their close relationship to this fluctuating community, which included the engraver and painter Tirzah Garwood, to whom Ravilious had been married, was demonstrated by Cook's gift of one of Smith's cameras to their son James, who used it to record rural life in Devon in a manner that owed a considerable debt to Smith's appreciation of landscape and topography. Under the sharp East Anglian light, in one of the remoter parts of Essex, a more coherent artistic community grew up around Edward Bawden's home at Great Bardfield, which he had discovered together with Ravilious. There Cook and Smith came into contact with a notable group of artists, illustrators and designers, among them, in addition to those already mentioned, Kenneth Rowntree and Walter Hoyle, who took as their main subject the landscape they found on their doorstep. In 1962 Smith and Cook showed their affection for the area and its art by moving to Saffron Walden, where in 1985 Cook was instrumental in helping to found the Fry Art Gallery as a permanent home for the work of the artists of Great Bardfield and the surrounding villages.

Smith's post-war photography was part of a much wider photographic contribution to the rediscovery of Britain, which has scarcely been acknowledged despite the fact that the new emphasis on the cultivation of visual appreciation boosted the medium. In the late 1920s and 1930s, thanks largely to the efforts of O.G.S. Crawford and Alexander Keiller, archaeology was revolutionized through the application of aerial photography, providing a new vision of Britain and inspiring such artists/photographers as Piper and Nash to look afresh at ancient monuments and artefacts. After the war, when the use of aerial photography became more commonplace, this fascination with the primitive translated into Smith's work. Some of the most powerful images in *Scotland* and *England* were of prehistoric sites: the cavernous dwellings of Skara Brae (see p. 94), the undulating, grassy contours of Maiden Castle (see p. 96), the dramatic majesty of Stonehenge (see p. 95). Also during the 1930s, Piper and Richards together toured Britain, seeking out its neglected architectural heritage. The results were published in a series of articles in the *Architectural Review* that were illustrated with Piper's lively, unfussy snapshots highlighting the visual delights and unselfconscious propriety of seaside architecture and such structures as lighthouses and Nonconformist chapels. These kinds of individual journeys of discovery were put on a more systematic footing with the creation of the National Buildings Record in 1941 in response to the threat posed to

the country's architecture by bombing. Charged with collecting and commissioning documentary drawings, and especially photographs, of England's endangered historic monuments, the Record was yet another example of the perceived need for a national stocktaking. For a short time the Record employed as one of its staff photographers Bill Brandt (1904–1983), who during the 1940s was spurred by the reawakened affection for the land to turn to landscape subjects. It is instructive to compare his treatment of Stonehenge, one of the great signifiers of Britain, with that of Smith. Whereas Brandt's photograph portrays the prehistoric monument, moonlit and snow-clad, as a mystical symbol of endurance and survival, Smith's image remains fully legible, dwelling on the immensity and weather-beaten surfaces of the stones.

While Smith was concentrating predominantly on ecclesiastical and domestic architecture, his fellow photographer Eric de Maré (1910–2002), his contemporary at the Architectural Association, was turning his lens on Britain's neglected industrial heritage in an extension of the subject-matter that had excited Richards and Piper before the war. Mostly commissioned by the *Architectural Review*, de Maré photographed warehouses, factories, canal buildings and other similarly anonymous but well-built industrial structures that were held to exemplify what came to be labelled 'the functional tradition'. Published in a book produced with Richards in 1958, entitled *The Functional Tradition in Early Industrial Buildings*, de Maré's fresh and well-composed images were highly influential, manifesting a feeling for texture and an ironic humour akin to Smith's, as well as a heightened sense of drama and rigour that was well-attuned to the robust detailing and the stark geometry of the buildings he depicted.

De Maré's photographs differed in one further significant respect from Smith's, demonstrating how architecture too was consumed by the debate about Britishness. They had a more purposeful agenda, being intended not merely to serve as a record but to propose 'the functional tradition', with its "forthright, spare and logical use of materials"[60], as a source of inspiration to those architects eager to rebuild Britain in a Modernist idiom. They were, therefore, part of a concerted campaign, led by the *Architectural Review*, to establish an indigenous ancestry for Modernism and thus counteract the oft-levelled accusation that it was a foreign import and, as Cook witheringly expressed it, "not just a negation of local, but of national traditions".[61] Modernists, too, were now anxious to secure the blessing of history and don the mantle of Britishness. To this end the *Architectural Review*, chiefly under the aegis of its owner Hubert de Cronin Hastings and its associate editor Pevsner, sought further native precedents that might profitably be applied to contemporary architectural practice. They thus not only championed the picturesque, which was the dominant aesthetic of Smith's photography, but also, in rebuttal of the other part of Cook's charge, encouraged Modernist architects to respect British traditions by paying increased attention to context and regional differences – the very qualities highlighted in Smith's photographs. These were also attributes stressed in one of the period's most impressive engagements with Britishness, and one that underlined the contribution of émigrés intent

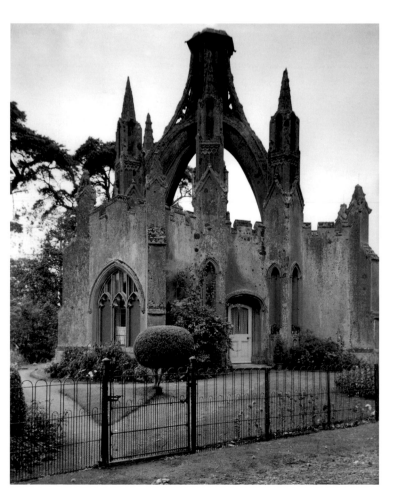

Fig. 14 Woodbridge Lodge, Rendlesham, Suffolk (1953)

on finding out more about their adopted homeland, Pevsner's magisterial *Buildings of England* series, launched in 1951. Arranged by county and with an introductory section that significantly outlined the county's particular topography, geology and vernacular building practices, these were an example of what Pevsner elsewhere referred to as an experiment in the "geography of art".[62] Although Pevsner's volumes were more analytically rigorous and visually austere than Smith's publications, in this respect at least they resonated with Smith's photography.

For Smith himself, many of the subjects he photographed during the 1950s, either for Thames & Hudson or *The Saturday Book*, were quintessentially British. Parish churches were held to "epitomize English history and the English way of life".[63] To go in quest of once-flourishing abbeys and priories was "to see England with new eyes",[64] while the landscape garden so captivatingly rendered in Smith's photographs of Stourhead (see p. 145) was hailed as "one of the most distinctly English of all aesthetic achievements".[65] Carefully selected and framed, Smith's vision of Britain was highly partial, prizing evolution rather than revolution, variety, rootedness, respect for the landscape and traditional crafts, such as the flint knapping of Essex or the thatching of Sussex, and fantasy, seen, for example, in his views of follies (fig. 14 and p. 89), which Cook characterized as "the architecture of unreason".[66] Nowhere is there any hint of the country's darker underbelly, as revealed in Nigel Henderson's photographs of Bethnal Green or Roger Mayne's of North Kensington, or even as observed but not photographically recorded by Smith:

> I had ordered a car for the day, it arrived at 9 am – a magnificent Rolls-Royce with uniformed chauffeur! We sped about Glasgow in intermittent sunshine recording the absolute essentials. Working in the Gorbals district, a kind of classical slum, I was accosted by a most kind policeman who took me on a little tour and into some of the tenements. It was a truly horrifying experience; the conditions were not so much bad as utterly evil, only a desire to produce such fantastic chaos and filth could have possibly created them, no mere neglect could have come within any distance at all.[67]

Smith instead poignantly explored another Britain. The thrill he experienced on this voyage of discovery, as well as the acute powers of observation that made him such an outstanding photographer, are vividly conveyed in a letter he wrote to Cook from Lindfield:

> The vernacular building of Sussex is adorable and in this long village street there is every variety. One begins, at the south end, with a white-paled pond and a vast village-green; then one rises slowly past shops and cottage-Banks in weather boarding or pale burnt bricks each shallow garden enclosed with long stretches of white railing or a dark cut hedge. An occasional half-timbered home, like huge heavy barges among pretty boats, and these have roofs of stone slates, thick and heavy and gradated from ridge to eaves. I had quite forgotten that Sussex had stone slates. A shingle-spired church at the top of the street round which the road bends, and around which, at various angles, are gathered the larger houses. The oldest and largest an almost impossibly romantic crucked and crooked Elizabethan Manor. Tall narrow bays in brick and timber of almost the same colour & texture. Close by a mid-Georgian mansion with a bust, seemingly of Shakespeare, in the broken pediment of the door case, across which a small-flowering plant has climbed and obscures the eyes. Opposite, another, in black mathematical tiles with large white

windows set flush with its face – a perfect example. Then an earlier Georgian house, all fat sash windows, with heavy bars, separated by mere seams of brick; a carved door-case with a shallow bay window above. Farther on, where the road begins to descend again into the country, a type of Parsonage: plastered medieval bones, with Georgian windows inserted, thin black painted bars with the top pane of each sash boldly painted. A fat curving bay similarly paned through which one could see a deep medieval fireplace.

Behind this lovely street there is a certain 'development' on the west side large houses much sunk in foliage of Edwardian and early 20's. On the east of the 50's and 60's. But from top to bottom there are no wires but those of cotton-thin telephone issuing from very discreetly placed poles. Perhaps in bolder light and at another hour I might rate it lower, but this evening there was perhaps no more than 5% of the total that one had to disregard – to make allowances for. It was like a romantic dream of the Sussex of our Grand-fathers and though it may well seem a caricature to-morrow it had a very magic reality this evening.[68]

As Cook later observed of Smith's photographs, "They are themselves an expression of Englishness, for they reflect an essentially English mind, an English way of thinking and feeling about every subject."[69] It remained to be seen how this typically English sensibility would adjust to the task of photographing the foreign subjects he was increasingly commissioned to tackle during the next decade.

1 Ralph Mayer, *The Artist's Handbook of Material and Techniques*, ed. Edwin Smith, London (Faber & Faber) 1951.
2 Quoted in letter from Nigel Nicolson to Edwin Smith, London, 23 February 1960 (Olive Cook Papers, Newnham College Archives, Cambridge, Box 34 6/3/10).
3 As revealed in Daniel Snowman, *The Hitler Emigrés: The Cultural Impact on Britain of Refugees from Nazism*, London (Pimlico) 2003, p. 244.
4 *Architectural Review*, vol. 101, January 1947, p. 25.
5 The book was intended to be part of a series called *Introductions to Architecture*, under the general editorship of Hugh Casson. Smith's text greatly exceeded the designated length and remained unpublished, although it was announced and others in the series did appear (Olive Cook Papers, Newnham College Archives, Cambridge, Box 32 6/3/2).
6 Nikolaus Pevsner, *Ruskin and Viollet-Le-Duc: Englishness and Frenchness in the Appreciation of Gothic Architecture*, London (Thames & Hudson) 1969, p. 5.
7 John Betjeman, *First and Last Loves*, London (John Murray) 1952, p. 179.
8 Edwin Smith, 'On Photographing Cathedrals and Parish Churches', in Olive Cook, *English Parish Churches*, rev. edn (World of Art series), London (Thames & Hudson) 1976, p. 7.
9 Graham Hutton, *English Parish Churches*, London (Thames & Hudson) 1952, p. 5.
10 John Ruskin, *The Works of John Ruskin*, ed. E.T. Cook and A. Wedderburn, vol. 3, London (George Allen) 1903–12, p. 210.
11 W.H. Fox Talbot, *The Pencil of Nature*, London (Longman Brown Green & Longman) 1844, caption to plate i.
12 John Betjeman, *Church Poems*, London (John Murray) 1981, p. 7.
13 The logbooks record only the exposures Smith made using his larger-format cameras. They do not record those he made using his Autorange 820 hand camera.
14 Smith 1976, p. 6.
15 *Ibid.*, p. 7.
16 John Lewis and Edwin Smith, *The Graphic Reproduction and Photography of Works of Art*, London (W.S. Cowell) 1969, p. 96.
17 *Ibid.*, p. 132.
18 'Recollections by His Friends: Leonard Russell', in *Aspects of the Art of Edwin Smith*, exhib. cat., Colchester, The Minories, 1974, p. [6].
19 Lewis and Smith 1969, p. 141.
20 A much-revised edition with many different photographs appeared in 1967 in Thames & Hudson's World of Art series.
21 Olive Cook, *English Cottages and Farmhouses*, London (Thames & Hudson) 1954, p. 8.

22 *Ibid.*, p. 7.
23 *Ibid.*, p. 9.
24 *Ibid.*, p. 8.
25 *Ibid.*, p. 9.
26 *Ibid.*, pp. 15–16.
27 Quoted in Keith Thomas, 'Introduction', in W.G. Hoskins, *The Making of the English Landscape*, London (Folio Society) 2005, p. xvi.
28 *Agricultural History Review*, vol. 3, 1955, p. 51.
29 *Daily Telegraph & Morning Post*, 23 August 1954.
30 Conversation with the author.
31 *Architectural Review*, vol. 73, June 1946, pp. 159–60.
32 *Daily Telegraph & Morning Post*, 23 August 1954.
33 Cf. "I am not a fair weather photographer". Letter from Edwin Smith to Leonard Russell, 12 August 1965 (Olive Cook Papers, Newnham College Archives, Cambridge, Box 34 6/3/9).
34 Letter from Edwin Smith to Olive Cook, Bomarzo, 8 May [year unknown] (Edwin Smith Collection, RIBA British Architectural Library Photographs Collection).
35 Geoffrey Grigson, *England*, London (Thames & Hudson) 1957, p. 29.
36 In correspondence with Peter Brown, for example, Cook reveals that Smith did not know the work of Thomas Keith but asserts that, had he done so, he would have loved the early Scottish photographer's deeply romantic images. I am grateful to Peter Brown for showing me this correspondence.
37 William Gilpin, *Three Essays*, London 1792, p. 46.
38 *Photographic News*, vol. 3, 10 February 1860, p. 266.
39 *The Amateur Photographer*, vol. 40, 8 November 1904, p. 367.
40 *Camera Work*, no. 4, 1903, p. 25.
41 Quoted in Beaumont Newhall, *Frederick H. Evans* (Image Monograph no. 1), Rochester, NY (George Eastman House) 1954, p. 41.
42 Cf. *Record and Revelation: Photographs by Edwin Smith*, exhib. cat., York, Impressions Gallery of Photography, 1983.
43 Richard Ingrams and John Piper, *Piper's Places: John Piper in England and Wales*, London (Chatto & Windus/The Hogarth Press) 1983, p. 46. J. Dixon-Scott was a popular topographical photographer who, for example, illustrated *England Under Trust: The Principal Properties Held by the National Trust* (1937).
44 Ingrams and Piper 1983, p. 46.
45 Undated typescript synopsis of *England* (Olive Cook Papers, Newnham College Archives, Cambridge).
46 Quoted in William and Mary Howitt, 'Preface', in *Ruined Abbeys and Castles of Great Britain*, London (Bennett) 1862.

47 Letter from Edwin Smith to Eva Neurath, London, 4 August 1955 (Olive Cook Papers, Newnham College Archives, Cambridge, Box 31 6/1/1).
48 *The Studio*, vol. 132, November 1946, p. 148.
49 Quoted in *A Paradise Lost: The Neo-Romantic Imagination in Britain 1935–55*, ed. David Mellor, exhib. cat., London (Lund Humphries in association with the Barbican Art Gallery) 1987, p. 110.
50 Opening line of poem in the collection, *Look, Stranger!*, London (Faber & Faber) 1936.
51 Song by Ross Parker and Hughie Charles, 1939.
52 See Nannette Aldred, 'A Canterbury Tale: Powell and Pressburger's Film Fantasies of Britain', in *A Paradise Lost* 1987, pp. 117–24.
53 For an excellent analysis of this myth, see Angus Calder, *The Myth of the Blitz*, London (Pimlico) 1991.
54 Aldred 1987, p. 118.
55 Michael Balcon, *Michael Balcon: Balcon Presents … A Lifetime of Films*, London (Weidenfeld & Nicolson) 1971, p. 61.
56 Cook was also the illustrations editor for C.W. Ceram, *Archaeology of the Cinema*, London (Thames & Hudson) 1965.
57 J.B. Priestley, 'The Beauty of England', in *The Beauty of Britain: A Pictorial Survey*, London (Batsford) 1935, p. 8.
58 *Architectural Review*, vol. 107, April 1950, p. 276.
59 *Sunday Times*, 1962, quoted in Ingrams and Piper 1983, p. [9].
60 Eric de Maré, *The Canals of England*, London (Architectural Press) 1950, p. 42.
61 Olive Cook, *The English House through Seven Centuries*, London (Nelson) 1968, p. 311.
62 Nikolaus Pevsner, *The Englishness of English Art*, London (British Broadcasting Corporation) 1955, p. 3.
63 Hutton 1952, p. 5.
64 Olive Cook, *English Abbeys and Priories*, London (Thames & Hudson) 1960, p. 5.
65 Essay by Cook in *Aspects of Englishness – Part 1: Photographs by Edwin Smith*, exhib. cat., London, House, 62 Regents Park Road, 1979.
66 See Olive Cook and Edwin Smith, 'Follies', *The Saturday Book 19*, London (Hutchinson) 1959, pp. 65–75.
67 Letter from Edwin Smith to Olive Cook, Ayr, 20 May 1954 (Edwin Smith Collection, RIBA British Architectural Library Photographs Collection).
68 Letter from Edwin Smith to Olive Cook, Lindfield, 21 May [1963] (Edwin Smith Collection, RIBA British Architectural Library Photographs Collection).
69 Essay by Cook in *Aspects of Englishness – Part 1*, 1979.

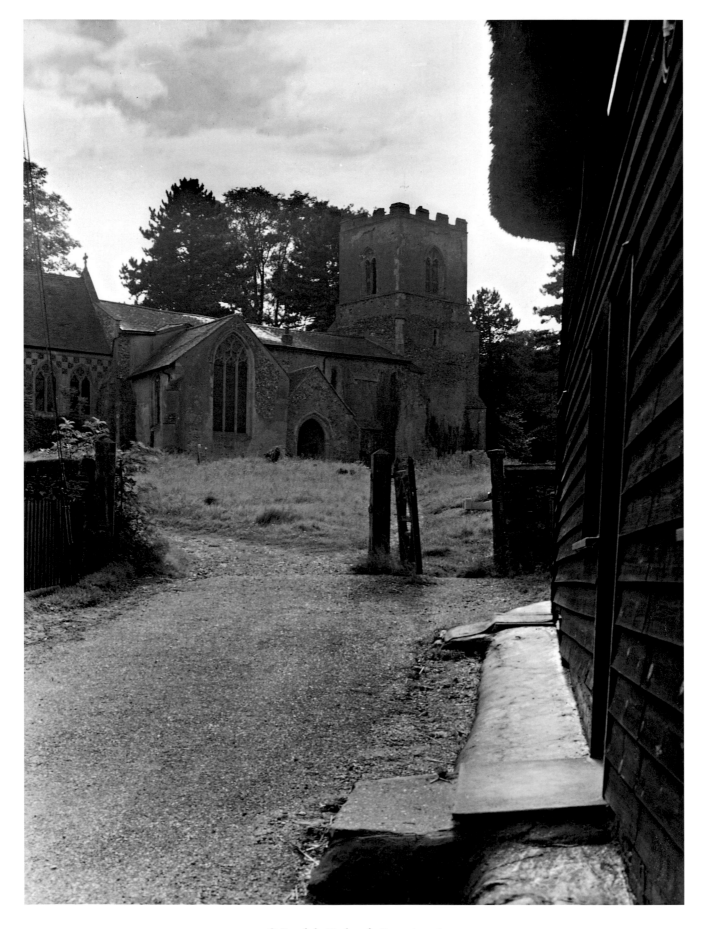

St Botolph, Hadstock, Essex (1950)

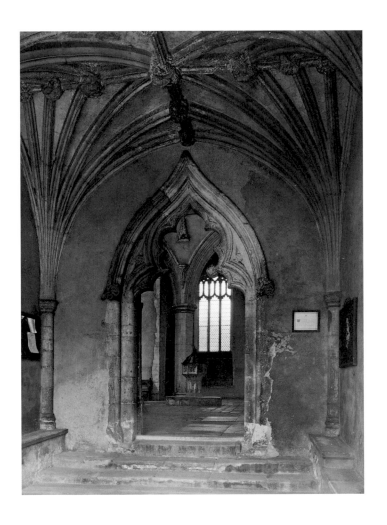

St Margaret's, Cley-next-the-Sea, Norfolk (1951)

St Lawrence, Bradford-on-Avon, Wiltshire (1950)

Monte Allegro, Sicily (1954) Funeral car, Agrigento, Sicily (1954)

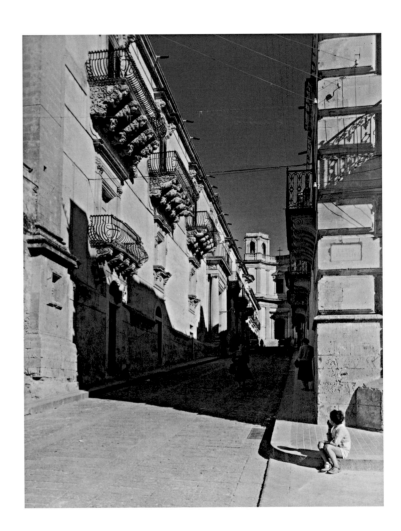

Agrigento, Sicily (1951)

Palazzo Nicolaci (Villadorata), Noto, Sicily (1954)

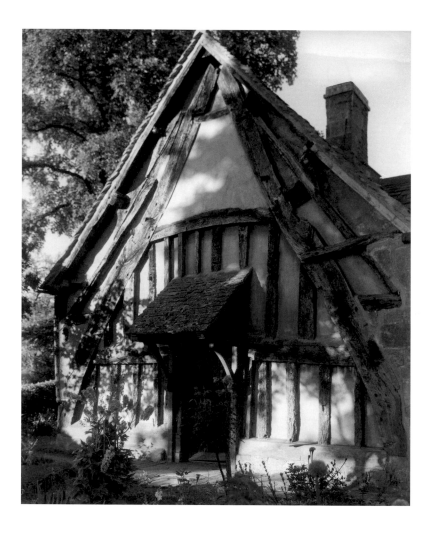

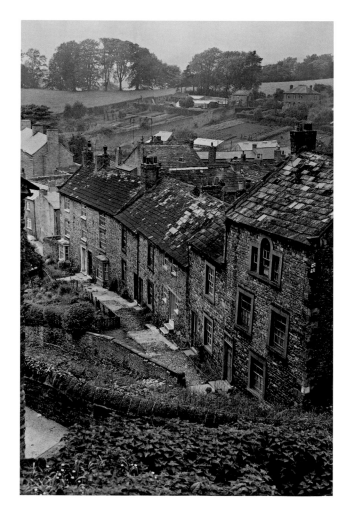

Cottage, Didbrook, Gloucestershire (1953)

Cottages, Richmond, North Yorkshire (1953)

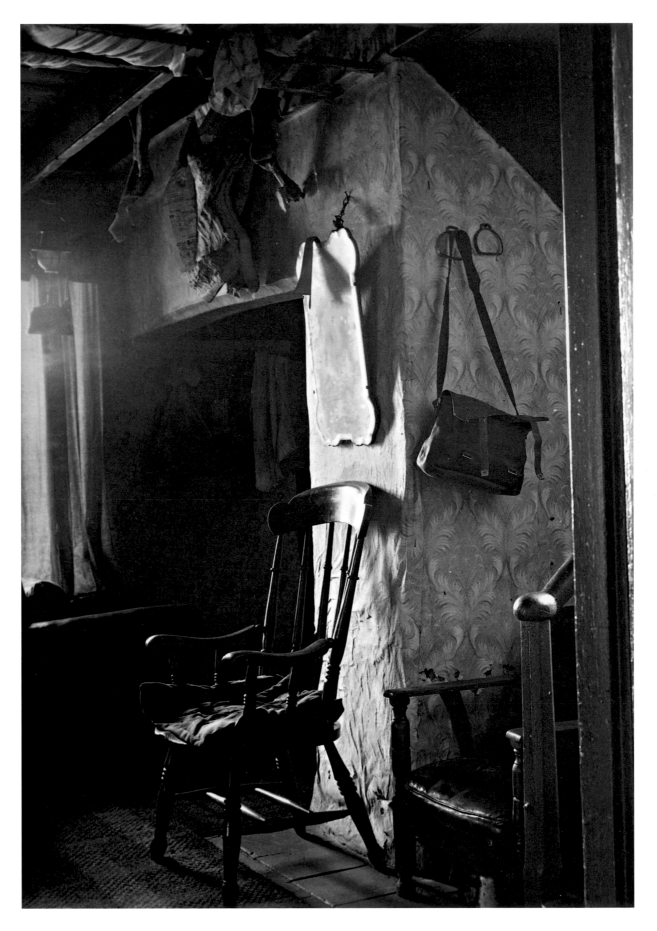

Cottage, Trefgarn, Pembrokeshire (1953)

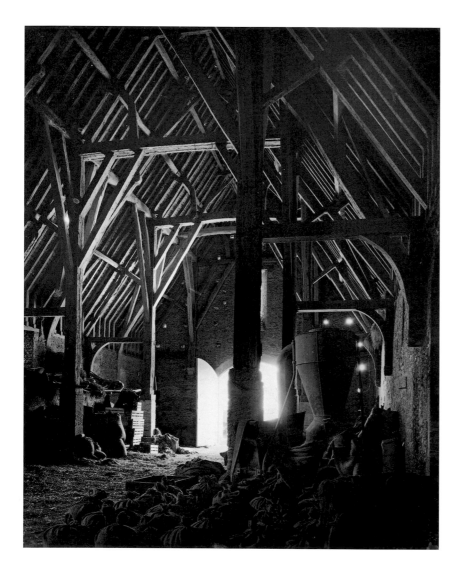

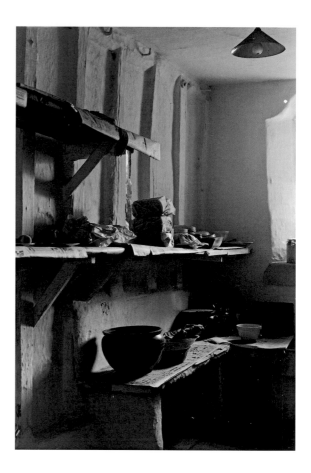

Harthill Hall Farm, Alport, Derbyshire (1953)

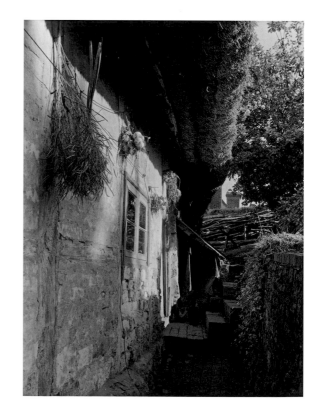

Tithe barn, Great Coxwell, Berkshire (1953)

Cottage, Selborne, Hampshire (1953)

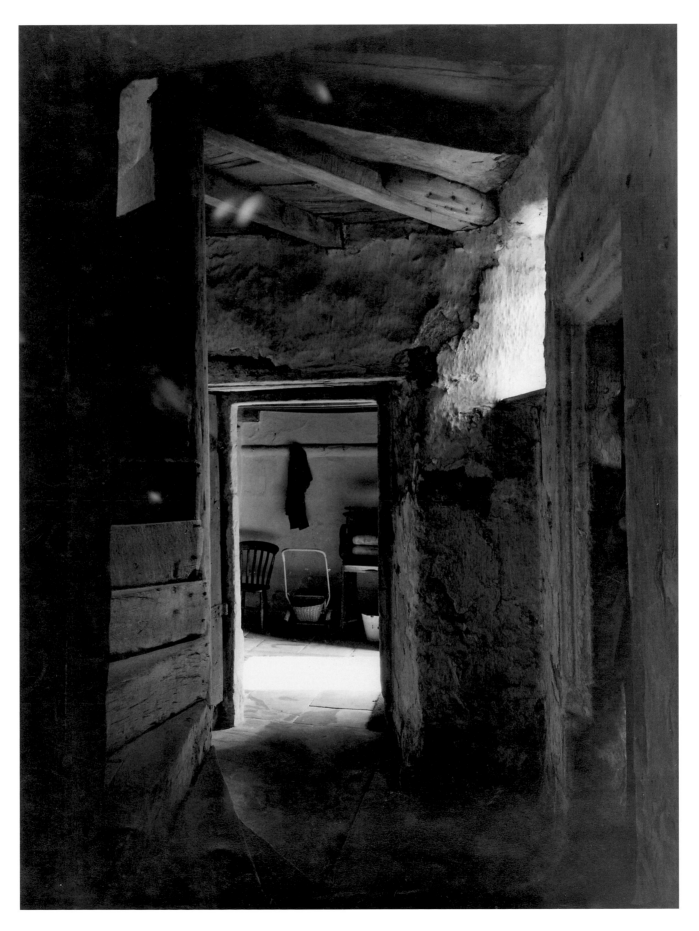

North Lees Hall, Hathersage, Derbyshire (1953)

James Court, Edinburgh (1954)

St Michael's Churchyard, Dumfries (1954)

Edinburgh (1954)

Tarbert, Harris, Outer Hebrides (1954)

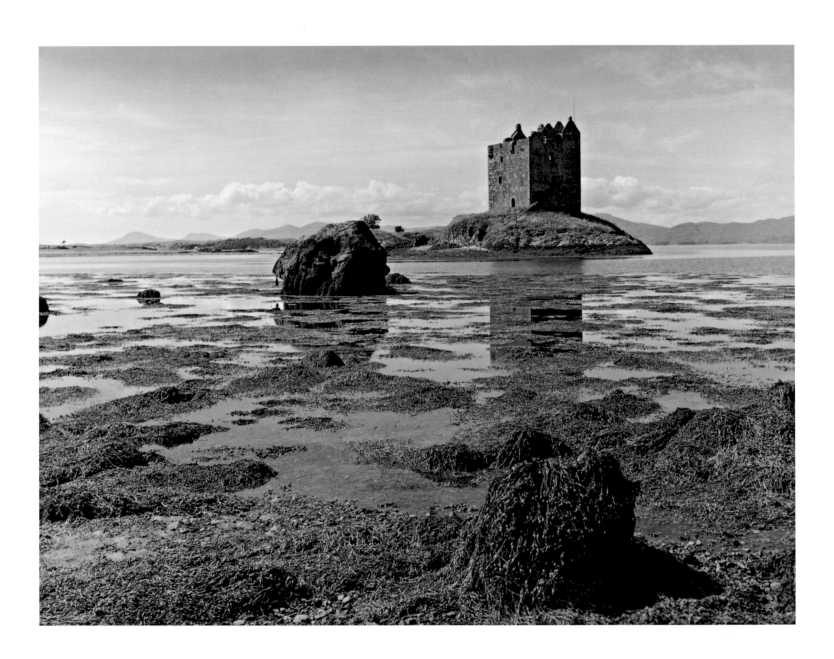

Castle Stalker, Loch Laich, Appin, Argyllshire (1954)

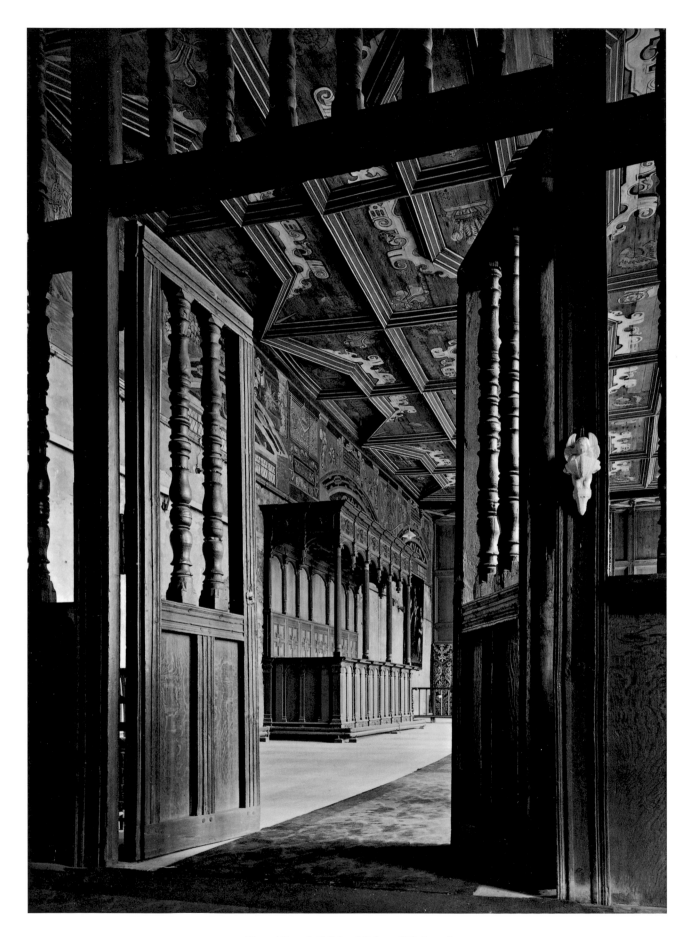

Chapel Royal, Falkland Palace, Fife (1954)

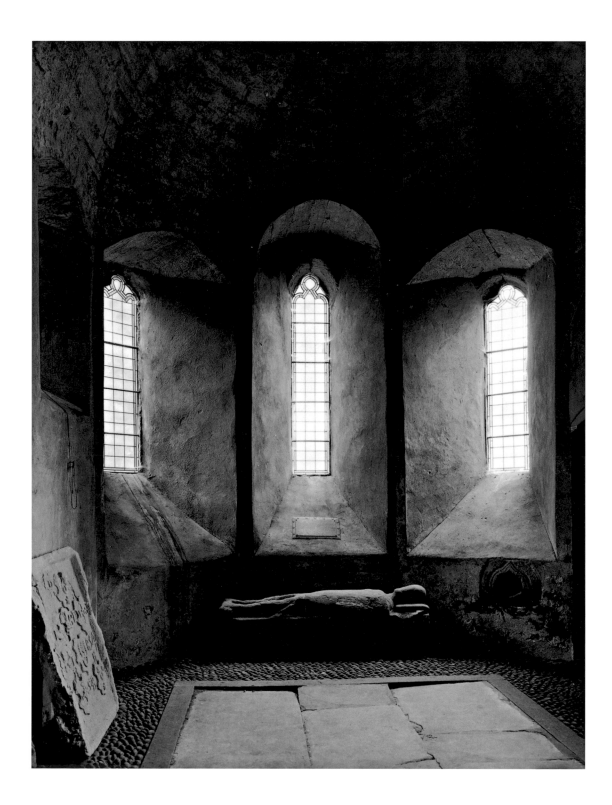

St Ternan, Arbuthnott, Kincardineshire (1954)

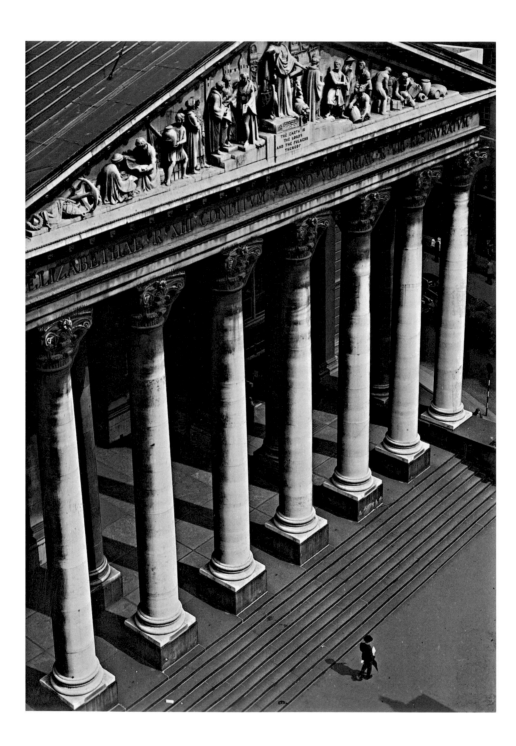

Royal Exchange, London (1957)

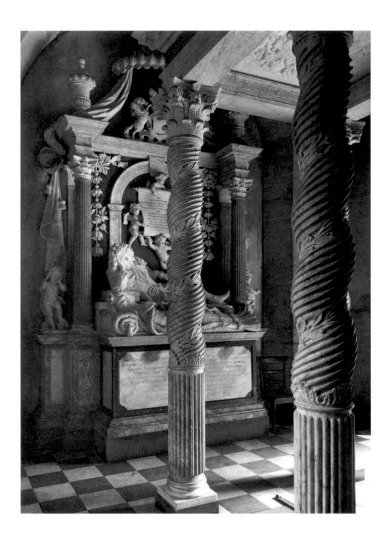

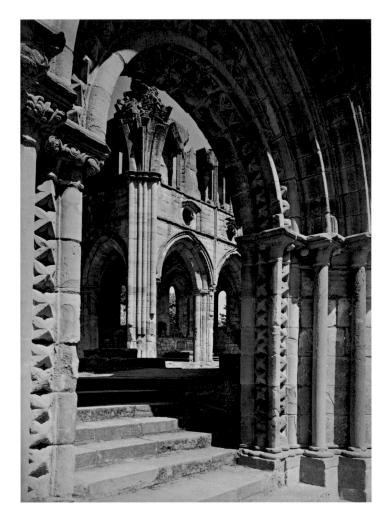

Monument to the 2nd Duke of Queensberry and his wife,
Durisdeer Parish Church, Dumfriesshire (1954)

Dryburgh Abbey, near Melrose, Roxburghshire (1954)

82 Detail of choir stall, St George's Chapel, Windsor (1958)

Seated figure of Sennefer, Thebes (*c.* 1500 BC)
in the British Museum, London (1955)

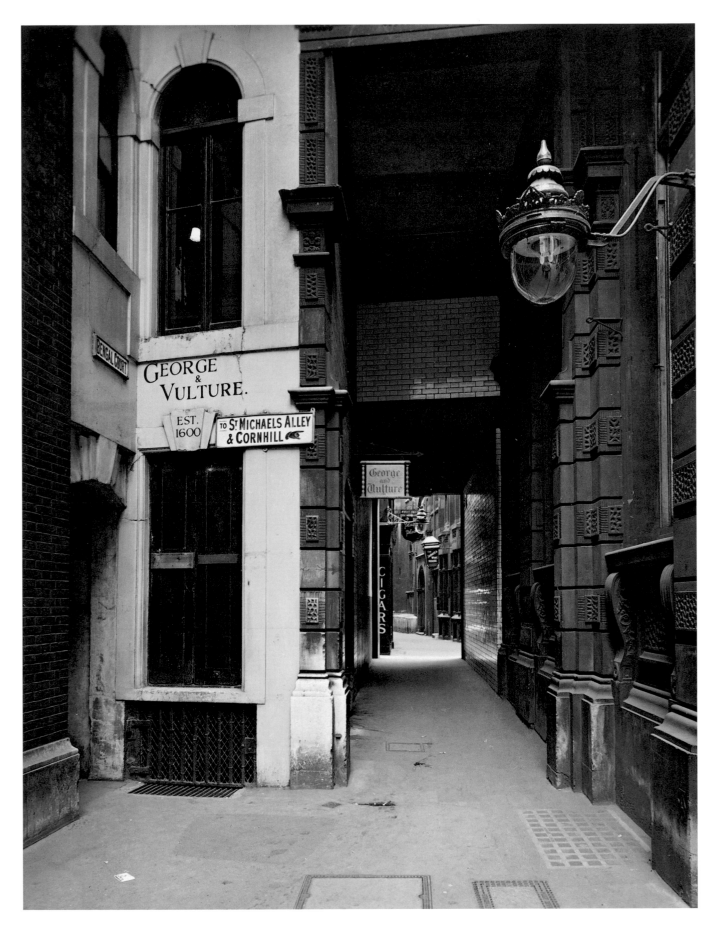

Bengal Court, City of London (1957)

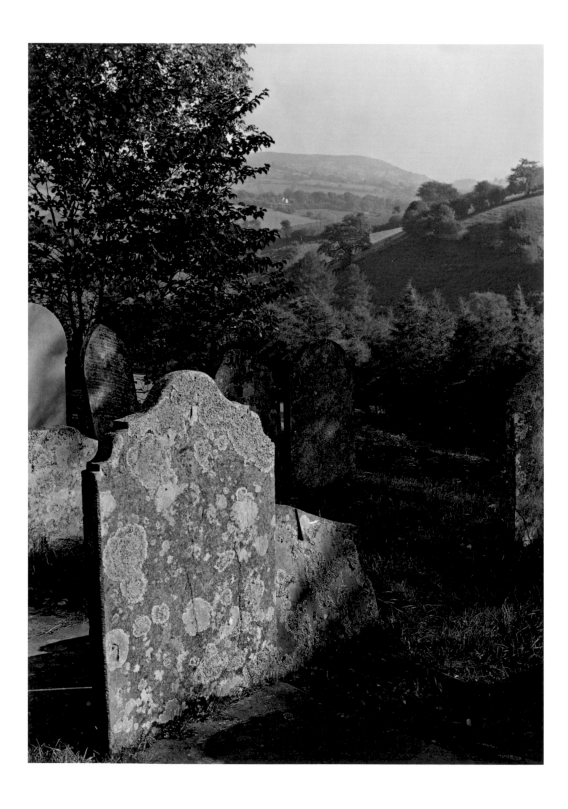

Churchyard of St Ishow, Partrishow, Breconshire (1957)

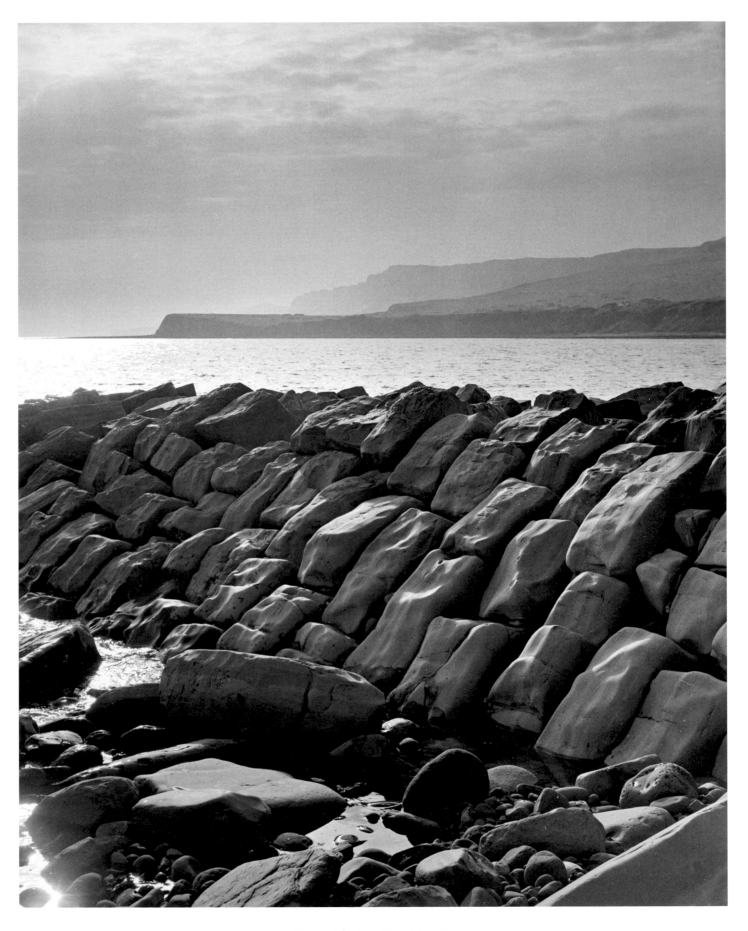

Kimmeridge Bay, Dorset (1956)

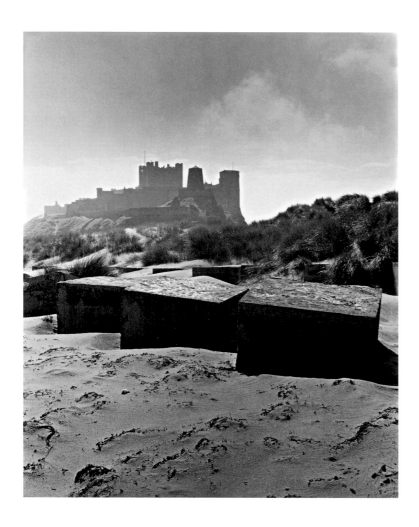

Bamburgh Castle, Northumberland (1957)

King's Lynn, Norfolk (1956)

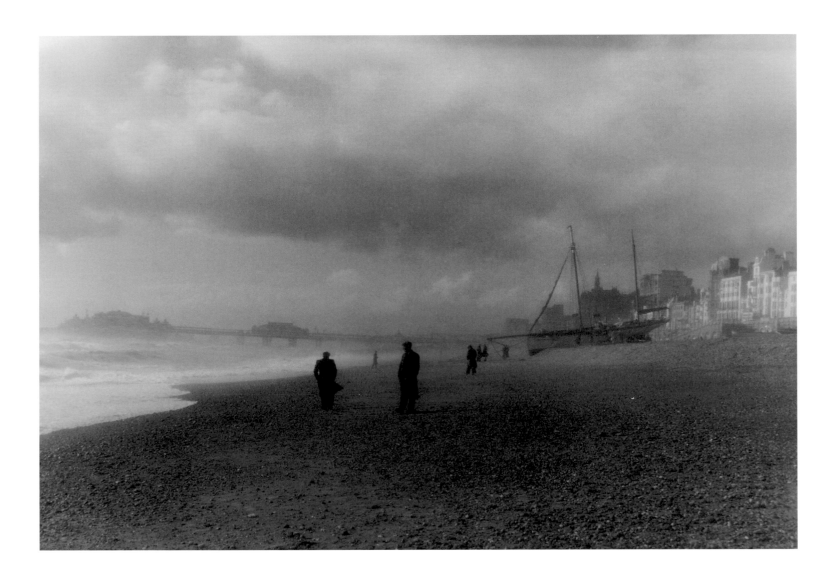

Brighton beach (1952)

Hardwick Hall, Derbyshire (1956)

Gates, Hardwick House Park, Bury St Edmunds, Suffolk (1955)

Shobdon Arches, Herefordshire (1959)

Peterstone farmhouse, Burnham Overy, Norfolk (1958)

Chinese Tea Room, Claydon House,
Buckinghamshire (1959)

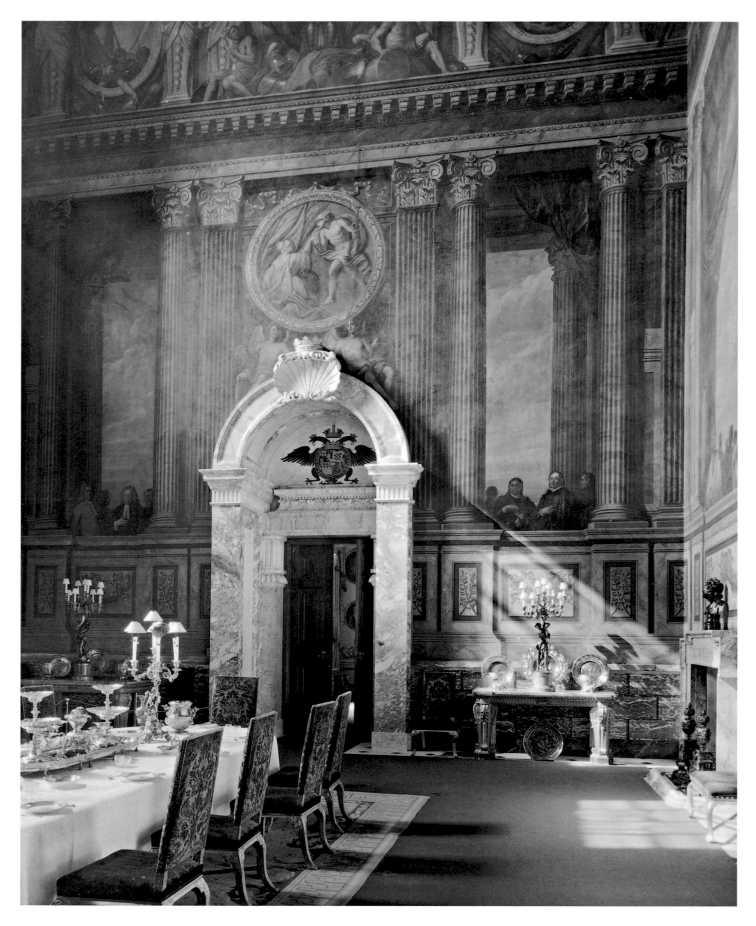

Saloon, Blenheim Palace, Oxfordshire (1959)

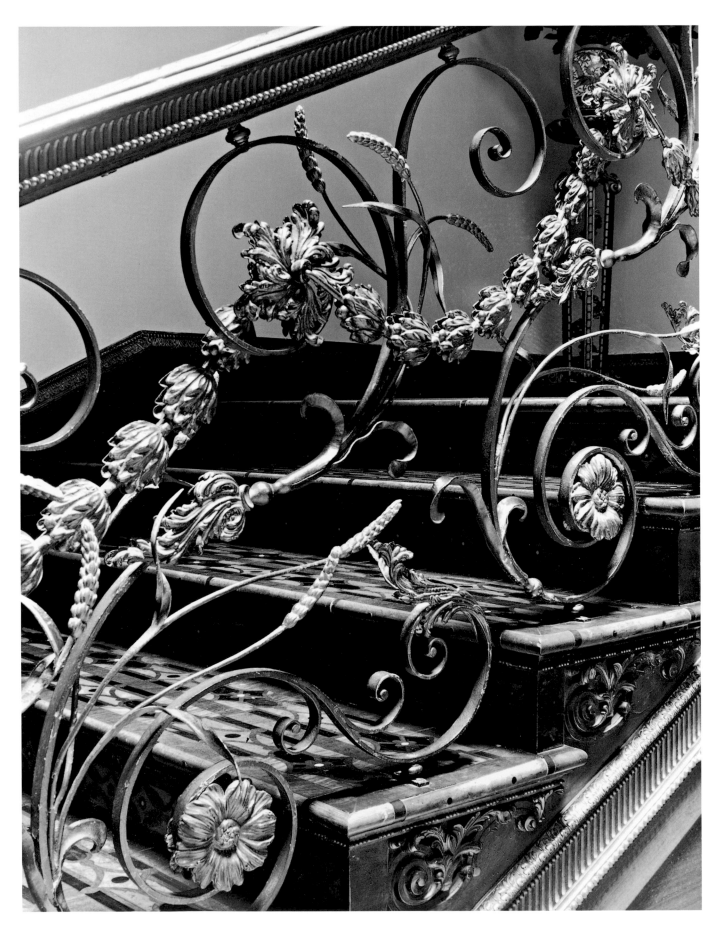

Staircase, Claydon House, Buckinghamshire (1959)

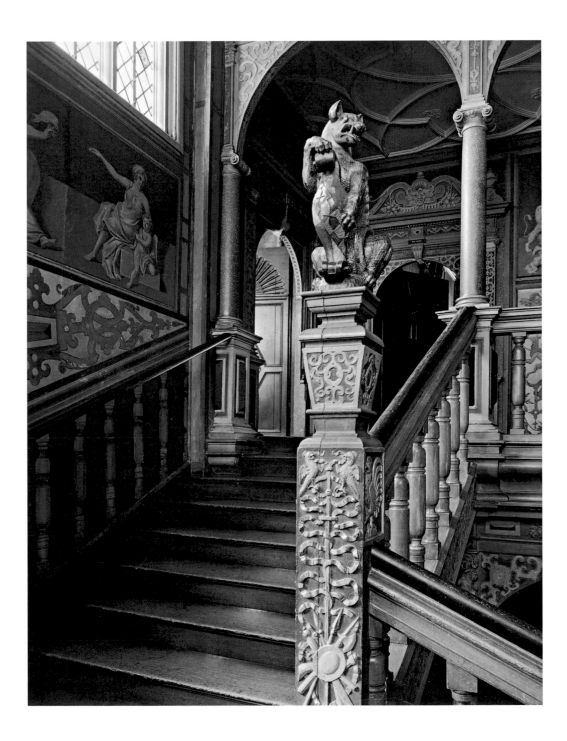

The Great Staircase, Knole, Kent (1959)

Skara Brae, Orkney (1954)

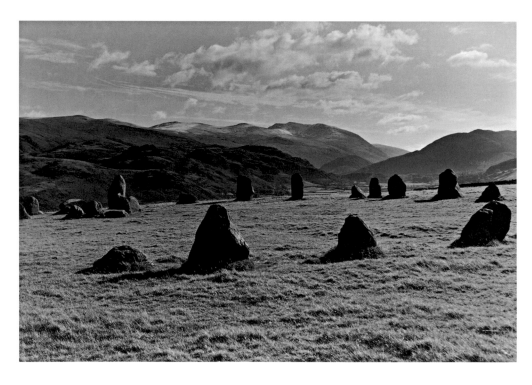

The Keswick Carles, Keswick, Cumberland (1956)

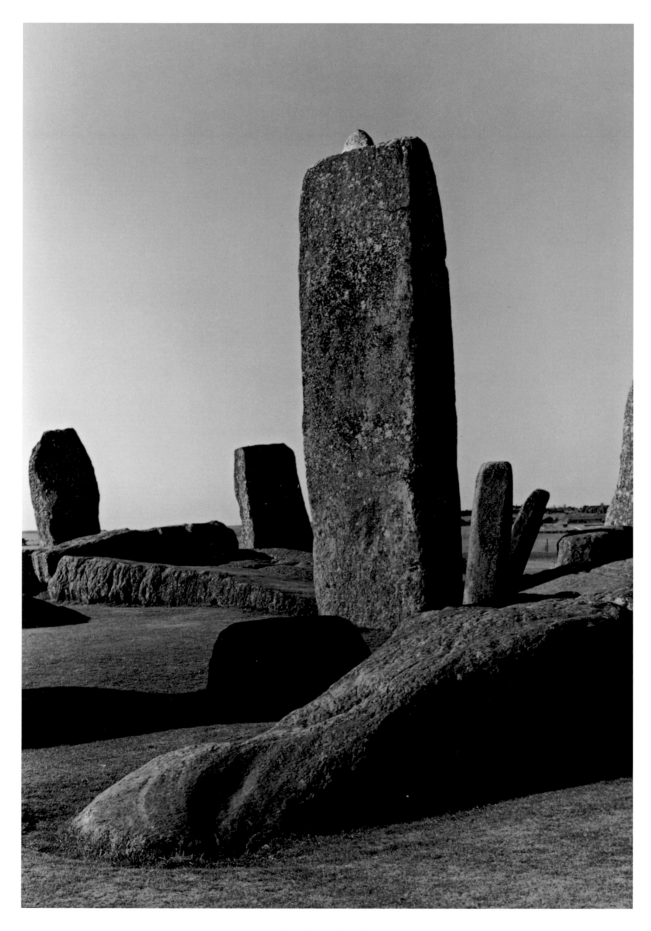

Stonehenge (1956)

Maiden Castle, Dorset (1956)

Wastwater below Scafell, Cumberland (1956)

'Roman Bank' and irrigation channel at Leverton,
Holland, Lincolnshire (1956)

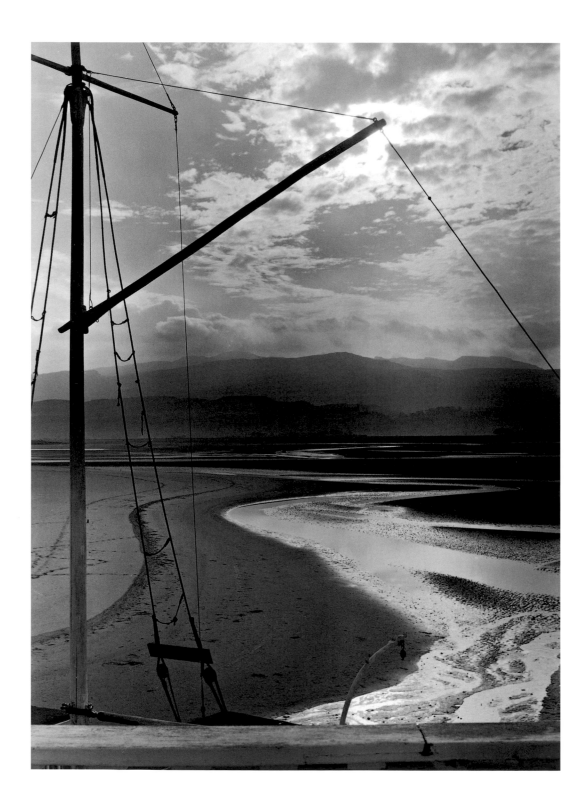

Estuary, Portmeirion, Merionethshire (1959)

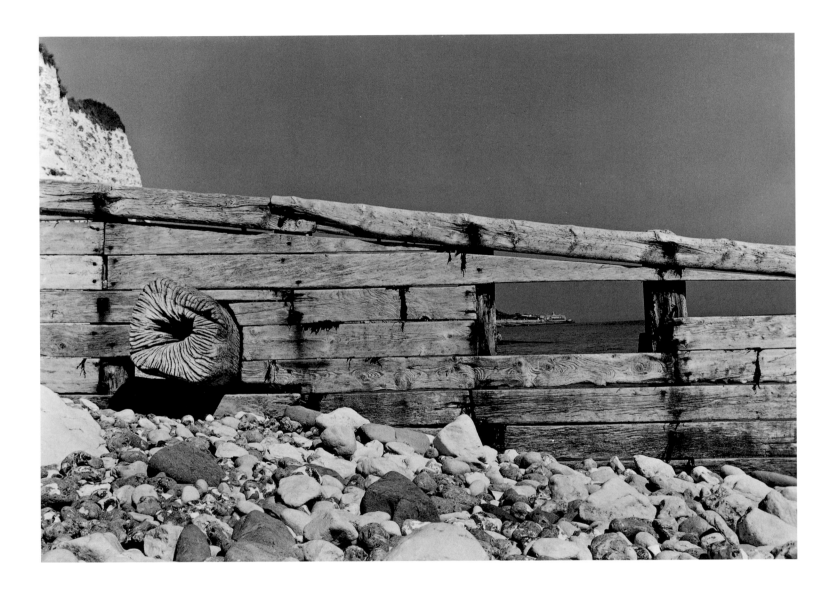

Beach, Eastbourne, Sussex (1955)

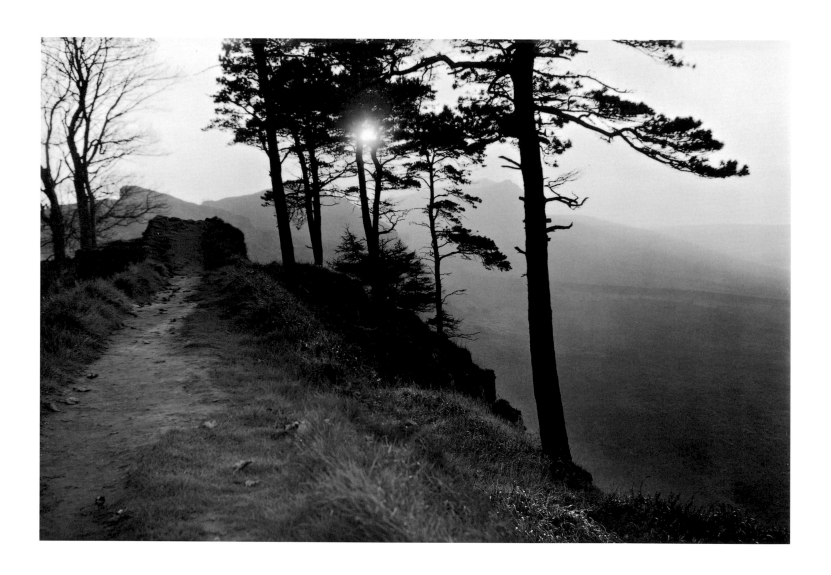

On Hadrian's Wall west of Housesteads, Northumberland (1956)

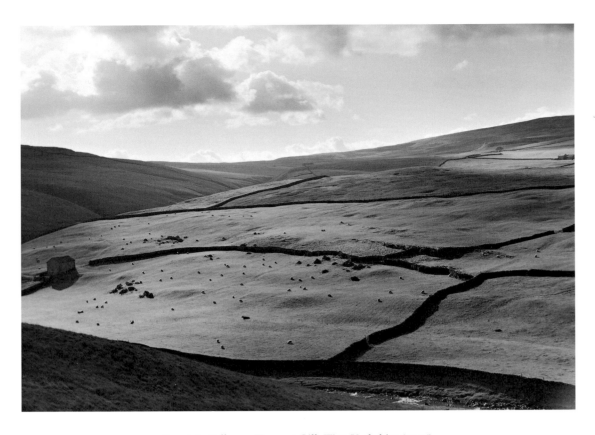

Fountain Fell near Tennant Gill, West Yorkshire (1956)

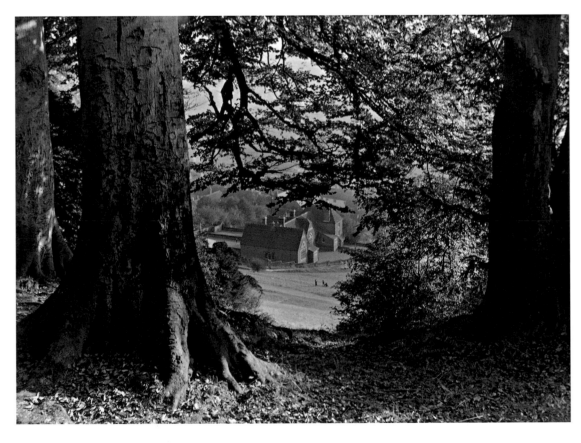

Village school, West Wycombe, Buckinghamshire (1955)

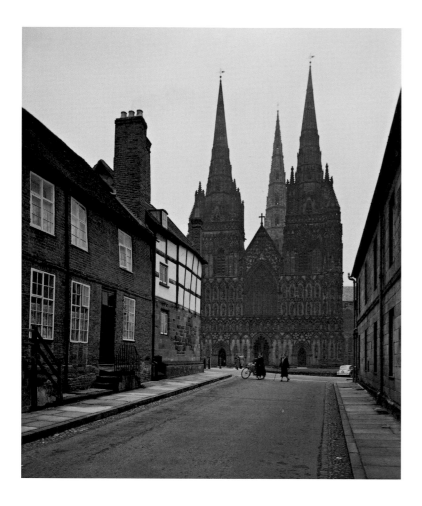

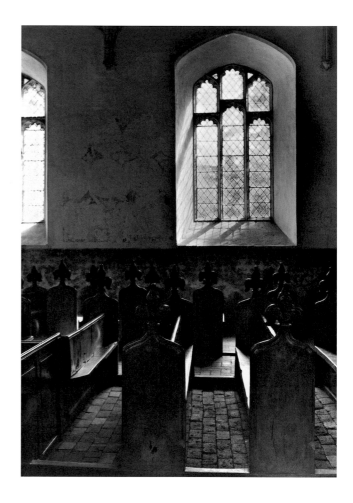

Lichfield Cathedral, Staffordshire (1956)

St Andrew, Westhall, Suffolk (1959)

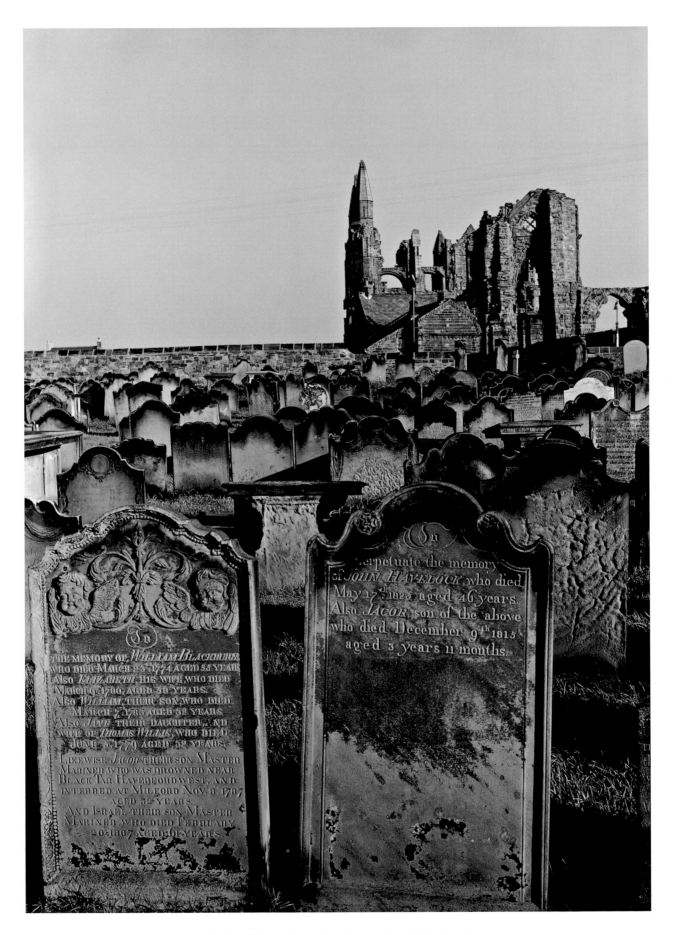

Whitby Abbey and churchyard, North Yorkshire (1956)

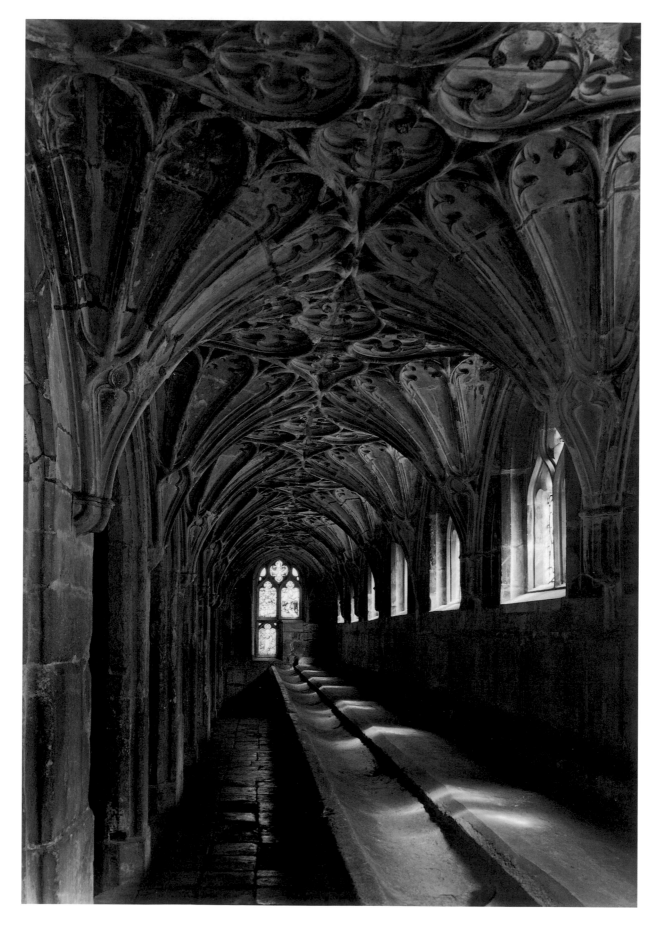

Monks' lavatorium, cloisters, Gloucester Cathedral (1958)

Triangular Bridge, Crowland, Lincolnshire (1958)

Christ entering the house of Martha and Mary, detail from the
south choir aisle, Chichester Cathedral, Sussex (1958)

'Ideal' fish and chip shop, London (1958)

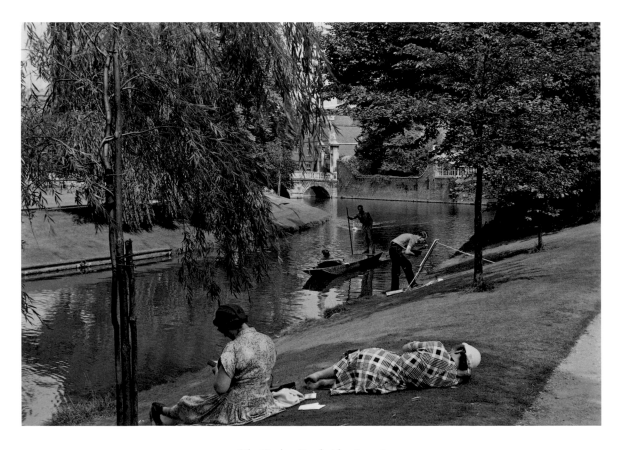

The Backs, Cambridge (1955)

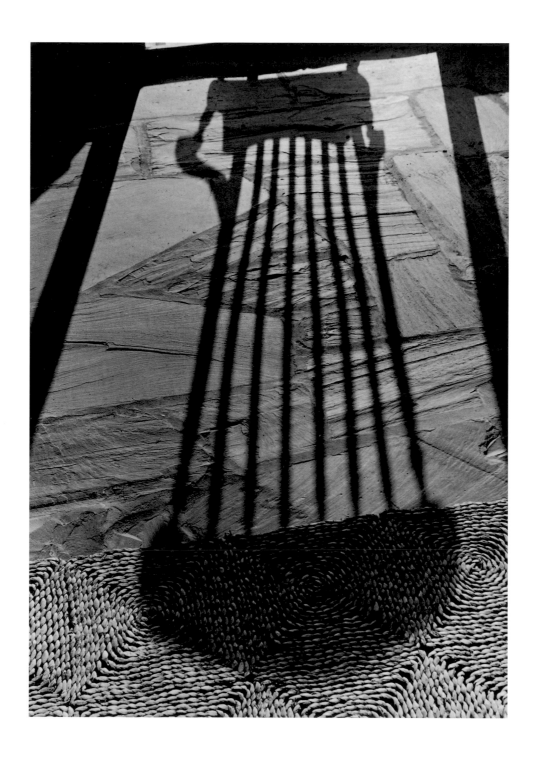

Shadow of a chair in a cottage, Beudy Newydd, Wales (1958)

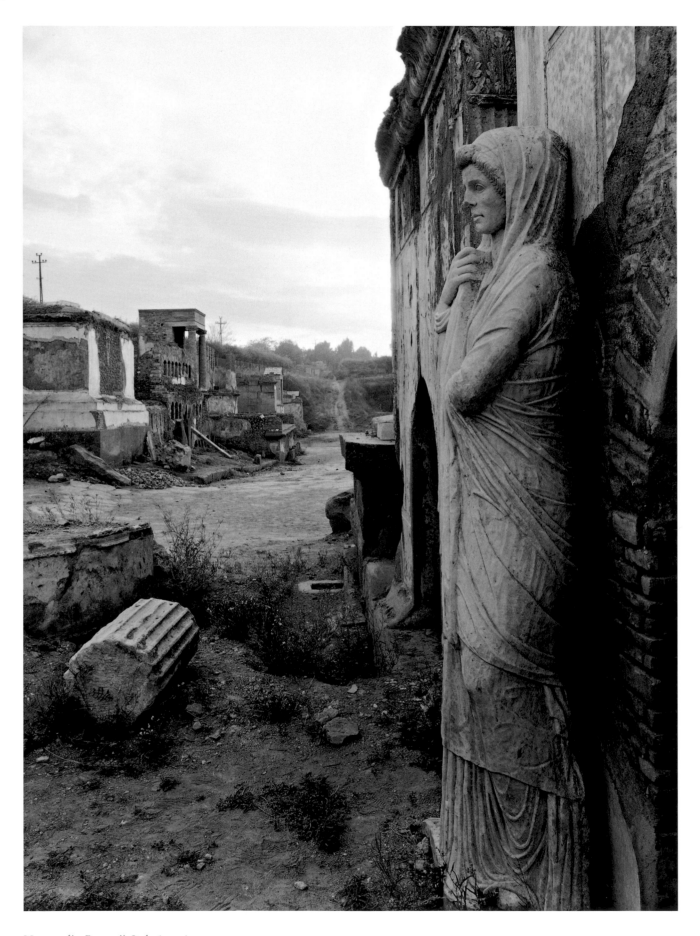

Necropolis, Pompeii, Italy (1959)

CHAPTER 3
DISCOVERING ABROAD

In a lecture given in Bristol in 1970, a year before his death, Smith finally conceded that he was a photographer. This belated admission came at the end of his most productive decade, when, following the success of his books for Thames & Hudson, his imagery was in almost constant demand from a greatly extended range of publishers, including Weidenfeld & Nicolson, Paul Elek and Batsford, eager to commission new work or to exploit his existing stock. In addition his photographs now reached a mass market through their translation into a prestigious and highly acclaimed series of art postcards issued by Gordon Fraser. As a result Smith became very much the peripatetic photographer, required to travel extensively throughout Europe and to interpret new buildings and landscapes. At home his horizons similarly broadened to encompass a more active participation in conservation, and a deeper and richer photographic engagement with landscape.

This expanded vision engendered no radical changes in Smith's photographic technique but rather a refinement of the approach he had successfully formulated the decade previously. Characteristically he remained resolutely aloof from the changes, such as a greater use of colour and the rise of a more hard-edged school of photography, that were transforming the medium during the 1960s. While, in a Britain riven by social and political unrest, what John Donat termed Smith's "patient observations of an unmoving world"[1] may have appeared increasingly anachronistic, the stream of books to which he contributed the majority of the photographs from 1960 to 1971, together with those produced previously for Thames & Hudson, were instrumental in changing people's perceptions of the world around them. In an era when the photographer was hailed as "the darling of the arts",[2] with such lensmen as David Bailey achieving celebrity status and the film director Michelangelo Antonioni making a photographer the protagonist of his *Blow-Up* (1966), Smith unassumingly consolidated his reputation as one of Britain's most perceptive and responsive photographers whose books, in the words of author and friend Norman Scarfe, "opened the eyes of a generation".[3]

Although, when finally confronted with the subjects he had been requested to photograph, Smith was often enthralled and always devoted himself to achieving the best possible results, he was a reluctant traveller. This ambivalence emerges strongly from the copious letters he wrote from abroad to Cook and others. In their scenic descriptions, these possess the sharp, vivid quality of Emile Zola's realist novels or, to use a photographic analogy, of collodion glass plate negatives, but they are also full of complaints about poor food, noisy hotels, insensitive tourists and above all pettifogging bureaucracy. Frequently Smith's tight schedule was undermined by "pig-headed custodians",[4] although persistence could yield unexpected rewards:

The Vatican experience was tedious. I succeeded in gaining entry by bullying and bribing but thought it best to conceal my purpose and camera in case further difficulties were made – which turned out to be wisdom. I was quite alone, except for an

occasional priest behaving as one expects priests in gardens to behave (– reading a book), and an occasional gardener. I worked discreetly, without a tripod of course, and quickly. A stuccoed garden pavillion with a loggia is the central feature and the sole distinction, otherwise there are only winding paths among grass and trees. But the excitement is the imminence of the great dome which is wonderfully impressive from the garden. From the Piazza it sits too far behind the slab of the entrance facade. But from the back it soars up to immensity and one has to cry bravo from its sheer size.[5]

Smith's love of home was also revealed in his letters by the frequency with which Continental examples were weighed in the balance, sometimes favourably, sometimes not, against English equivalents, as in this verdict on Venetian churches: "Not one of them is as good as a first rate English parish church, for all their dark and shiny Titians and Tintorettos, Torcello excepted of course, but this in its sweet white simplicity is very like an English church."[6]

On account of its greater portability, the Ensign Autorange 820 with its Ross Xpres lens, which he had acquired in the 1940s, was the camera Smith used the most on his travels. Although this could take either eight 6 × 9 cm pictures or twelve 6 × 6 cm pictures on either 120 or 620 roll film, Smith never used the square format, perhaps because he considered it inimical to the proportions generally encountered in architecture. It was only in the last year of his life that he found it necessary to purchase a more modern, second-hand Linhof. For Smith, 'co-operating with the inevitable' went beyond his approach to his subject-matter to embrace what he termed a passive rather than an assertive attitude towards his camera. The latter, more ruthless stance began "with a strong idea of the end in view and adapts or forces the tool towards it", while the former "demanding sensitivity to the nature of the instrument and an awareness of the conditions under which it will operate sweetly and without undue pressure has subtler possibilities".[7] Even in situations where the camera had to be hand-held, Smith was able to exploit these "subtler possibilities" by his fortunate possession of an extremely steady hand. A friend marvelled at Smith's intensity when photographing: "it was like looking at another man; his face wore a stern, rapt look, he preserved a total silence; his concentration reminded one of the top when it is spinning so hard, it appears to be motionless".[8]

When working on *England*, time constraints had occasionally led Smith to print his negatives on the spot, as he disclosed in a letter written from Leeds:

> Despite commencing as soon as I arrived on Monday I have only completed 150 negatives in the 2½ days, I do indeed make a print every five minutes, to the astonishment of my fellow shadows and the acute dismay of the young girl who must wash and glaze them, but of some of the negatives I must make two prints, and of a few three prints, before I get one that is satisfactory.[9]

When venturing further afield, however, Smith waited until he returned home to process his plates and films, perversely enjoying the "'gorgeous' risk"[10] of discovering how good the results were when it was too late to rectify any misjudgements. This method of working was diametrically opposed to that of his namesake, the American architectural and travel photographer G.E. Kidder Smith, who was the archetypal photographer 'on the run', employing local laboratories for his processing.

Usually on these trips Smith would set out armed with a list of subjects to be photographed supplied by the author and accompanied on occasion by the author's

suggestions of viewpoints, many of which proved "ridiculously unpictorial".[11] Nor did Smith welcome the presence of the author on a photographic shoot, where he liked to be in control and exercise his own judgement. "I have to admit", he revealed, "that I have never really been helped by meeting an author. His list is what I need, conditions on the site and one's own sensitivity are then the only controlling factors."[12] Especially in major tourist areas Smith preferred to work early in the morning or late in the evening to avoid the crowds. The magic of these occasions, when he could commune alone with a majestic work of architecture or a glorious landscape, reverberates throughout his correspondence. One such epiphany came at Pompeii, which he had initially found disappointing: "It is excessively tourist-trodden, dusty and obvious with too little mystery. I felt how inferior it was to the best of our abbey ruins, the sense of its great age eludes me." But then, "I found the necropolis about 5 pm. It has a small collection of most exciting tombs some with memorial figures. The sun had almost set before I was finished and as I walked back through the deserted streets I began to be moved by the place for the first time."[13]

The result was a ravishing series of photographs of the site, both moving and informative, and replete with Smith's trademark ability to convey, in the words of one reviewer, "a remarkable, almost sensuous feeling for surfaces and textures"[14] that eluded many other photographers. His image of the necropolis at sunset (see p. 108) is particularly notable in being an affecting elegy for a lost world and at the same time a scene so vividly depicted that one almost expects the funerary statue to come alive and the whole vista to be populated and animated once again. Not surprisingly, *Pompeii and Herculaneum: The Glory and the Grief*, written by Marcel Brion and published by Elek Books in 1960, proved one of Smith's most enduringly successful publications. Interestingly, Smith possessed a proof copy of the book with the text missing, the blank pages of which he later filled with drawings of the subjects he had photographed, thus allowing a direct comparison of his differing approach to the two media, the one concerned with the sentient rendition of naturalistic detail, the other dissolving into a swirl of abstract impressions.

Although Smith grumbled that travel there was "about the most exhausting thing that life has to offer",[15] both he and Cook were smitten by the English love affair with Italy. In their case, however, they were seduced less by the Renaissance magnificence of Florence, and still less by the eternal glories of Rome that had so beguiled generations of Grand Tourists, than by the wild, romantic picturesqueness of Sicily. The couple had first visited the island together in 1950 to participate in a painting competition in Agrigento, and the money Cook received for winning second prize enabled them to stay for several months. They returned in 1954 to explore other parts of the island, for which their enthusiasm, shown in Smith's photographs and Cook's gushing prose, remained unbounded:

> [Sicily] combines all the delights of the picturesque. The poetry of its classical ruins, grander and more impressive than those of Greece itself, has only here and there been destroyed by the excavator; and temples and fallen columns adorned a savage, mountainous landscape. … And to the emotional appeal of the mouldering past and of the wildest natural beauty is added the awful fascination of a possible convulsion … What more could anyone, especially a writer ask?[16]

Cook might have added "or a photographer", as some of Smith's most indelible images were made while on Sicily:

as opposed to the world that seems to be sinking ever more rapidly into a uniform greyness and mediocrity … [it] impresses one above all with its vivid variety. It is a country that abounds … in sharp, bracing contrasts, emotional, aesthetic, intellectual, physical; it is a country of individuals, of peaks and valleys, where not even extreme poverty can suppress a captivating zest for life.[17]

These qualities are magnificently rendered in Smith's photographs, which, mostly taken in 1954 (see pp. 68–69), provide a striking early intimation of his ability to absorb and interpret cultures different from his own, while reflecting his abiding fascination with the picturesque, the exuberant and the bizarre. Into this last category came his photographs of Sicilian hearses (see p. 68), part of his obsession with the surrealistic imagery of death, which may have been inspired by Atget's *pompes funèbres* photographs and which became more pronounced in his later work in Ireland. A book on Sicily remained a long-cherished ambition of Smith and Cook, and the excellence of the photographs makes it all the more regrettable that this ambition remained unfulfilled.

Other books on Italy did, however, come to fruition. These included, in addition to *Pompeii and Herculaneum*, another book by Brion, *Venice: The Masque of Italy* (1962), and *Rome: From its Foundation to the Present* (1971) by Stewart Perowne, both published by Elek. Overshadowing them all was Thames & Hudson's sumptuous *The Wonders of Italy* (1965). In a sign of the increased affluence of the 1960s, this book differed markedly in both appearance and format from Smith's previous work for Thames & Hudson, being squarer in shape, with the illustrations gathered together in groups between blocks of text and notes to the plates written by Cook. Although there were significantly fewer illustrations, these were printed on heavier paper and allowed greater space to breathe. A generous number of full-page bleeds and double-page spreads lent the volume its lavish mien and heightened the dramatic impact of Smith's photographs. These were again reproduced in photogravure but this time executed in France by one of the leading specialists in the field, Braun et Cie. Typical of his desire to be involved in every stage of the process, Smith visited the company's plant at Mulhouse to observe the plates in production. His diligence was duly rewarded, as *The Wonders* proved an exemplary marriage of fine photography and fine reproduction.

When photographing in Italy, Smith had before him a rich tradition of view-making photography that stretched back almost to the origins of the medium and was exemplified in the work of such firms as James Anderson of Rome, founded in 1853, and particularly Fratelli Alinari of Florence, established a year later. Their photographs, aimed at both the tourist market and art and architectural historians, were most often classically composed in a one- or two-point (*all'angolo*) perspective that treated the building as an individual monument rather than as part of a wider townscape. This dispassionate recording, together with the precisely detailed caption information and catalogue numbers they stamped on their prints, created an impression of documentary objectivity. Smith's photographs, however, in their adoption of frequently unconventional viewpoints and often tighter framing, such as the off-centre view of the cascade at Caserta (fig. 15), in which the water tumbles down to the very front edge of the picture, betray a far greater degree of personal involvement and interpretation. These attributes also extend to his illustrations of subjects then little known or appreciated, such as the ornate Baroque forms of Noto's palaces and churches (see p. 69). Elek's complaint that the company did not wish to mix Alinari's "inferior quality work with Edwin's"[18] was

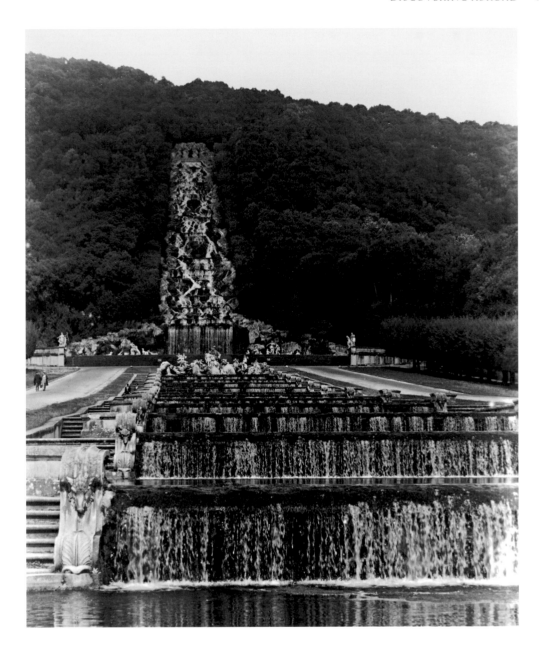

Fig. 15 Cascade, Caserta, Italy (1963)

undoubtedly unfair on Alinari, but it did highlight a fundamental difference in photographic visualization. Smith also distanced himself from the contemporaneous work of the Italy-domiciled author and photographer Georgina Masson (1912–1980), as published ironically by Thames & Hudson in *Italian Villas and Palaces* (1959). In 1960 he bemoaned her "eccentrically partial view"[19] of the Italian palazzi, including Mantua's Palazzo del Te, which he himself had photographed.

Much more modest offerings than *The Wonders*, the Elek books on Venice and Rome, as well as a companion volume on *Athens, City of the Gods: From Prehistory to 338 BC* (1964) by Angelo Procopiou, did not sell as well as the company had hoped. Smith was disappointed with the quality of the photographic reproductions, which were printed not in the rich but increasingly expensive photogravure but in the cheaper, more prosaic half-tone. Like Frederick Evans, who had consistently urged the photogravure reproduction of his imagery, Smith rightly conceived of half-tone as an inferior process

that failed to convey the subtly modulated tones of his prints. This problem of satisfactory reproduction became more pronounced towards the end of the 1960s as the use of photogravure waned. When working with Thomas Nelson on *The English House through Seven Centuries* (1968), Smith divulged that the publishers were experimenting with duotone,

> in which a double printing attempts to get over the rather depressing greyness of Photo-litho. The proofs they showed me had not succeeded in this and I believe they are being re-worked … I would of course like to insist that the book was done in gravure by one of the first-rate continental firms – this is the only way to get the best out of the pictures and to match up to my prints. But I am too reasonable to be a 'primo-signore' … I did a book for Weidenfeld (*Great Interiors)* which was printed photo-litho and the results in my opinion are dismal (though the colour plates in that book are the best I have had, which is a consolation).[20]

Conceived as a series on cities, the Elek books also suffered in comparison with other similar publications in the increasingly crowded topographical market, especially those graced by the photographs of Evelyn Hofer (1937–), who had been born in Marburg, Germany, and subsequently lived in the United States. Among these were *The Stones of Florence* (1959) by Mary McCarthy and V.S. Pritchett's *London Perceived* (1962) and *Dublin: A Portrait* (1967), all of which boasted superior-quality gravure reproductions, with the latter's publication prompting Elek to cancel its projected book with Smith on the Irish capital. Like Smith, Hofer combined an intuitive sense of place with a fondness for the offbeat and was unafraid to make use of whatever weather conditions prevailed. Unlike Smith, she mixed architectural studies with sensitive portraits of city-dwellers, was more willing to confront the contemporary realities of the civic experience, and became adept in the use of colour. It must also be admitted that Smith's photographs for *Rome*, many of them taken at the end of his life, when his movements were restricted by a leg injury, are not among his best, reflecting perhaps his less-than-enthusiastic response to the city: "It was such a pleasure to leave Rome behind even apart from its eternal noise I do not find it a sympathetic or congenial city. Nowhere has the essence of place – wherever one happens to be seems not quite 'it' and one never succeeds in arriving at 'it'."[21]

To a lesser extent the same criticism could be levelled against Smith's coverage of Athens, where he was appalled by the amount of over-restoration he encountered and the consequent "loss of the sense of antiquity":

> the famous church at Daphni, where I worked this afternoon, is just a shell of cement in which are embedded fragments of mosaic, with no sense of atmosphere or mystery. One sees the intention but the eye is baulked of any pleasure. I think perhaps the Greeks are no longer artists. The Akropolis is littered with newly worked statues and there is scaffolding in two places. I fear their intention is almost to rebuild it.[22]

Like Piper, Smith preferred the picturesqueness of "pleasing decay".[23] Thus, Smith's views of Grecian antiquities generally have none of the bombastic monumentality of those taken by the German photographer Walter Hege for his *Die Akropolis* (1930), nor do they seek to set them in the splendid, pristine isolation aimed for by nineteenth-century photographers wishing to project an unsullied image of Greece's Golden Age. On the contrary, Smith frequently placed the remains in an unprepossessing landscape of overgrown

wild flowers and modern encumbrances, although his view of the Temple of Poseidon at Cape Sounion (see p. 134) discloses that edge-of-the-world romanticism that pervades the paintings of Caspar David Friedrich.

Although a perusal of Brion's book might lead the observer to a contrary conclusion, so completely do the muddied reproductions occlude the light-infused distinctiveness of Smith's original prints, Smith's photographs of Venice were far more assured, as he revelled in a succession of "romantically pictorial experiences".[24] He did not, however, train his lens solely on the scenes his audience would expect but again demonstrated his capacity to invest the seemingly humdrum with especial significance:

> A half-open door revealed a dark court dramatically lit from high above and a wonderful stair starting in black shade, its newel-lion silhouetted against a far pile of kindling, and turning into the light. At the turn, another decorated newel. A classical head, bearded, with a cherubs [*sic*] head below, both so worn and battered, the head above so polished on top and pitted below but still so wonderfully expressive in black silhouette. Nothing much to the stair architecturally, just simple square-section balusters. But the sensation of having been used to the utmost and still gallantly supporting was fierce and then this black shapeless head at the turn taking on the task of making the whole magic and noble.[25]

Fig. 16 Gondola rowlock, Venice (1961)

It was this "knowing eye"[26] that made Smith such a wonderfully expressive photographer and enabled him to transform even a humble rowlock (fig. 16) into something "magic and noble":

> In a side street I found a carpenter's shop where the rowlocks of gondole were being made. These are fantastic elbowed claws that have, I am afraid, a rather obvious likeness to modern sculpture, but they are magnificent, functional yet fantastic. I had several times tried to record one adequately from the quaysides but they were never well lit or well seen. The carpenter Giuseppe Carli let me take two into the alley which ended in water to see them with a shimmering reflection behind. He was fascinated by my procedures, "you have the equipment of an artist, not bright, like a tourist".[27]

While Smith's contributions to such books as *Great Houses of Europe* (1961) and *Great Interiors* (1967), edited respectively by Sacheverell Sitwell, one of Smith's favourite writers on architecture,[28] and Ian Grant, took him to France, Spain, Germany, the Low Countries and Scandinavia, Smith also spent much of his time photographing on home soil. A thread common to both his foreign and his domestic work at this time is a newly emergent delight in gardens, which was manifested in some of his most enthralling images, combining, as fellow photographer Walter Nurnberg maintained, "the lyricism of broad scenic views with commanding elements of architectural forms".[29] Appearing both in more general volumes and in specific books, such as Peter Coats's *Great Gardens*

(1963) and Edward Hyams's *The English Garden* (1964) and *English Cottage Gardens* (1970), Smith's photographs proved empathetic to a wide variety of garden types. As he made clear in a letter to Nigel Nicolson, however, "My interest in the gardens depends to a certain extent on the gardens. I have great sympathy for the landscape garden and the formal and architectural kind. Pure horticulture not, the thought for instance of making colour photographs of a 'fine display of blooms' fills me with horror."[30] Thus, Smith's photographs encompassed compelling evocations of the box parterres of the Villa Lante at Bagnaia, which he considered "superb" (see p. 147);[31] the verdant romanticism of Hidcote with a 'casually' abandoned, brimming wheelbarrow, typically suggestive of human intervention, dominating the picture foreground (see p. 141); and the Neptune Fountain at the Villa d'Este, Tivoli (see p. 150), which Smith's powerful composition dissolved into a tumultuous, elemental mass of water, stone and light. Many of these photographs are similar compositionally to Atget's garden imagery, with oblique viewpoints being likewise employed to undermine the Classical symmetry of gardens such as that at Versailles, where Smith's view of the *Tapis Vert* fills the foreground with a huge marble vase in another compositional device borrowed from the French photograper (see p. 139). Although there are exceptions, such as his view of the statuary at Lord Burlington's villa at Chiswick (see p. 144), Smith's photographs do not generally exude the minatory quality that in Atget's images suggests the surface calm is about to be disturbed. Instead they radiate a serenity that intimates the scene will remain forever thus.

Fig. 17 Coal Exchange, London (1957)

On the home front Smith became more directly embroiled in a number of conservation issues. In 1967 he and Cook left their home in the centre of Saffron Walden to seek refuge from the incessant traffic noise in the quiet sanctuary of a converted coach house on the town's edge. Here they fashioned a fantastical retreat, spiritually akin to Bawden's home at The Place in Great Bardfield, which was filled with the Victoriana and other *objets d'art*, such as Staffordshire figures, that they were continuing to celebrate in *The Saturday Book*. It was decorated with wallpaper by Peggy Angus and Smith's own paintings and creations, among them the colourful, hexagonally tiled living-room chimney piece. The garden, part of which was given over to a vegetable patch, was similarly enchanting, being embellished with statuary and a pair of ball finials salvaged from the demolished barracks at Knightsbridge. When this peaceful haven and the tranquility of the surrounding countryside they loved was threatened by plans to site London's third airport either at Stansted or Nuthampstead, Smith and Cook campaigned vigorously against the proposals. Smith photographed the towns and villages imperilled, and Cook produced at speed a pamphlet that, in defence of 'Deep England', drew attention to the unique architectural, topographical and sociological features of the Hertfordshire parish that would be destroyed.[32]

More generally, Smith's keen appreciation of Victorian architecture, which was hailed as a striking feature of *England* (1971), the book he produced in collaboration with Cook and the novelist Angus Wilson,[33] drew him into some of the most

bitter conservation controversies of the period. Thus, for example, his photographs of J.B. Bunning's Coal Exchange (fig. 17) assumed a new importance, once this Victorian masterpiece had been shamefully demolished in 1962. Smith's concern with conservation spread beyond individual buildings and the landscape, however, to embrace the preservation of traditional crafts as well as such dying arts as tomb sculpture[34] and topiary. "Who in this speed-obsessed and mortgage-minded world of the late 'sixties", lamented Cook, "would plant for a more distant future than four or five years. Until some sense of stability and security is restored, there is as little prospect for the delightful and extraordinary art of topiary as there is for civilisation itself."[35] The darkly pessimistic tenor of this observation is typical of the couple's later work.

As they had done the previous decade, such preservationist concerns underpinned many of Smith's publications on British themes during the 1960s, giving substance to his declaration that he valued his "negatives very much as a collection and as a record of places that are changing and disappearing".[36] One of the most exceptional groups assembled at this time was the set specially commissioned for A.J. Youngson's groundbreaking study of the economic and social factors underlying the construction of Edinburgh's New Town, *The Making of Classical Edinburgh* (1966).[37] Although the rather matter-of-fact reproduction does scant justice to Smith's sensitive photographs, and the landscape-orientated views do not sit well within the book's vertical page layout, the critical success of Youngson's study added further lustre to Smith's reputation. *House & Garden* hailed it as "one of the finest, most comprehensive and exploratory records of a city ever made",[38] and *The Sunday Times* applauded Smith's photography as "near three-dimensional".[39] Again Smith largely employed off-centre rather than axial viewpoints to place the Georgian buildings in their context, thereby bolstering Youngson's argument that the New Town derived its special significance from the *tout ensemble* nature of its creation and "the visual conjunction of Old Town and New Town".[40] Alternating between crisply detailed images and languidly atmospheric evocations, none better than the elevated view of Edinburgh looking west from the crags to the castle observed through a smoky haze (see p. 75), Smith's photographs provide a mesmerizing visual correlative to Youngson's historical analysis.

This particular photograph recurs to much more striking effect in Thames & Hudson's *Scotland* (1968), which, besides Smith's photographs, comprised an introduction by the novelist and biographer Eric Linklater and Cook's plate notes. This was not a second edition of the Fraser book of 1955 but a completely different work that was one of a trio on which Smith and Cook collaborated with Thames & Hudson, the other two being *Ireland* (1966) and the already mentioned, slightly wider-format *England*. Part of a new, updated topographical series to which the indefatigable Hürlimann contributed the majority of the foreign volumes, these books boasted the highest production values, with Braun et Cie, as in *The Wonders of Italy* and *The English Garden*, achieving the most delicately faithful photogravure reproductions of Smith's photographs. Together these books reveal Smith as a photographer at the peak of his powers displaying a finely honed responsiveness to a subtly diffuse range of subject-matter.

In *Ireland* Smith's camera records with equal facility its vernacular architecture, exemplified by the pegged and roped thatching of the cottages of Donegal; the enigmatic stone figures of Boa Island; the harmonious proportions of its Georgian architecture; and what Cook termed the "superb melancholy" and "delicious gloom"[41] of the monastic remains at Glendalough (fig. 18). In his effusive introduction the actor and theatre director

Fig. 18 The Churchyard and St Kevin's 'Kitchen', Glendalough, Co. Wicklow (1965)

Micheál Mac Liammóir described Ireland as "the home of incongruities and contradictions".[42] This, together with the beauty of its landscape, was what above all enchanted Smith, whether it be the unabashed sentimentality but nevertheless alluring fascination of its religious shrines (see p. 154) that gave visible expression to that "deep sense of the other-world, which dominates the imagination of the people",[43] or the eerie desolation of the desiccated limestone terrain of the Burren. For *The Irish Times* this was simply "the most attractive book that has yet appeared about Ireland … . The photographer, Mr Edwin Smith, deserves whatever Oscars Mr Mac Liammóir can forego the copyright in",[44] while the *Guardian*'s reviewer, W.L. Webb, waxed lyrical:

> No prose coruscations can compete with the grave lyric beauty of Edwin Smith's photographs. This is not just the best landscape photography I have ever seen: it is so subtly responsive to the particular mysteries of light, image, and perspective that the limits of the medium seem dissolved, and one passes from page to page through a series of frozen dreams.[45]

A reverence for the landscape expressed increasingly through the sweeping vista rather than the homely scene was a feature of Smith's late photography that can be glimpsed in *Scotland* and *England*. His treatment of Gordale Scar is illuminating in this respect, as the view that appears in the 1971 *England* is literally the reverse of that chosen for the 1957 book. The earlier, less atmospheric composition, taken from the most common vantage point, tends to play down the sublimity of the gorge, with the two climbers in the foreground suggesting its vulnerability to human conquest. The later, mistier view, however, taken from a wholly unusual viewpoint, is ironically more indicative of the gorge's soaring majesty that had for two hundred years beguiled writers, artists and latterly photographers of a romantic disposition. In a rare lecture about his photography shortly before he died, Smith intimated that it was this landscape photography of which he was most proud, as in it he "had perhaps managed to convey something of infinity".[46] It is difficult in Smith's photography, however, to make such simple divisions, as landscape and architecture often meld seamlessly into a unified whole, or nature reveals surprisingly architectonic forms, as for example in County Antrim's Giant's Causeway (fig. 19), which, seen in close-up, appears as a closely packed cluster of skyscraper blocks. In his introduction to *England*, Wilson, echoing Neurath two decades previously (see p. 49), maintained that no country had so relied upon the printed word to proclaim the quality of its thought and imagination as England, and that therefore the shift away from print towards image and vision that was then being experienced was of much greater revolutionary import here than elsewhere: "English Literature, philosophy and science have stood in the way of the great visual beauties of England. These – the scenery, churches, country houses, towns, seaside, gardens and parks – offer another way of looking into the complicated, ambiguous English civilization."[47] Wilson's roll-call of what was in essence Smith's subject-matter indicates how it was this "another way of looking" that Smith's photography above all helped to inspire.

Fig. 19 Giant's Causeway, Co. Antrim (1965)

Aside from the greater awareness of landscape and the other concerns mentioned, Smith's photography broke no new ground in the 1960s. The same lyrical potency, delight in incongruity, tactile intensity and eye for the telling detail that had informed his photography since the 1930s still obtained although now handled, as the diminished number of failures in his negative files indicate, with increased assurance. A good example can be found in his treatment of the grand interiors he photographed for *Great Interiors* (1967), many of which posed formidable problems of shot selection and lighting. Like Frederick Evans, who hated its perspectival distortion, Smith was wary of the wide-angle lens. He rarely simply stood in a corner and used the lens's 'space-exploding' qualities to cram as much of the room as possible into a single picture, as so many architectural photographers were prone to do. Instead, the belief that more could often be conveyed about a subject through a judicious selection of details, rather than a general view, had always been a central tenet of Smith's photography. The famous aphorism 'less is more', coined by the architect Ludwig Mies van der Rohe, certainly did not articulate an exclusively Modernist credo. Smith's photographs in *Great Interiors* therefore abound in well-chosen and suitably illumined details, as Cecil Beaton (1904–1980) recognized:

> Though appreciative of the cool, calm, and beautifully controlled photographs beloved of *Country Life*, he has also a mastery over dramatising the composition; for making the significant detail loom large in the foreground. He appreciates the elusive effects of dark shadows on sculptural giants, or of sunlight filtering through the clouds on to the plaster *putti* flying among arabesques of ribbon, or on to some glorious golden goddess caressing her naked body. But although drama is here, there are no shortcuts to effect, no clumsy mis-uses of horizontals, no accidentally falling columns or tottering towers.[48]

Beaton was a great admirer of Smith's photography and wrote these words in 1967 as part of a broader assessment of Smith's work in the context of architectural photography generally. It was, he maintained, "a happy mean"[49] between the two main schools, which he described thus:

> Of recent years the photography of great architecture has floundered between the Scylla of the super-technological and the Charybdis of the amateur snapshotter. With ever more highly sensitised film, and a greater accuracy of colour emulsion, architectural photographs, particularly in France, Germany, and the United States, have become so precise that one can discern with equal clarity, and with scarcely little difference of emphasis, the bowl of fruit in the foreground and the brick on the farthest horizon. The antiseptic quality of the results is apt to rob the subject of its shadows, its patina, and its innate personality, particularly when flash and strobe, and other artificial means of lighting are used. In contrast the work produced by young photographers with their hand-held cameras has introduced us to

pictures that are violent in juxtaposition of light and shade, or great distortions, and often of a Samsonesque effect, not necessarily intended, of columns falling inwards. An egg-cup or silver canister, by being placed so near the lens, is given more importance than the distant triumphal arch. The effects are all very atmospheric and in the contemporary mood, but they often result in a lack of detail and a falsity in the tonality.[50]

Although Beaton's trenchant comments were exaggerated, he was right to regard Smith's photography as *sui generis* and largely out of step with contemporary developments. Thus, Smith had no truck with the marriage of in-vogue street photography to architectural depiction that in the work of such photographers as John Donat and Tim Street-Porter was reshaping the genre. Using hand-held, small-format cameras and the faster films then becoming available, these photographers were concerned to show buildings in use, inhabited by people undertaking real tasks rather than stiffly posed figures whose inclusion was designed merely to convey a sense of scale. Often retaining the frame's black border and emphasizing the graininess that resulted from enlargement, their prints were deliberately designed to present an illusion of gritty reality. Donat's assertion that it was worth sacrificing technical perfection to achieve a 'live' picture rather than a sterile, beautiful one was anathema to such a painstaking craftsman as Smith, who had long left behind his youthful flirtation with smaller formats. For his part Donat, who admired Smith's gentle, unassuming eye and consistency of vision, nevertheless found "the absence of humanity, the absence of traffic … of the world … strange for pictures which were still being taken in 1971".[51]

By this time even Smith's most ardent supporters at Thames & Hudson were also having misgivings. Eva Neurath wrote to Smith in 1970 apropos *England*:

> Your photographs are really very wonderful. … Not having seen the second half of the pictures I am left with the impression that we are a touch too architectural, and that the human element is somewhat missing. I know that this is so in a number of the Hürlimann books, but he changed this in his recent work … if you should have some pictures to bring out the English way of life then let's consider that.[52]

Seen against the changing ideals of the 1960s, Smith's photographs were beginning to be thrown into sharper relief as depicting what the cathedral interior had been to Frederick Evans, the Fens to Peter Emerson or Antarctica to Herbert Ponting – a pristine, utopian world far removed from the reality of contemporary existence. This is also evident in Smith's continued reluctance to photograph modern architecture, as his book assignments now sometimes required him to do. The results show Smith's distaste for an architecture he considered neither rooted in time nor place, and that his first inclination was always to seek to soften its geometrical rigour. When photographing 66 Frognal, London (fig. 20), one of the most uncompromising Modernist houses, designed in 1937 by Connell Ward and Lucas, he abjured the close-ups and worm's-eye views that mainstream architectural photographers had employed to give the house a heroic dimension, opting instead for an *all'angolo* distance view, which allowed him to picture the house's rectangular forms through a romantic filter of overhanging trees and a fortuitously broken gate. In this way, the view became a contemporary urban equivalent of the picturesque country house in its park portraiture of such nineteenth-century topographical engravers as John Preston Neale.

Fig. 20 66 Frognal, Hampstead, London (1957)

Smith also looked aghast at the increasing demand for colour photography. Although many of his books contained a smattering of colour illustrations, he was never enamoured of a medium in which creative control was taken away from the photographer by the need for the film's laboratory processing, which he felt lacked depth and subtlety, and to which his favoured reproductive process of photogravure was not inherently suited. Above all, Smith maintained, "light and shade and full colour are ultimately incompatible and no pictorial convention has succeeded in combining chiaroscuro and colour with both working to full capacity".[53]

Some of Smith's most acerbic criticisms of colour came in an illuminating essay he wrote about the photography of three-dimensional objects, including sculpture, of which, as movingly demonstrated by his beautifully contemplative rendition of the monument to Mary Anne Boulton in Great Tew church (see p. 168), he was a master. His conclusion was unbending. "It must be acknowledged that most colour photography of sculpture can only be considered a mistake."[54] Smith was a brilliantly inventive virtuoso in black and white, and his attempts to use colour were unconvincing. Whereas, when Betjeman in 1954 praised Smith's ability to convey a sense of colour in black and white there was little viable alternative, by the time Beaton made a similar observation in 1967 – "Even in black and white he is able to suggest the richness of the dark Christmas-pudding panelling below the brandy-butter stucco ceilings of English country houses, the delicate spirals of the wood carving at Chatsworth, Belton, or Petworth"[55] – colour film had greatly improved, and the clamour for its more frequent use was becoming harder to resist. The demise of the Gordon Fraser range of black-and-white postcards, to which Smith and de Maré had jointly contributed, highlighted this trend. Trevor Thomas of Gordon Fraser lamented to Smith in 1965 the production problems caused by the rising costs of silver, the difficulties in obtaining materials and increased competition:

Suddenly the postcard world is all horribly cut-throat and whilst the GFG [Gordon Fraser Gallery] black and white cards still receive the connoisseurs' accolade, I'm afraid the more vulgar (but not always) and cheaper colour ones are winning the markets. The days of black and white cards are decidedly numbered as commercial propositions.[56]

To his disquiet about colour was added another contemporary trend in publishing of which Smith heartily disapproved, as he made clear in a letter to Paul Elek in 1971:

Naturally the choice and presentation of picture [sic] is vital, in these books and I must say I view with misgiving the modern trend of giving text and pictures to a 'book designer' to sort out. I have been involved in two books where this was done. In both cases the choice of picture was either so eccentric or inept and

the suggested trimming so drastic that even the publisher realised something was wrong.[57]

This disjunction between Smith's photography and contemporary developments in the medium was less apparent at the time than it became later, when these emerging trends had blossomed more fully. When he died of pancreatic cancer in 1971, therefore, Smith's reputation remained high, as the accolades universally showered upon his work attest. Smith and Cook's relationship, certainly on her side, had always been intensely passionate, and, once she had recovered from the trauma of her 'darling's' death, Cook devoted the remaining thirty-one years of her life to perpetuating the memory of Smith and his work. This task she tirelessly performed by the supply on demand of images to publishers and co-operation on a series of exhibitions and further books filled with Smith's photographs, among them *The Countryside of Britain* (1977), written by the poet James Turner; a new version she wrote herself of *English Cottages and Farmhouses* (1982); *Divine Landscapes* (1986) by Ronald Blythe of *Akenfield* fame; and Lucy Archer's *Architecture in Britain and Ireland 600–1500* (1999). The peak of these endeavours came in 1984 with the publication, appropriately by Thames & Hudson, of a selection of Smith's photographs in the winningly designed *Edwin Smith: Photographs 1935–1971*, to which Cook again contributed the text. This could also be said to represent the high-watermark of Smith's standing as a photographer, for, although the book was generally warmly received, a growing number of dissenting voices could now be heard. Thus, the reviewer in *SLR Camera* admitted he had never heard of Smith and, while conceding that he had produced some fine work on gardens and churches, complained of Smith's "mausoleum-type images", adding, "I begin to long for the sight of a friendly face, or at least a little action to relieve the oppressive 'sanctity' of this world."[58]

That the tide had turned against Smith's picturesque, romantic style of photography was recognized by *The Times*'s critic John Russell Taylor in a review of Smith's work in 1997:

> Although there are enough books by and about him to warrant him a great modern photographer, Edwin Smith is perhaps too close to the English grain to be really fashionable at the moment. He was a born romantic with a passionate delight in the elegiac grace of the English garden, the oddities of the English character, and the way light falls on dusty stones in old country churches.[59]

Despite the abiding admiration of his publisher Eva Neurath, who stressed the "eternal quality" and "humanity" of his pictures;[60] the praise of architectural historians, such as Jonathan Glancey, Colin Amery and Ken Powell – "For many of us, the late Edwin Smith's photographs … were a gateway to the history of architecture";[61] and the warm appreciation of fellow photographers, such as Beaton, Nurnberg and Roloff Beny, who acclaimed Smith as "a sensitive and superb artist with the camera",[62] Laurence Scarfe's assertion in 1972 that "there is no doubt his work will last"[63] today seems less secure. While *Camera Weekly* could in 1984 maintain that "the subtle, poetic art of Edwin Smith has come to be recognised as one of the most outstanding achievements of post-war British photography",[64] and his images adorned book covers for Penguin Twentieth Century Classics, such as James Joyce's *Dubliners* and Graham Greene's *Brighton Rock*, since then his work has gradually disappeared from photographic reference books.

Mention of his name today is generally met with looks of incomprehension, despite his influence on such later photographers as James Ravilious, Fay Godwin, Martin Charles and Hugh Palmer. For those who regard Smith's photography as incurably infected with the peculiarly English disease of sentimental nostalgia or too narrowly parochial, this neglect doubtless seems well deserved. Yet this view is itself too blinkered and, were Smith's work to languish forgotten and ignored, this would represent a regrettable loss of an important part of our photographic patrimony. Not only, as he himself hoped, have Smith's photographs become an invaluable record of worlds we have lost, but they also provide a unique insight into the cultural and social milieu of mid-twentieth-century Britain. In addition, Smith's highlighting of the fragility of both our natural and our built heritage, together with the need for an architecture respectful of its environment, is today more topical than ever. Above all, despite its deceptive ease on the eye and seemingly circumscribed subject-matter, Smith's photography is challenging. In an era of instant culture, of the readily assimilable 'sight-bite', of visually numbing photography the 'significance' of which has to be explained by its creators' self-justifying statements of intent, Smith's photographs speak to us directly, gently drawing us in and inviting us to pause and consider. Ultimately, as Norman Scarfe said, they teach us how to see.[65] Surely this is photography at its most inspiring.

1 Transcript of John Donat talking to Michael Oliver on the BBC radio programme *Kaleidoscope*, 18 November 1976 (Olive Cook Papers, Newnham College Archives, Cambridge, Box 30 5/4/4).
2 *The Saturday Book 28*, London (Hutchinson) 1968, p. 6.
3 Quoted in Julia Hedgecoe, 'In Memoriam: Life Stories. Olive Muriel Smith', *Newnham College Roll Letter*, 2003, p. 111.
4 Cf. Letter from Edwin Smith to Olive Cook, Venice, 25 September [1961] (Edwin Smith Collection, RIBA British Architectural Library Photographs Collection).
5 Letter from Edwin Smith to Olive Cook, Bomarzo, 8 May [year unknown] (Edwin Smith Collection, RIBA British Architectural Library Photographs Collection).
6 Letter from Edwin Smith to Olive Cook, Venice, 17 September [1961] (Edwin Smith Collection, RIBA British Architectural Library Photographs Collection).
7 Undated and untitled manuscript (Edwin Smith Collection, RIBA British Architectural Library Photographs Collection).
8 'Recollections by His Friends: Elizabeth Jenkins', in *Aspects of the Art of Edwin Smith*, exhib. cat., Colchester, The Minories, 1974, p. [8].
9 Letter from Edwin Smith to Olive Cook, Leeds, Wednesday evening [n.d.] (Edwin Smith Collection, RIBA British Architectural Library Photographs Collection).
10 Cecil Beaton, 'Preface', in *Great Interiors*, ed. Ian Grant, London (Weidenfeld & Nicolson) 1967, p. 9.
11 Olive Cook, *Edwin Smith: Photographs 1935–1971*, London (Thames & Hudson) 1984, p. 12.
12 Letter from Edwin Smith to Moira Johnston of Paul Elek, Saffron Walden, 26 February 1970 (Olive Cook Papers, Newnham College Archives, Cambridge, Box 35 6/3/13).
13 Letter from Edwin Smith to Olive Cook, Naples, 9 October [year unknown] (Edwin Smith Collection, RIBA British Architectural Library Photographs Collection).
14 'A Look Beneath the Lava', review of *Pompeii and Herculaneum: The Glory and the Grief* from the *Times Literary Supplement*, 29 March 1974, p. 321.
15 Letter from Edwin Smith to Olive Cook, Naples, 20 October [1959] (Edwin Smith Collection, RIBA British Architectural Library Photographs Collection).
16 Typescript entitled 'The Virtue of Extremes: Impressions of Sicily', [n.d.] p. 1 (Olive Cook Papers, Newnham College Archives, Cambridge, Box 19 3/1/2).
17 *Ibid.*
18 Letter from Moira Johnston of Elek to Mrs Ann Natanson, London, 1 October 1970 (Olive Cook Papers, Newnham College Archives, Cambridge, Box 35 6/3/13).
19 Letter from Edwin Smith to Olive Cook, Mantua, 21 March 1960 (Olive Cook Papers, Newnham College Archives, Cambridge, Box 2 1/1/1).
20 Letter from Edwin Smith to Leonard Russell, Saffron Walden, 12 December 1967 (Olive Cook Papers, Newnham College Archives, Cambridge, Box 34 6/3/9).

21 Letter from Edwin Smith to Olive Cook, Bomarzo, 8 May [year unknown] (Edwin Smith Collection, RIBA British Architectural Library Photographs Collection).
22 Letter from Edwin Smith to Olive Cook, Athens, 23 March 1962 (Edwin Smith Collection, RIBA British Architectural Library Photographs Collection).
23 Phrase first coined by Hubert de Cronin Hastings, owner and editor of *Architectural Review*, and used by John Piper as the title of an essay in the *Architectural Review* in September 1947, reprinted in *Buildings and Prospects*, London (Architectural Press) 1948.
24 Letter from Edwin Smith to Olive Cook, Venice, 20 September [1961] (Edwin Smith Collection, RIBA British Architectural Library Photographs Collection).
25 Letter from Edwin Smith to Olive Cook, Venice, 23 September [1961] (Edwin Smith Collection, RIBA British Architectural Library Photographs Collection).
26 'Recollections by His Friends: Eva Neurath', in *Aspects of the Art of Edwin Smith* 1974, p. [10].
27 Letter from Edwin Smith to Olive Cook, Venice, 15 September [1961] (Edwin Smith Collection, RIBA British Architectural Library Photographs Collection).
28 Revealed in unpublished draft of 'On Photographing Cathedrals and Parish Churches' [n.d.], p. 3 (Olive Cook Papers, Newnham College Archives, Cambridge, Box 37 7/3/5).
29 *British Journal of Photography*, 20 December 1985, p. 1427.
30 Letter from Edwin Smith to Nigel Nicolson, London, 9 November 1960 (Olive Cook Papers, Newnham College Archives, Cambridge, Box 34 6/3/10).
31 Letter from Edwin Smith to Olive Cook, Viterbo, 1 April 1960 (Olive Cook Papers, Newnham College Archives, Cambridge, Box 2 1/1/1).
32 Cf. Olive Cook, *The Stansted Affair: A Case for the People*, London (Pan Books) 1967; Olive Cook, *A Study of Anstey: The Sense of Continuity in a Hertfordshire Parish* (Nuthampstead Preservation Association) 1969.
33 See review in *The Times*, 8 April 1971.
34 On tomb sculpture, see Olive Cook, 'Sepulchral Effigies', *The Saturday Book 16*, London (Hutchinson) 1956, pp. 217–30.
35 Olive Cook, 'The Curious Art of Topiary', *The Saturday Book 29*, London (Hutchinson) 1969, p. 196.
36 Letter from Edwin Smith to Trevor Thomas of Gordon Fraser, 28 April 1962 (Olive Cook Papers, Newnham College Archives, Cambridge, Box 34 6/3/7).
37 Although the list of plates claimed "these photographs were taken specially for this book by Mr Edwin Smith", some had been taken earlier and used for *Scotland* (1955).
38 *House & Garden*, March 1972, p. 71.
39 Quoted on back dust jacket, A.J. Youngson, *The Making of Classical Edinburgh*, Edinburgh (Edinburgh University Press) 1993 hardback reissue.

40 A.J. Youngson, 'Preface', in *The Making of Classical Edinburgh* 1988 reissue, p. xi.
41 Olive Cook, 'Glendalough, the Monastic City', *The Saturday Book 26*, London (Hutchinson) 1966, p. 101.
42 *Ireland*, London (Thames & Hudson) 1966, p. 53.
43 *Ibid.*, p. 111.
44 *The Irish Times*, 27 June 1966.
45 *The Guardian*, 15 July 1966.
46 Quoted in Olive Cook, 'Edwin Smith – the Photographer', in *Record and Revelation: Photographs by Edwin Smith*, exhib. cat., York, Impressions Gallery of Photography 1983, p. [9].
47 *England*, London (Thames & Hudson) 1971, p. 11.
48 Beaton 1967, p. 9.
49 *Ibid.*
50 *Ibid.*, pp. 8–9.
51 Donat, *Kaleidoscope* 1976.
52 Letter from Eva Neurath to Olive Cook and Edwin Smith, London, 13 April 1970 (Olive Cook Papers, Newnham College Archives, Cambridge, Box 33 6/3/6).
53 John Lewis and Edwin Smith, *The Graphic Reproduction and Photography of Works of Art*, London (W.S. Cowell) 1969, p. 91.
54 *Ibid.*, p. 92.
55 Beaton 1967, p. 9.
56 Letter from Trevor Thomas to Edwin Smith, London, 19 August 1965 (Olive Cook Papers, Newnham College Archives, Cambridge, Box 34 6/3/7).
57 Letter from Edwin Smith to Paul Elek, Saffron Walden, 1 June 1971 (Olive Cook Papers, Newnham College Archives, Cambridge, Box 35 6/3/13).
58 *SLR Camera*, December 1984 (press cutting in the Edwin Smith Collection, RIBA British Architectural Library Photographs Collection).
59 John Russell Taylor, 'The Big Show: Edwin Smith', *The Saturday Times*, 27 September 1997, review of *The Other Side of the Coin* exhib. at the Fry Art Gallery.
60 'Recollections by His Friends: Eva Neurath', in *Aspects of the Art of Edwin Smith* 1974, p. [10].
61 *Twentieth Century Society Newsletter*, Summer (June) 2000, p. 27.
62 Letter from Roloff Beny to Edwin Smith, Rome, 9 September 1971 (Olive Cook Papers, Newnham College Archives, Cambridge, Box 31 6/1/7).
63 Letter from Laurence and Duffey Scarfe to Olive Cook, 20 January 1972 (Edwin Smith Collection, RIBA British Architectural Library Photographs Collection).
64 *Camera Weekly*, 29 September 1984, p. 19.
65 Norman Scarfe, 'Edwin Smith (1912–1971): A Memorial Exhibition of His Photographs, Selected by Olive Smith', in *The Twenty-Sixth Aldeburgh Festival of Music and the Arts*, Ipswich (W.S. Cowell for the Aldeburgh Festival) 1973, p. 66.

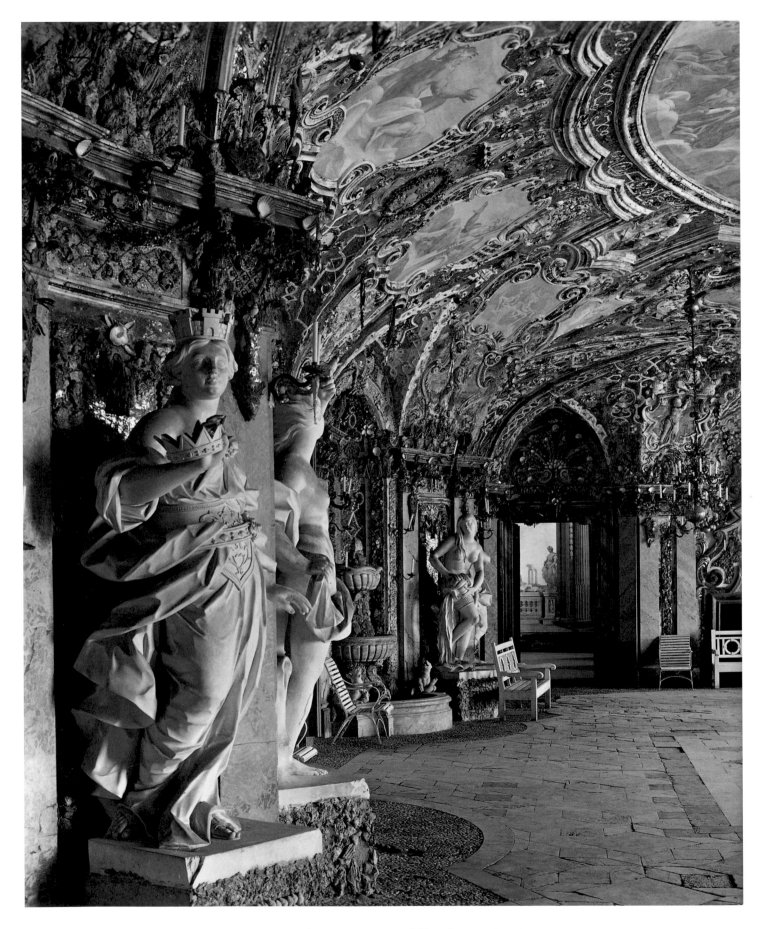

Grotto or Sala Terrena, Pommersfelden, Germany (1960)

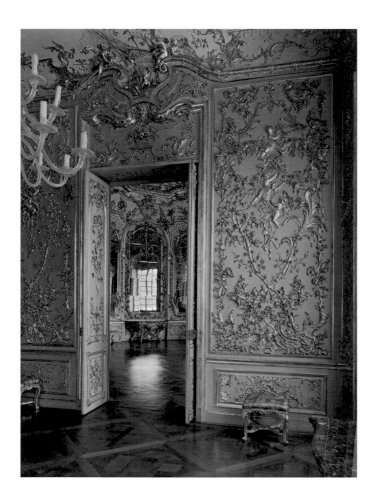

Amalienburg, Munich (1960)

Cardiff Castle (1961)

Roof, St Enoch's Station, Glasgow (1961)

Galleria Umberto I, Naples (1963)

Suburban Baths, Herculaneum, Italy (1959)

Stepping stones at the junction of Via di Stabia and Via dell'Abbondanza, Pompeii, Italy (1959)

Dovecote, Tattershall Castle, Lincolnshire (1962)

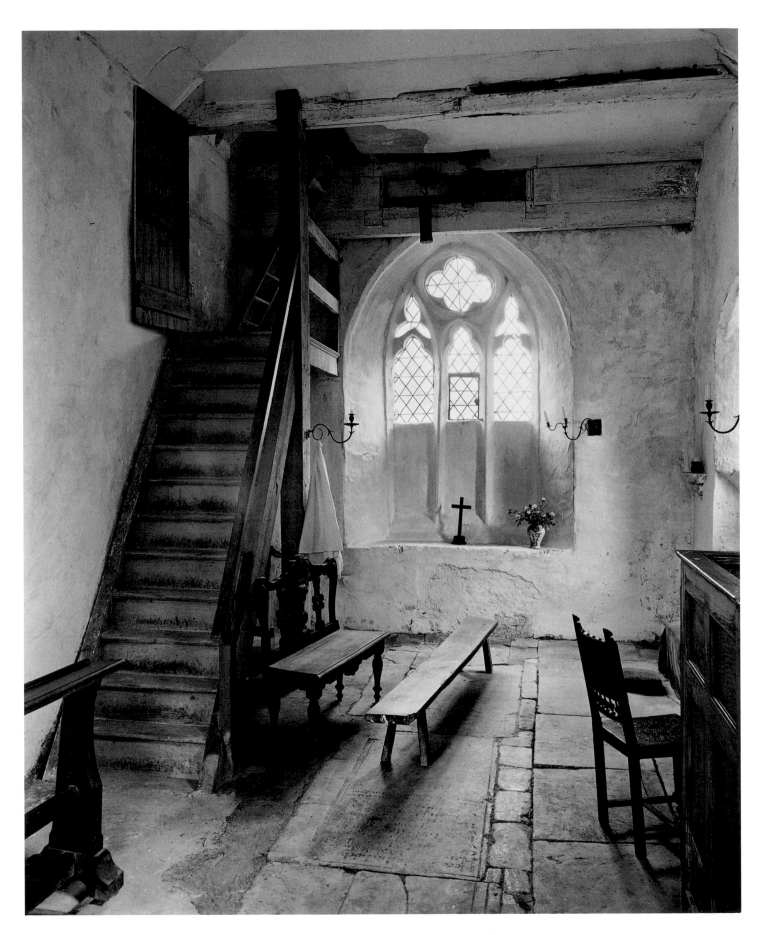

St Lawrence, Didmarton, Gloucestershire (1961)

Oakfield Crescent, London (1961)

Mr Tyler's council flat, Poplar, London (1961)

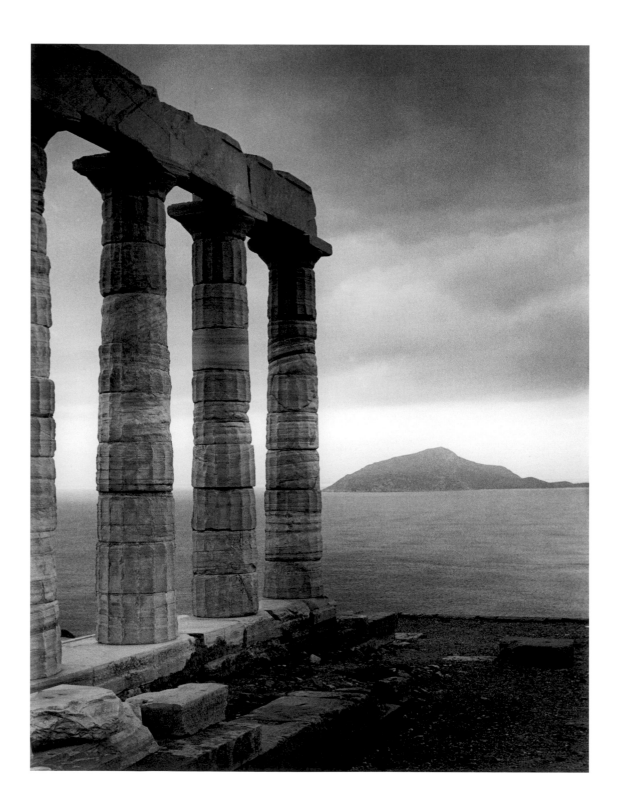

Temple of Poseidon, Cape Sounion, Greece (1962)

The lagoon, Venice (1968)

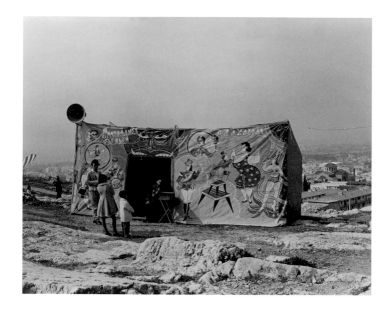

Fairground tent, outskirts of Athens (1962)

Casa de Pilatos, Seville (1960)

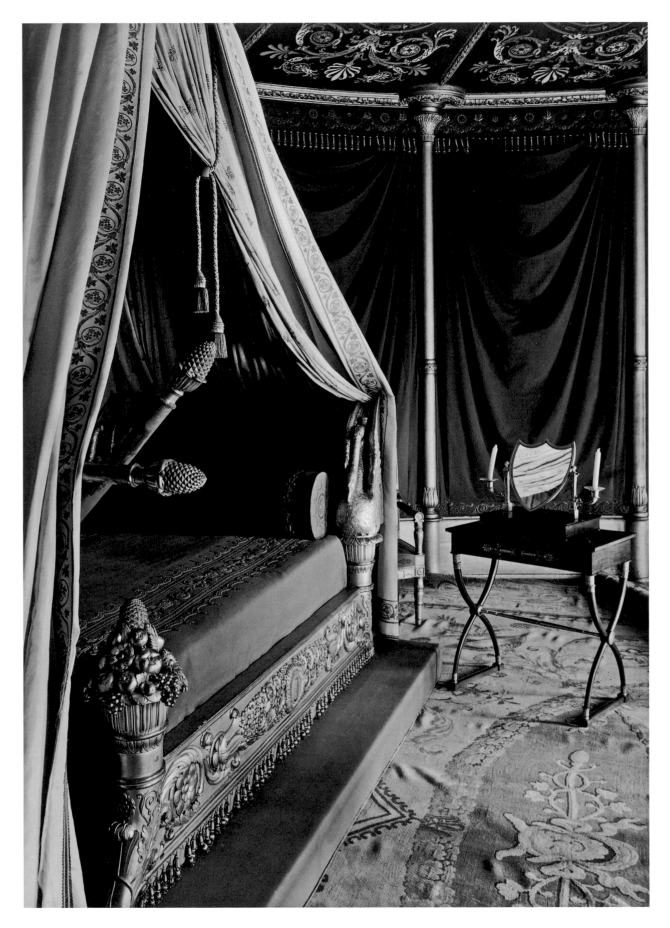

Josephine's bedroom, Malmaison, near Paris (1966)

River Deben, Ramsholt, Suffolk (1965)

Sphinx in the rose garden, Bodnant Gardens, Denbighshire (1963) Allée Royale, Versailles, France (1962)

Vita Sackville-West's boots, Sissinghurst Castle, Kent (1962)

Hidcote Manor Gardens, Gloucestershire (1962)

Rousham Park, Oxfordshire (1963)

New Court, St John's College, Cambridge (1964)

Farm in the mountains between Auletta and Potenza, Italy (1963)

Chiswick House, London (1965)

Temple of Flora, Stourhead, Wiltshire (1956)

Villa Garzoni, Collodi, Italy (1962)

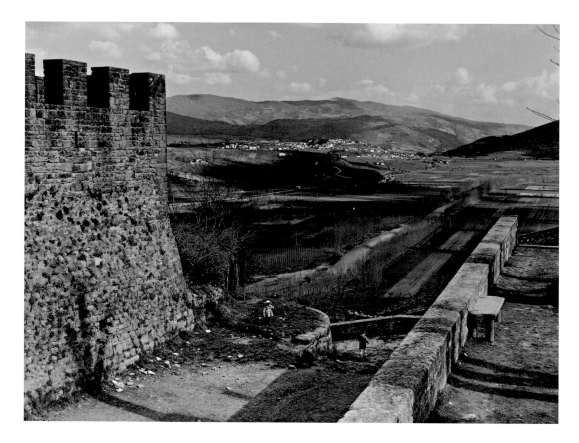

View of Raggiolo from Poppi, Italy (1963)

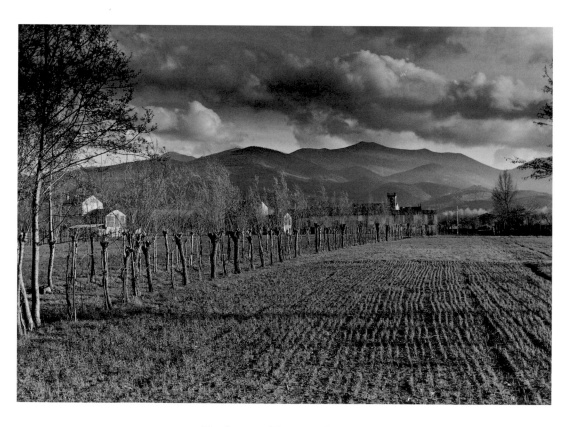

North-west of Lucca, Italy (1963)

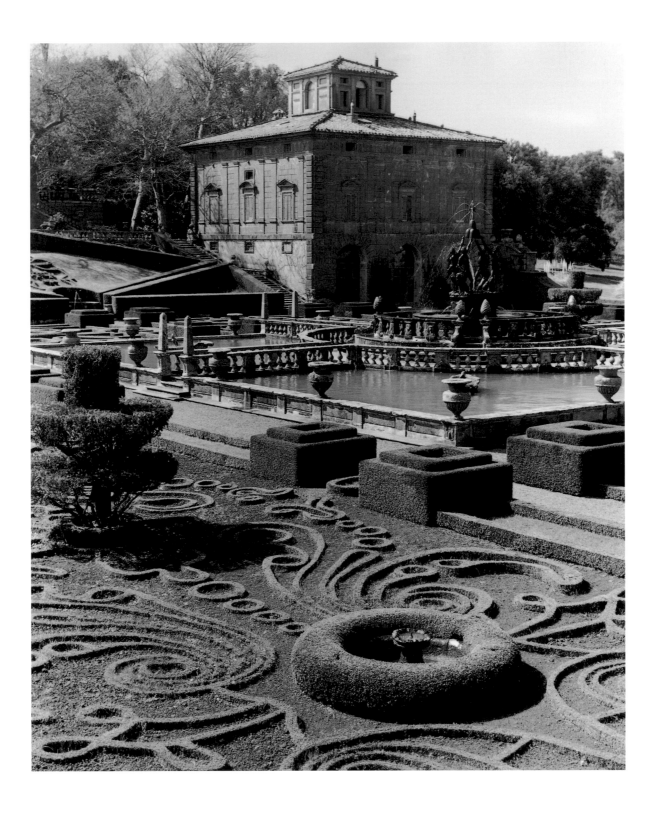

Villa Lante, Bagnaia, Italy (1960)

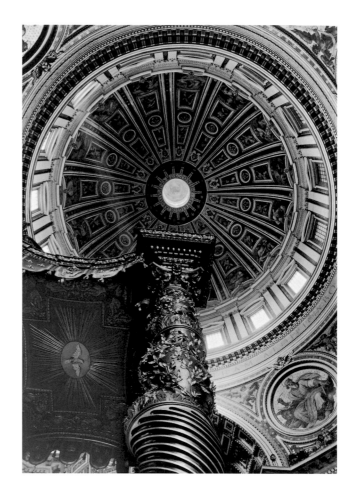

Fontana Grande, Viterbo, Italy (1963) St Peter's, Vatican, Rome (1970)

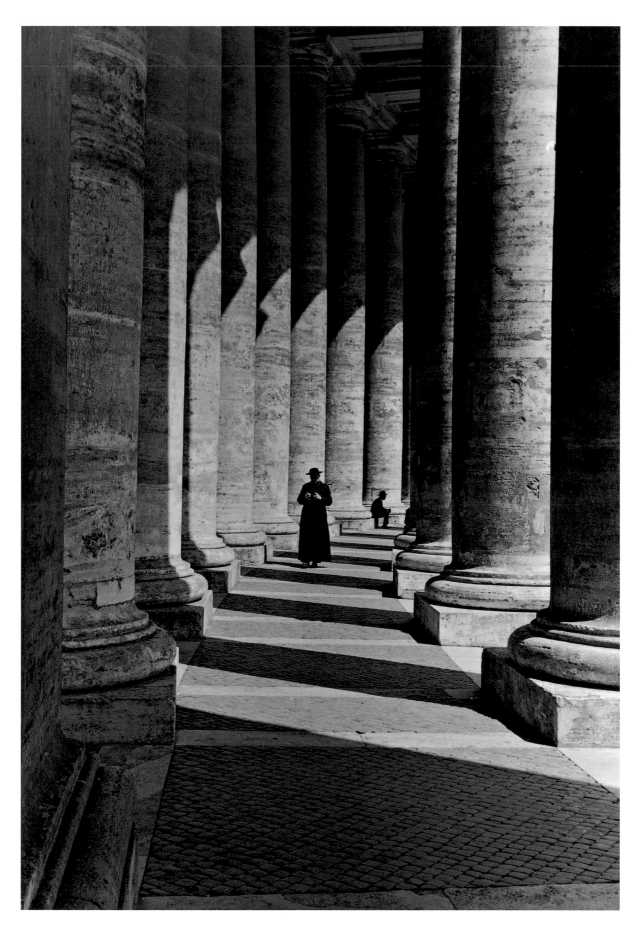

Colonnade, St Peter's, Vatican, Rome (1960)

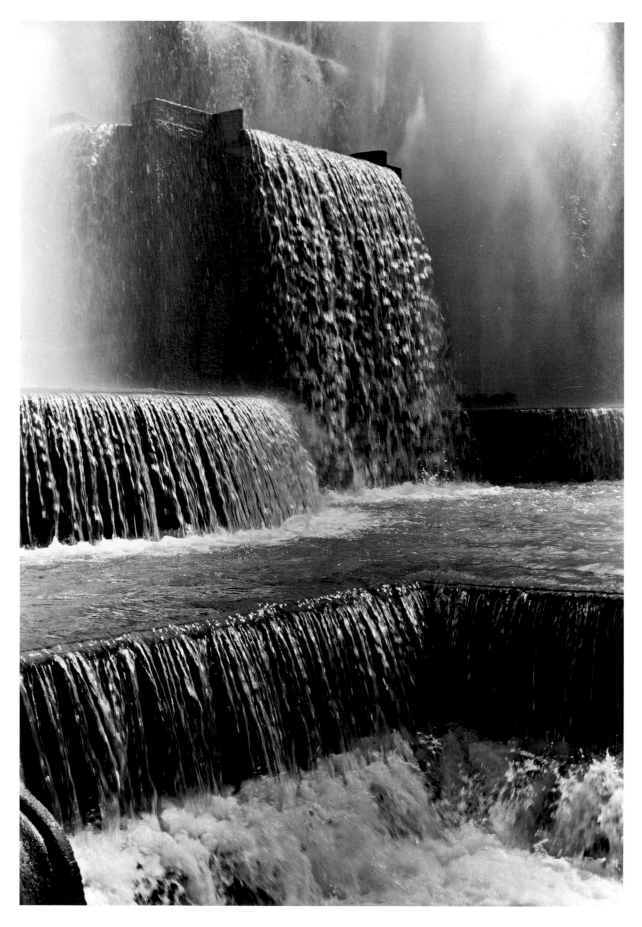

Neptune Fountain, Villa d'Este, Tivoli, Italy (1960)

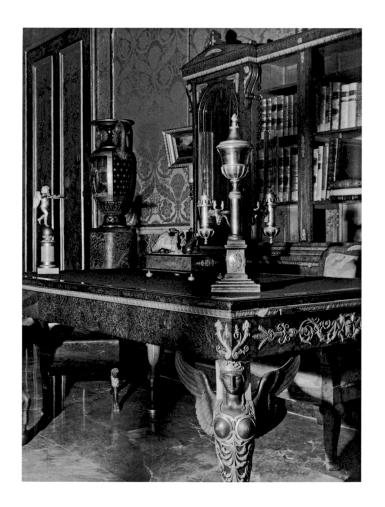

Palazzo Reale, Naples (1963)

Treasury, San Marco, Venice (1961)

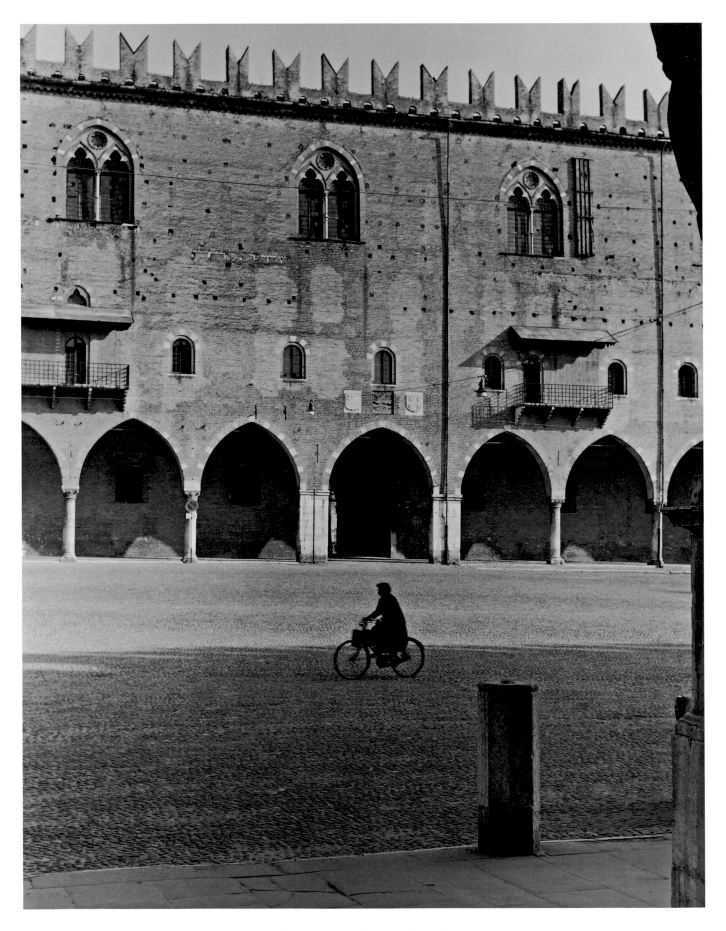

Palazzo Ducale, Mantua, Italy (1960)

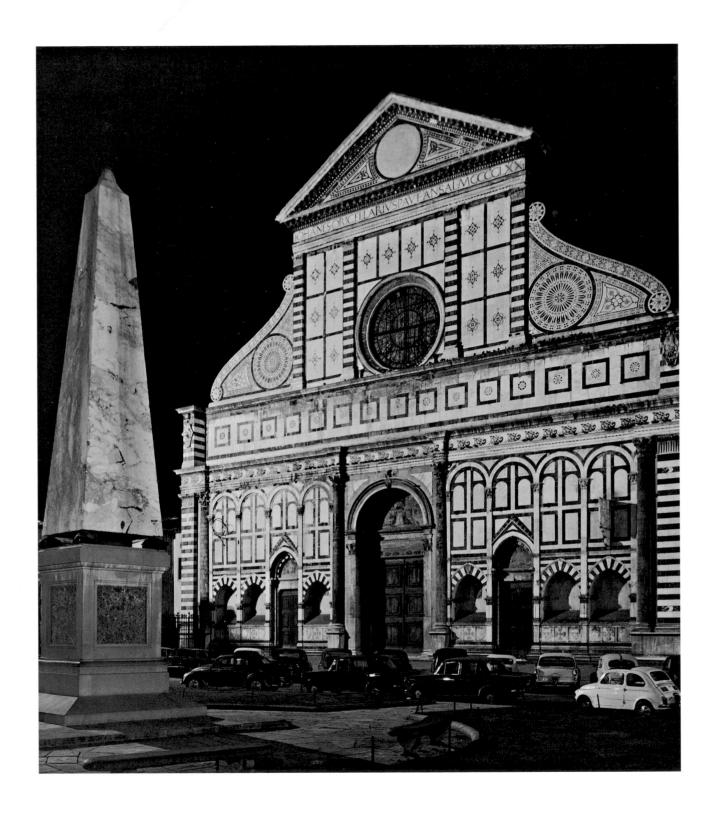

Santa Maria Novella, Florence (1963)

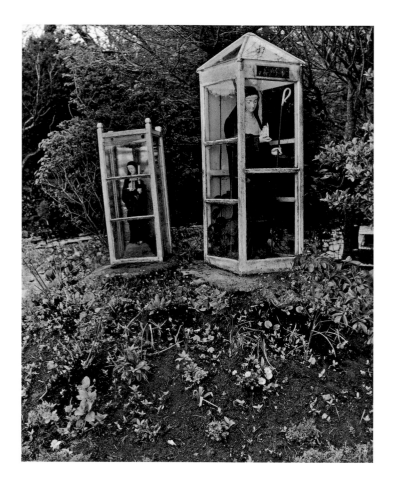

St Brigid's Well, Liscannor, Co. Clare (1965)

Waterloo Place, Edinburgh (1964)

Pyramid of Caius Cestius, Rome (1963)

Central Station, Milan (1962)

Queen's Station, Glasgow (1961)

Phoenix Park, Dublin (1965)

St Columba's Wells, Londonderry (1965)

Powerscourt, Co. Wicklow (1965)

Casita del Labrador, Aranjuez, Spain (1960)

Skandia Cinema, Stockholm (1966)

The White Horse and Dragon's Hill, Uffington, Berkshire (1969)

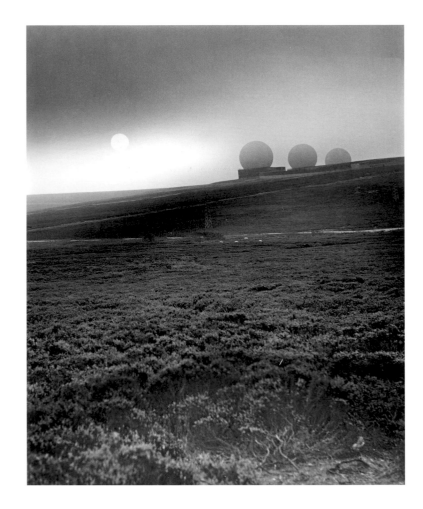

Howth, Co. Dublin (1965)　　　　　　　　　　　　Fylingdales, North Yorkshire (1969)

Frost patterns on window (1966) Tracks in the snow (1963)

Rocks on the coast, Welcombe, Devon (1968)

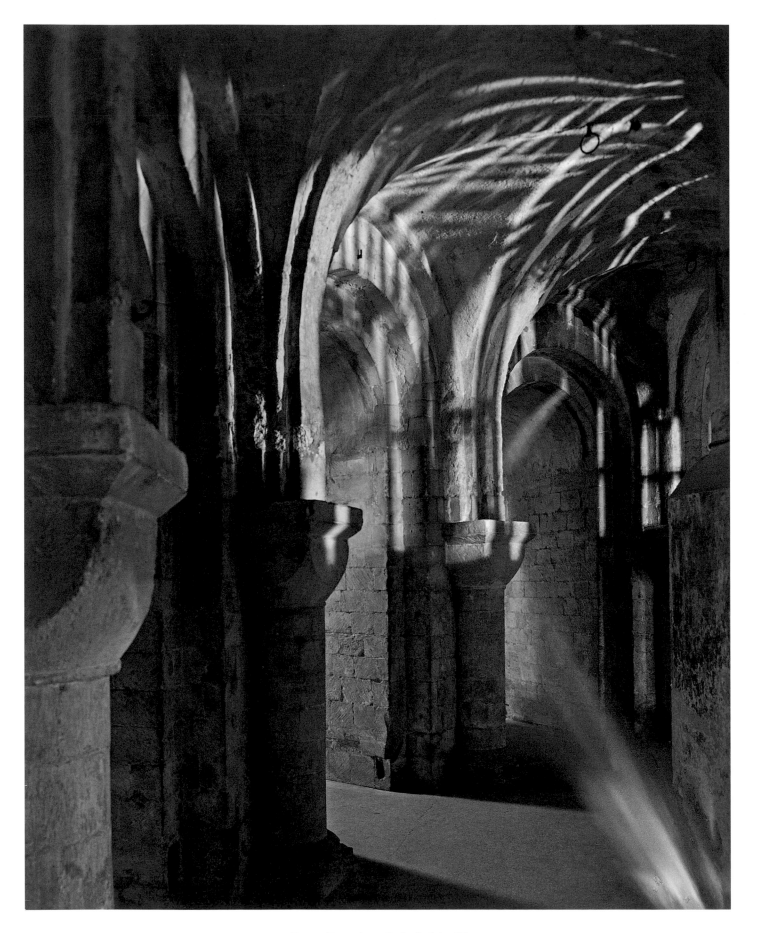

Crypt, Canterbury Cathedral (1968)

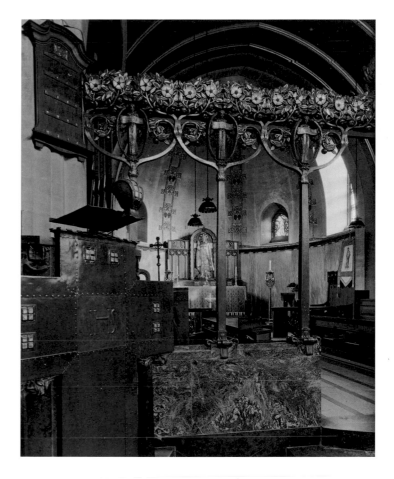

Anne of Bohemia's effigy, Westminster Abbey, London (1966)

St Mary the Virgin, Great Warley, Essex (1967)

Monument to Mary Anne Boulton in St Michael's Church, Great Tew, Oxfordshire (1961)

La Vagenende restaurant, Paris (1966)

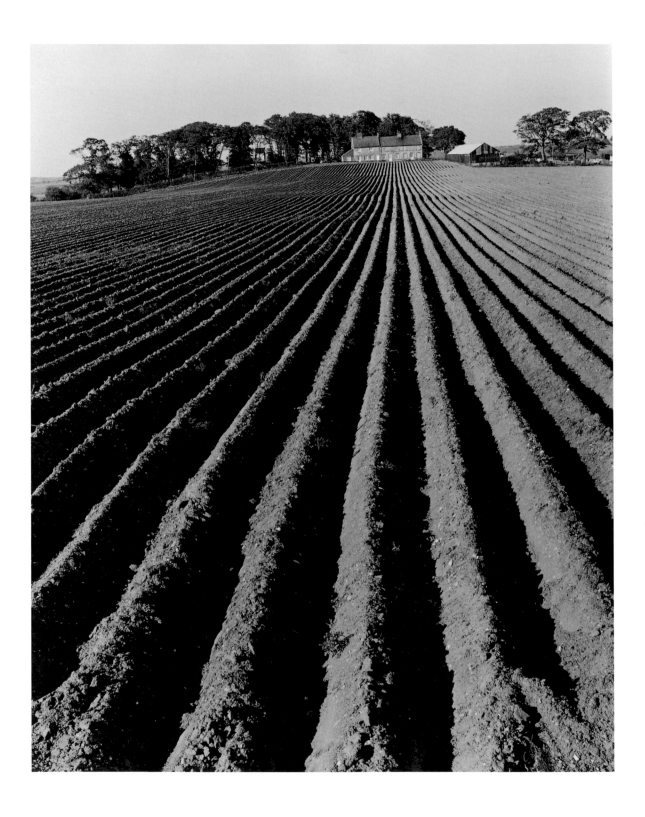

Ploughed field near Holkham, Norfolk (1970)

WORKS WRITTEN OR ILLUSTRATED BY EDWIN SMITH

Listed here are the main publications that Smith wrote or to which he contributed all or a substantial number of the illustrations. 'Photographs by' implies that Smith either took all the photographs for that particular publication or that the publishers gave his photographs special recognition. New editions are included only when these differ substantially from the original. For a more detailed, annotated bibliography, readers are referred to that compiled in *A View of the Cotswolds* (see Select Bibliography, p. 174, under Alan Powers).

1938

Edwin Smith and Oswell Blakeston, *Phototips on Cats and Dogs: Not for Beginners Only*, London (Focal Press) 1938

1939

Rudolph and Mary Arnheim, *Phototips on Children*, drawings by Edwin Smith, London (Focal Press) 1939

Oswell Blakeston and F.W. Frerk, *Cruising with a Camera: Phototips for Sea and Shore*, drawings by Edwin Smith, London (Focal Press) 1939

Edwin Smith, *Better Snapshots with Any Camera*, London (Focal Press) 1939

1940

Edwin Smith, *All about Light and Shade and Your Camera*, London and New York (Focal Press) 1940

Edwin Smith, *All about Winter Photography and Your Camera*, London and New York (Focal Press) 1940

Edwin Smith, *All the Photo-Tricks*, London and New York (Focal Press) 1940

1942

Edwin Smith, *All about Sunshine and Your Camera*, London and New York (Focal Press) 1942

1944

Cats and Women: Catalogue of Work by Edwin Smith, exhib. cat., with foreword by Oskar Kokoschka, London, Berkeley Galleries, 1944

1946

W.S. Scott, *A Clowder of Cats*, many drawings by Edwin Smith, London (John Westhouse) 1946

1951

Ralph Mayer, *The Artist's Handbook of Materials and Techniques*, ed. Edwin Smith, London (Faber & Faber) 1951

1952

Graham Hutton, *English Parish Churches*, photographs by Edwin Smith, London (Thames & Hudson) 1952. Revised and enlarged edition (Thames & Hudson) 1957

1953

The Picture Post Coronation Peep-Show Book, devised and drawn by Edwin Smith, with a commentary on the ceremony and regalia by Olive Cook, London (Hulton Press) 1953

1954

Olive Cook, *English Cottages and Farmhouses*, photographs by Edwin Smith, London (Thames & Hudson) 1954

Miles Hadfield, *The Gardener's Album*, London (Hulton Press) 1954

Edwin Smith, *All about the Light and Your Camera*, London and New York (Focal Press) 1954

1955

Olive Cook and Edwin Smith, *Collectors' Items from The Saturday Book*, London (Hutchinson) and New York (Macmillan) 1955

George Fraser, *Scotland*, photographs by Edwin Smith, London (Thames & Hudson) 1955

1956

Olive Cook, *Breckland*, London (Robert Hale) 1956. 2nd edition with new preface 1980

1957

Geoffrey Grigson, *Art Treasures of the British Museum*, photographs by Edwin Smith, London (Thames & Hudson) and New York (Abrams) 1957

Geoffrey Grigson, *England*, photographs by Edwin Smith, London (Thames & Hudson) and New York (Studio Publications) 1957

The Living City: A New View of the City of London, introduction and notes by Raymond Smith, photographs by Edwin Smith, London (Thames & Hudson) 1957. 2nd edition 1966 with English/Russian, English/Italian, English/German and English/French versions

1958

Collins Guide to English Parish Churches, ed. and intro. by John Betjeman, London (Collins) 1958

Clough Williams-Ellis, *Portmeirion, Still Further Illustrated and Explained*, 10th edition, Glasgow (Blackie & Son) 1958

1960

Marcel Brion, *Pompeii and Herculaneum: The Glory and the Grief*, photographs by Edwin Smith, London (Elek Books) 1960

Olive Cook, *English Abbeys and Priories*, photographs by Edwin Smith, London (Thames & Hudson) 1960

Norman Scarfe, *Suffolk* (Shell Guide), London (Faber & Faber) 1960 (Smith contributed to a greater or lesser extent to many titles in the Shell Guide series)

1961

'The Churches of Suffolk', in *A Suffolk Garland for the Queen*, photographs by Edwin Smith, Ipswich (East Suffolk County Council, West Suffolk County Council and Ipswich County Borough Council) 1961

Great Houses of Europe, ed. Sacheverell Sitwell, photographs by Edwin Smith, London (Weidenfeld & Nicolson) and New York (Putnam) 1961

Ian Norrie, *The Book of the City*, photographs by Edwin Smith, London (High Hill Press) 1961

Laurence Scarfe, 'Bomarzo and Early Baroque Gardens in Italy', photographs by Edwin Smith, *Motif*, no. 7, Summer 1961

Laurence Scarfe, 'Giacomo Serpotta and Themes from Sicilian Baroque', photographs by Edwin Smith, *Motif*, no. 8, Winter 1961

Lin Yutang, *Imperial Peking*, artefact photographs by Edwin Smith, London (Elek Books) 1961

1962

Marcel Brion, *Venice: The Masque of Italy*, photographs by Edwin Smith, London (Elek Books) and New York (Crown Publishers) 1962

The Carpet Makers: One Hundred Years of Designing and Manufacturing Carpets of Quality, photographs by James Mortimer and Edwin Smith, Elderslie, Scotland (A.F. Stoddard & Co. Ltd) 1962

Heathside Book of Hampstead and Highgate, ed. Ian Norrie, photographs by Edwin Smith, London (High Hill Books) 1962

Laurence Scarfe, 'Noto and the Villas of Bagheria', photographs by Edwin Smith, *Motif*, no. 9, Summer 1962

1963

F.R. Banks, *English Villages*, photographs by Edwin Smith, London (Batsford) 1963

Olive Cook, *Movement in Two Dimensions*, London (Hutchinson) 1963

Great Gardens, ed. Peter Coats, London (Weidenfeld & Nicolson) 1963

Clough Williams-Ellis, *Portmeirion: The Place and Its Meaning*, photographs by Edwin Smith, London (Faber & Faber) 1963

1964

F.R. Banks, *Old English Towns*, photographs by Edwin Smith, London (Batsford) 1964

Book of Westminster, ed. Ian Norrie, London (High Hill Books) 1964

Edward Hyams, *The English Garden*, photographs by Edwin Smith, London (Thames & Hudson) 1964

Angelo Procopiou, *Athens, City of the Gods: From Prehistory to 338 BC*, photographs by Edwin Smith, London (Elek Books) 1964

Edwin Smith and Olive Cook, *British Churches*, London (Studio Vista) and New York (E.P. Dutton & Co.) 1964

1965

Donald Bullough, *The Age of Charlemagne*, photographs by Edwin Smith, London (Elek Books) 1965

Olive Cook, *Prospect of Cambridge*, photographs by Edwin Smith, London (Batsford) 1965

Olive Cook, *The Wonders of Italy*, photographs by Edwin Smith, London (Thames & Hudson) and New York (Viking) 1965

1966
Micheál Mac Liammóir and Olive Cook, *Ireland*,
photographs by Edwin Smith, London
(Thames & Hudson), New York (Viking) and
Zurich (Atlantis Verlag) 1966
Ian Norrie, *Hampstead: A Short Guide*,
photographs by Edwin Smith, London
(High Hill Books), 1966
A.J. Youngson, *The Making of Classical Edinburgh*,
photographs by Edwin Smith, Edinburgh
(Edinburgh University Press) 1966

1967
Olive Cook, *The Stansted Affair: A Case for the
People*, foreword by John Betjeman, London
(Pan Books) 1967
Kenneth Fowler, *The Age of Plantagenet and Valois*,
London (Elek Books), New York (Putnam) and
Toronto (Ryerson Books) 1967
Great Interiors, ed. Ian Grant, photographs
by Edwin Smith, London (Weidenfeld & Nicolson)
and New York (E.P. Dutton) 1967
Ian Norrie, *Highgate and Kenwood: A Short Guide*,
photographs by Edwin Smith, London
(High Hill Books) 1967
Giuseppe Tucci, *Tibet: Land of Snows*, London
(Elek Books) and Toronto (Ryerson Books) 1967

1968
Book of Hampstead, ed. Mavis and Ian Norrie,
2nd rev. edn, London (High Hill Press), 1968
Olive Cook, *The English House through Seven
Centuries*, photographs by Edwin Smith,
London (Nelson) 1968
Eric Linklater and Olive Cook, *Scotland*,
photographs by Edwin Smith, London
(Thames & Hudson) and New York
(Viking Press) 1968
Betty Massingham, *Town Gardens*, photographs
by Edwin Smith, London (Pelham Books) 1968

1969
Olive Cook, *A Study of Anstey: The Sense
of Continuity in a Hertfordshire Parish*,
photographs by Edwin Smith (Nuthampstead
Preservation Association) 1969
Hilaire Hiler, *Notes on the Technique of Painting*,
ed. Edwin Smith, with preface by Sir William
Rothenstein, London (Faber & Faber) 1969
Minnie Lambeth, *A Golden Dolly: The Art, Mystery
and History of Corn Dollies*, photographs by
Edwin Smith, London (John Baker Ltd) 1969
John Lewis and Edwin Smith, *The Graphic
Reproduction and Photography of Works of Art*,
London (W.S. Cowell) and New York (Praeger)
1969
Sacheverell Sitwell, *Gothic Europe*, London
(Weidenfeld & Nicolson) and New York (Holt,
Rinehart & Winston) 1969

1970
Olive Cook, *Ardna Gashel*, linocuts and pattern
paper by Edwin Smith, Cambridge
(Golden Head Press) 1970
Edward Hyams, *English Cottage Gardens*,
photographs by Edwin Smith, London
(Nelson) 1970

1971
David Piper, *London*, special photography
by Edwin Smith (World Cultural Guides),
London (Thames & Hudson) and New York
(Holt, Rinehart & Winston) 1971
Stewart Perowne, *Rome: From Its Foundation
to the Present*, photographs by Edwin Smith,
London (Elek Books) 1971
Angus Wilson and Olive Cook, *England*,
photographs by Edwin Smith, London
(Thames & Hudson) and New York
(Viking) 1971

1972
John Betjeman, *A Pictorial History of English
Architecture*, London (John Murray) 1972

1973
David Cecil, *The Cecils of Hatfield House*,
photographs by Edwin Smith, London
(Constable) and Boston (Houghton Mifflin)
1973
Ian G. Lindsay and Mary Cosh, *Inveraray and
the Dukes of Argyll*, photographs by Edwin
Smith, Edinburgh (Edinburgh University
Press) 1973

1976
Olive Cook, *English Parish Churches*, photographs
by Edwin Smith, rev. edn (World of Art series),
London (Thames & Hudson) 1976

1977
James Turner, *The Countryside of Britain*,
photographs by Edwin Smith, London
(Ward Lock) 1977
Peter Willis, *Charles Bridgeman and the English
Landscape Garden*, photographs by Edwin
Smith, London (A. Zwemmer) 1977

1981
Paul Jennings, *Britain*, photographs
by Edwin Smith, London (Cassell) 1981

1982
Olive Cook, *English Cottages and Farmhouses*,
photographs by Edwin Smith, London and
New York (Thames & Hudson) 1982

1984
Olive Cook, *Edwin Smith: Photographs
1935–1971*, photographs by Edwin Smith,
London (Thames & Hudson) 1984

1986
Ronald Blythe, *Divine Landscapes*, photographs
by Edwin Smith, Harmondsworth and
New York (Viking) 1986
Sacheverell Sitwell's England,
ed. Michael Raeburn, photographs by
Edwin Smith, London (Orbis) 1986

1989
Edwin Smith and Olive Cook, *English Cathedrals*,
London (Herbert Press) 1989

1992
Edwin Smith, *Cuts*, with an introduction by Olive
Cook, limited edition, Church Hanborough
(Previous Parrot Press) 1992

1998
Walter Hoyle, *To Sicily with Edward Bawden*,
with an introduction by Olive Cook and
drawings by Edward Bawden, Walter Hoyle
and Edwin Smith, Church Hanborough
(Previous Parrot Press) 1998

1999
Lucy Archer, *Architecture in Britain and Ireland
600–1500*, photographs by Edwin Smith,
London (Harvill Press) 1999
Betjeman's Britain, selected, ed. and intro. by
Candida Lycett Green, photographs by Edwin
Smith and others, London (Folio Society) 1999

2005
Alan Powers, Ian Mackenzie-Kerr, Shawn Kolucy
and Rory Young, *A View of the Cotswolds*,
photographs by Edwin Smith, limited edition,
Risbury, Herefordshire (Whittington Press) 2005

CONTRIBUTIONS TO *The Saturday Book*
Edwin Smith, 'The Domestic Shell', *The Saturday
Book 4*, London (Hutchinson) 1944, pp. 145–60
Edwin Smith, 'Household Gods', *The Saturday
Book 5*, London (Hutchinson) 1945, pp. 129–44
Edwin Smith, 'Rare and Common', *The Saturday
Book 6*, London (Hutchinson) 1946,
pp. 97–112
Olive Cook and Edwin Smith, 'Art Album',
The Saturday Book 7, London (Hutchinson)
1947, pp. 5–32
Edwin Smith, 'Fair and Frail', *The Saturday
Book 7*, London (Hutchinson) 1947, pp. 113–28
Olive Cook and Edwin Smith, 'The Art of
Acquisition', *The Saturday Book 8*, London
(Hutchinson) 1948, pp. 25–48
Edwin Smith, 'Purrs and Paws', *The Saturday
Book 8*, London (Hutchinson) 1948, pp. 217–24
Olive Cook and Edwin Smith, 'The One in the
Window', *The Saturday Book 9*, London
(Hutchinson) 1949, pp. 49–72
Edwin Smith, 'The Gold Salt Cellar', *The Saturday
Book 9*, London (Hutchinson) 1949, pp. 73–80
Olive Cook and Edwin Smith, 'Ship Shape',
The Saturday Book 10, London (Hutchinson)
1950, pp. 57–80
Olive Cook, 'Under the Yew Tree's Shade',
photographs by Edwin Smith, *The Saturday
Book 10*, London (Hutchinson) 1950,
pp. 245–52
Olive Cook and Edwin Smith, 'Sports for All
Seasons', *The Saturday Book 11*, London
(Hutchinson) 1951, pp. 65–88
Olive Cook and Edwin Smith, 'Beside the Seaside',
The Saturday Book 12, London (Hutchinson)
1952, pp. 22–44
Olive Cook, 'Embroidered in White', photographs
by Edwin Smith, *The Saturday Book 12*, London
(Hutchinson) 1952, pp. 59–65
Edwin Smith and Olive Cook, 'The Festive Season',
The Saturday Book 13, London (Hutchinson)
1953, pp. 17–36
Olive Cook, 'Exits and Entrances', photographs
by Edwin Smith, *The Saturday Book 13*,
London (Hutchinson) 1953, pp. 134–40

Edwin Smith and Olive Cook, 'The Art of Beauty', *The Saturday Book 14*, London (Hutchinson) 1954, pp. 14–37

Olive Cook, 'A Street in Sicily', photographs by Edwin Smith, *The Saturday Book 14*, London (Hutchinson) 1954, pp. 102–14

Olive Cook and Edwin Smith, 'Ups and Downs: Some Studies of Ceilings and Floors', *The Saturday Book 14*, London (Hutchinson) 1954, pp. 146–54

Edwin Smith and Olive Cook, 'The Art of Adornment', *The Saturday Book 15*, London (Hutchinson) 1955, pp. 18–40

Olive Cook, 'Moving Pictures before the Cinematograph', photographs by Edwin Smith, *The Saturday Book 15*, London (Hutchinson) 1955, pp. 247–52

Olive Cook, 'Sepulchral Effigies', photographs by Edwin Smith, *The Saturday Book 16*, London (Hutchinson) 1956, pp. 217–30

W.G. Corp, 'The Pleasures of Snuff', photographs by Edwin Smith, *The Saturday Book 16*, London (Hutchinson) 1956, pp. 238–45

Olive Cook and Edwin Smith, 'Bluebeard in Bits and Pieces', *The Saturday Book 16*, London (Hutchinson) 1956, pp. 281–96

Olive Cook and Edwin Smith, 'No Place Like Home', *The Saturday Book 17*, London (Hutchinson) 1957, pp. 15–36

Vivien Greene, 'Doll's House and Baby House', photographs by Edwin Smith, *The Saturday Book 17*, London (Hutchinson) 1957, pp. 37–48

Olive Cook and Edwin Smith, 'The "Fifties"', *The Saturday Book 18*, London (Hutchinson) 1958, pp. 16–36

John Betjeman, 'Betjeman's Britain', photographs by Edwin Smith, *The Saturday Book 18*, London (Hutchinson) 1958, pp. 78–112

Olive Cook and Edwin Smith, 'Cinderella', *The Saturday Book 18*, London (Hutchinson) 1958, pp. 289–304

Olive Cook and Edwin Smith, 'Follies', *The Saturday Book 19*, London (Hutchinson) 1959, pp. 65–75

Olive Cook and Edwin Smith, 'Breakfast, Luncheon, Tea, Dinner: Or, All the Human Frame Requires', *The Saturday Book 19*, London (Hutchinson) 1959, pp. 221–37

Olive Cook and Edwin Smith, 'Sculpture and Situation', *The Saturday Book 20*, London (Hutchinson) 1960, pp. 74–91

L.T.C. Rolt, 'A Railway in Miniature', photographs by Edwin Smith, *The Saturday Book 20*, London (Hutchinson) 1960, pp. 221–35

John G. Garratt, 'Little Armies', photographs by Edwin Smith, *The Saturday Book 20*, London (Hutchinson) 1960, pp. 264–71

Olive Cook and Edwin Smith, 'An Imaginary Museum', *The Saturday Book 21*, London (Hutchinson) 1961, pp. 128–43

Fred Bason, 'London Street Markets', photographs by Edwin Smith, *The Saturday Book 21*, London (Hutchinson) 1961, pp. 144–64

Olive Cook and Edwin Smith, 'English Suburban', *The Saturday Book 22*, London (Hutchinson) 1962, pp. 120–40

Olive Cook, 'Any Old Iron?', photographs by Edwin Smith, *The Saturday Book 23*, London (Hutchinson) 1963, pp. 112–19

Olive Cook and Edwin Smith, 'Puss in Boots', *The Saturday Book 23*, London (Hutchinson) 1963, pp. 273–88

Edwin Smith, 'Edwin Smith's Domestic Alphabet', *The Saturday Book 24*, London (Hutchinson) 1964, pp. 26–55

Edwin Smith and Olive Cook, 'The Golden Age of the Bicycle', *The Saturday Book 25*, London (Hutchinson) 1965, pp. 96–104

Olive Cook, 'Glendalough, the Monastic City', photographs by Edwin Smith, *The Saturday Book 26*, London (Hutchinson) 1966, pp. 100–15

Olive Cook and Edwin Smith, 'Disasters', *The Saturday Book 26*, London (Hutchinson) 1966, pp. 220–35

Olive Cook, 'The Postman's Palace', photographs by Edwin Smith, *The Saturday Book 27*, London (Hutchinson) 1967, pp. 71–83

Olive Cook, 'Lantern Moralities', photographs by Edwin Smith, *The Saturday Book 28*, London (Hutchinson) 1968, pp. 205–23

Olive Cook, 'The Curious Art of Topiary', photographs by Edwin Smith, *The Saturday Book 29*, London (Hutchinson) 1969, pp. 192–203

Olive Cook, 'The Art of Collecting', photographs by Edwin Smith, *The Saturday Book 30*, London (Hutchinson) 1970, pp. 8–35

Olive Cook, 'Fairground Baroque', photographs by Edwin Smith, *The Saturday Book 31*, London (Hutchinson) 1971, pp. 73–86

Olive Cook, 'Photographer by Chance: Valediction to Edwin Smith', photographs by Edwin Smith, *The Saturday Book 32*, London (Hutchinson) 1972, pp. 237–56

Olive Cook, '*The Saturday Book* Pictorial Quiz', photographs by Edwin Smith, *The Saturday Book 33*, London (Hutchinson) 1973, pp. 228–56

Olive Cook, 'The Fabric of a Dream', photographs by Edwin Smith, *The Saturday Book 34*, London (Hutchinson) 1975, pp. 185–201

SELECT BIBLIOGRAPHY

UNPUBLISHED SOURCES

The chief source is Smith's collection of 60,000 negatives and 20,000 prints held in the RIBA British Architectural Library Photographs Collection. Catalogue entries for these can be found on the Library's database at www.architecture.com. A selection of Smith's pictures can be seen on the Library's image database, RIBApix, at www.ribapix.com. In addition to the photographs, the collection contains some of Smith's cameras, correspondence between Smith and Cook, books that Smith illustrated, including his proof copy of *Pompeii and Herculaneum: The Glory and the Grief*, technical manuals and ephemera.

Cook's own archive is held by Newnham College, Cambridge, and catalogue entries for this can be found via http://janus.lib.cam.ac.uk

Edwin Smith: Tape Transcripts of Interviews, conducted and transcribed by Brian Human, 1990

Transcript of John Donat talking to Michael Oliver on the BBC radio programe *Kaleidoscope*, 18 November 1976 (Olive Cook Papers, Newnham College Archives, Cambridge, Box 30 5/4/4).

PUBLISHED SOURCES

Lucy Archer, 'Working with Olive Cook', *Matrix*, no. 23, Winter 2003, pp. 41–49

Artists at the Fry: Art and Design in the North West Essex Collection, ed. Martin Salisbury, Cambridge (Ruskin Press and the Fry Art Gallery) 2003

As We Were: Photographs by Edwin Smith, exhib. cat., Saffron Walden, Fry Art Gallery, 1997

Aspects of the Art of Edwin Smith, exhib. cat., Colchester, The Minories, 1974

Aspects of Englishness – Part 1, Photographs by Edwin Smith, exhib. cat., London, House, 62 Regents Park Road, 1979

Atget: Photographe de Paris, Paris (Henri Jonquières) 1930

Martin Barnes, *Benjamin Brecknell Turner: Rural England through a Victorian Lens*, London (V&A Publications) 2001

Behind the Auguste Mask: An Exploration of the Clown Character – Jill Freedman, Maggi Hambling, Laura Knight, Edwin Smith, exhib. cat., Brighton, Gardner Centre Gallery, University of Sussex, 1985

Nicholas Bullock, *Building the Post-War World: Media, Architecture and Reconstruction in Britain*, London (Routledge) 2002

Angus Calder, *The Myth of the Blitz*, London (Pimlico) 1991

Michael Carney, 'Britain in Pictures', *Antiquarian Book Monthly*, February 1995, pp. 10–14

Andrew Causey, *Paul Nash's Photographs: Document and Image*, London (Tate Gallery) 1973

Olive Cook, *Movement in Two Dimensions*, London (Hutchinson) 1963

Olive Cook, 'Edwin Smith 1912–1971', in *Creative Camera International Year Book*, 1978, pp. 10–37

Olive Cook, *Edwin Smith: Photographs 1935–1971*, photographs by Edwin Smith, London (Thames & Hudson) 1984

Olive Cook, 'The Southwold Columbia', *Matrix*, no. 17, Winter 1997, pp. 32–34

Olive Cook, 'Photography and the Visual Arts', *Matrix*, no. 18, Winter 1998, pp. 44–49

Olive Cook, 'Novelty and the Sense of Continuity', *Matrix*, no. 20, Winter 2000, pp. 37–44

Olive Cook, 'A View of the Cotswolds', *Matrix*, no. 21, Winter 2001, pp. 44–45

Gillian Darley, 'Edwin Smith: Photographer', *Architects' Journal*, 15 December 1976, pp. 1106–107

Paul Delany, *Bill Brandt: A Life*, London (Jonathan Cape) 2004

'Edwin Smith (1912–1971): A Memorial Exhibition of His Photographs, Selected by Olive Smith', in *The Twenty-Sixth Aldeburgh Festival of Music and the Arts*, Ipswich (W.S. Cowell for the Aldeburgh Festival) 1973

'Edwin Smith', *Period Home*, no. 4, June/July 1983, pp. 20–26

Robert Elwall, *Photography Takes Command: The Camera and British Architecture 1890–1939*, London (RIBA Heinz Gallery) 1994

Robert Elwall, *Building with Light: The International History of Architectural Photography*, London and New York (Merrell) 2004

Robert Elwall, 'Wolds that Time Forgot', *The World of Interiors*, vol. 25, September 2005, pp. 118–23

Jonathan Glancey, 'The Dream Life of Buildings', *The Guardian*, 15 April 2002, p. 12

Dennis Hall, 'Edwin Smith and Olive Cook', *Parenthesis*, no. 6, August 2001, pp. 28–29

Ray Hammans, website *Edwin Smith 1912–1971: Photographer, Painter, Architect*, at http://www.weepingash.co.uk/es/es01.html

Elain Harwood and Alan Powers, *Tayler and Green, Architects 1928–1973: The Spirit of Place in Modern Housing*, London (Prince of Wales's Institute of Architecture) 1998

Julia Hedgecoe, 'In Memoriam: Life Stories. Olive Muriel Smith', in *Newnham College Roll Letter*, 2003, pp. 110–12

Rayner Heppenstall, *Saturnine*, London (Secker & Warburg) 1943

Rayner Heppenstall, *The Lesser Infortune*, London (Jonathan Cape) 1953

Robert Hewison, *Culture and Consensus: England, Art and Politics since 1940*, London (Methuen) 1995

W.G. Hoskins, *The Making of the English Landscape*, London (Folio Society) 2005 reissue

Walter Hoyle, *To Sicily with Edward Bawden*, with an introduction by Olive Cook and drawings by Edward Bawden, Walter Hoyle

and Edwin Smith, Church Hanborough (Previous Parrot Press) 1998

Richard Ingrams and John Piper, *Piper's Places: John Piper in England and Wales*, London (Chatto & Windus/The Hogarth Press) 1983

Barbara Jones, *The Unsophisticated Arts*, London (Architectural Press) 1951

Ian Mackenzie-Kerr, 'Gravure at Thames and Hudson', *Matrix*, no. 18, Winter 1998, pp. 84–88

John Marlowe, *Late Victorian: The Life of Sir Arnold Talbot Wilson*, London (The Cresset Press) 1967

Enid Marx and Margaret Lambert, *English Popular and Traditional Art*, London (Collins) 1946

Jay Merrick, 'A Sight for Sore Eyes', *ArtReview*, vol. 54, May 2003, p. 40

Brian Mills, 'Designed and Produced By … Some Notes on the Story of Adprint', *Antiquarian Book Monthly Review*, vol. 13, October 1986, pp. 368–73

Modern Photography: The Studio Annual of Camera Art, 1935–36, pp. 19, 28

Gilles Mora and John T. Hill, *Walker Evans: The Hungry Eye*, London (Thames & Hudson) 1993

Christopher Neve, *Unquiet Landscape: Places and Ideas in Twentieth-Century English Painting*, London (Faber & Faber) 1990

'New Look for Postcards', *Motif*, no. 3, September 1959, p. 92

Beaumont Newhall, *Frederick H. Evans: Photographer of the Majesty, Light and Space of the Medieval Cathedrals of England and France*, New York (Aperture) 1973

Walter Nurnberg, 'Edwin Smith', *British Journal of Photography*, 20 December 1985, pp. 1427, 1439

Olive Cook and Edwin Smith, catalogue 15, York (Stone Trough Books) 2003

A Paradise Lost: The Neo-Romantic Imagination in Britain 1935–55, ed. David Mellor, exhib. cat., London (Lund Humphries in association with the Barbican Art Gallery) 1987

Alan Powers, 'The Coach House, Essex', *Country Life*, vol. 192, 26 November 1998, pp. 46–49

Alan Powers, 'Soul Searching', *The Spectator*, 4 December 1999, p. 58

Alan Powers, Ian Mackenzie-Kerr, Shawn Kolucy and Rory Young, *A View of the Cotswolds*, photographs by Edwin Smith, limited edition, Risbury, Herefordshire (Whittington Press) 2005

V.S. Pritchett, *Dublin: A Portrait*, photographs by Evelyn Hofer, London (Bodley Head) 1967

Belinda Rathbone, *Walker Evans: A Biography*, New York (Houghton Mifflin) 1955

Reassessing Nikolaus Pevsner, ed. Peter Draper, Aldershot (Ashgate) 2004

ACKNOWLEDGEMENTS

Record and Revelation: Photographs by Edwin Smith, exhib. cat., York, Impressions Gallery of Photography, 1983

Mitchell Schwarzer, *Zoomscape: Architecture in Motion and Media*, New York (Princeton Architectural Press) 2004

John Szarkowski, *Atget*, New York (Museum of Modern Art) 2000

John Szarkowski and Maria Morris Hambourg, *The Work of Atget*, 4 vols, London (Gordon Fraser) 1981–85

Mike Weaver, *The Photographic Art: Pictorial Traditions in Britain and America*, London (Herbert Press) 1986

Sir Arnold Wilson, *Walks and Talks: The Diary of a Member of Parliament in 1933–4*, London (Oxford University Press, Humphrey Milford) 1934

Sir Arnold Wilson, *Walks and Talks Abroad: The Diary of a Member of Parliament in 1934–6*, London (Oxford University Press, Humphrey Milford) 1936

Malcolm Yorke, *The Spirit of Place: Nine Neo-Romantic Artists and Their Times*, London (Constable) 1988

Rory Young, 'A Nursery of Inventions', *Matrix*, no. 23, Winter 2003, pp. i–viii

Like so many, this book was not conceived by a solitary writer struggling in his garret, but has been heavily reliant on the generous co-operation and advice of a cast of individuals, which, if not of Cecil B. DeMille proportions, is nevertheless extensive. Among those I must single out, first and foremost is Olive Cook, one of the most remarkable women I have ever met, who, in an act of typical generosity, bequeathed Edwin's photographic collection to the Royal Institute of British Architects in 2002. While she may have wished to take issue with some of the things I have written, I hope she would have acknowledged that I have endeavoured to be fair to the memory of a photographer whose work I hold in the highest esteem.

Secondly, I must pay tribute to the many volunteers whose tireless work has transformed the collection of which I have the good fortune to be head, and in particular to those who have done such a superb job in organizing the Smith archive: Mandy McMahon, Pat Faris, Jane Maitland-Hudson, the late Tim Day, Sarah Brown, Keiko Shibata, Colin Godden and Laura Silver. Thirdly, I must salute my colleagues in the RIBA Library, among them my fellow tillers of the photographic soil and friends Jonathan Makepeace and Valeria Carullo; the Director, Dr Irena Murray, whose constant encouragement, not just for this project but for the collection as a whole, has been so inspirational; Jonathan Ridsdale, who has so efficiently tackled all my requests for loans from other libraries; and above all, since they will be enjoying their retirement 'gardening' by the time this book appears, Julian Osley and Sally Dale, whose professional support and personal friendship I have been privileged to enjoy over so many years. Fourthly, my effusive thanks go to Anne Thomson, the archivist at Newnham College, who has so patiently and willingly responded to all my requests for box after box from Cook's voluminous archive, and her colleague Patricia Ackerman, who not only so diligently achieved the daunting task of bringing order to the chaos of the archive but also generously volunteered to do the same with Smith's papers at the RIBA. Fifthly, I must again commend the staff at Merrell – I can give no higher praise to Hugh Merrell, Julian Honer, Michelle Draycott, Nicola Bailey, Anthea Snow and Marion Moisy other than to say that the second time has proved as enjoyable as the first – and the designer, Maggi Smith.

In no particular order I should also like to thank: Ray Hammans and Brian Human for generously making available to me transcripts of their interviews with Cook and her friends; Martin Smith, who provided biographical information and new leads; Martin Charles, who alerted me to Smith's 'coin tricks'; John Randle; Margaret and James Sutton; Nigel Weaver and Colin Wilkin of the Fry Art Gallery; Peter Brown; the late Ian Mackenzie-Kerr; the staff of the London Library; and A.C. Cooper (Colour) Limited and Norman Kent, who produced the new prints for this book. Finally, the last words of praise must go to my wife, Cathy, whose tireless devotion to the nuts-and-bolts of book production makes this a truly collaborative enterprise. In Edwin's favourite word she is "adorable", in Olive's, my "darling".

PHOTOGRAPHIC CREDITS

INDEX